TO BE
DISPOSED
BY
AUTHORITY

PRE-RAPHAELITE ART AND DESIGN

PRE-RAPHAELITE ART AND DESIGN

Raymond Watkinson

Studio Vista London

© Raymond Watkinson 1970
First published in Great Britain 1970
by Studio Vista Limited, Blue Star House,
Highgate Hill, London N19

Set in Baskerville 11 pt, 1 point leaded

Printed in Great Britain by
Richard Clay (The Chaucer Press), Ltd,
Bungay, Suffolk

SBN 289 79654 7

Contents

Acknowledgements

For permission to photograph and/or reproduce paintings, drawings, furniture, fabrics etc., acknowledgements are due to the following:

Cecil Higgins Art Gallery, Bedford; City Art Gallery, Birmingham; City Art Gallery, Bradford; National Museum of Wales, Cardiff; City Art Gallery, Carlisle; City Art Gallery, Leeds; Walker Art Gallery, Liverpool; South London Art Gallery; City Art Gallery, Manchester; Tate Gallery, London; The Laing Art Gallery, Newcastle upon Tyne; Lady Lever Art Gallery, Port Sunlight; The Society of Antiquaries; Victoria and Albert Museum.

I should like also to express warm thanks to all those who, as officers of galleries and museums or as friends, helped me to accumulate the material from which this book has been evolved: who lent books, took photographs, pointed out sources which I might well have missed, and made works accessible. Particular thanks are due to Dr Gilbert Leathart, Mr Dennis Frone, and Mr W.V.Whitaker for photographs; to the Society of Antiquaries and Peter Locke for the photograph (pl. 27) of Ford Madox Brown furniture rediscovered at Kelmscott Manor; and to Mrs T.H. Leathart for permission to reproduce *Portrait of James Leathart* (pl. 19) and *Mrs Leathart and three children* (pl. 32).

The device used on the half-title and title page is the trade-mark of Morris Marshall Faulkner and Co., designed by Ford Madox Brown.

Foreword

This is not another examination of the well-publicized private lives of the Pre-Raphaelites and their circle, but aims at inquiring into their work and its origins as part of a larger, European development, and suggesting some consequences of their association.

The term Pre-Raphaelite is well established, and much abused. Even in the lifetime of the men who formed the original Brotherhood in 1848, it was very loosely applied, often to work quite alien in intention. For a short time those seven young men seemed to have a common objective, in pursuit of which they made, in a couple of years, very marked inroads into the values of the art world of the mid-century. But at the same time as their concerted effort proceeded, their individual developments soon showed the essential differences of character which their initial association had disguised, and within five years they were all pursuing their separate paths. Not many years later different individuals were acclaimed as the originators of their first ideals, and the term Pre-Raphaelite began to lose its first definition. Long before the end of the century it was being applied to work quite opposite in conception to the highly finished, naturalistic, moral and dramatic paintings which had shocked, then captivated both artists and public in the 1850s.

Art-historical terms cannot easily be given two-line dictionary definitions; nor can individual works of art be clearly accounted for by the simple application of such terms. It is of the nature of a work of art, however single-minded and simple, to possess a variety of qualities, to contain in its style and forms the history of its own creation. But we should try to use our terms as clearly as we can.

When we consider the work of the Pre-Raphaelites, we are considering one of the fountain-heads of the art of our own time, not just another manifestation of English eccentricity. This is perhaps easiest to see precisely at the point where the original impulse is at its most attenuated, in the 1890s; but even in its strict form, Pre-Raphaelite painting—and it is a term which belongs strictly to painting—was seen outside Britain as early as 1855, only seven years after the mysterious initials PRB had first appeared. Pre-Raphaelite paintings were included in the Paris Exposition of 1855, and impressed Delacroix, as, thirty years before, the work of other English artists had impressed him. He found the work of Hunt and Millais worth recording in his journal. Nor was it only on the European continent that Pre-Raphaelite works were seen; they also became familiar in the United States. Both in its origins, to which earlier German developments contributed, and in its final stage, which fed into Art Nouveau, this essentially anti-academic spirit is a part of the whole story of modern art.

A growing proportion of new patrons of art came from the mercantile and the manufacturing sections of the middle class, rising in fortune with the enormous

expansion of industry. Many of them started life as artisans, even as labourers, and many, naturally, adapting themselves to the life and social habit of the existing middle class, submitted to its accepted values, lived their lives, furnished their homes conventionally, and included conventional paintings in their furnishings. But others, conscious of the extent to which their own talents, energy and judgement had lifted them from their origins and given them wealth and power, preferred to exercise their own judgement in the field of art. It was such men who found Ruskin's writings so stimulating and acceptable, and such men who figured largely among the patrons of the Pre-Raphaelites. Such were Fairbairn the engineer, Plint the stock-broker, Leathart the lead manufacturer, Craven and McCracken the shippers. Without such patronage the Brotherhood could not have made its way. Given the patronage, they and their followers were able to maintain their drive and go on creating not only more works of art, but with them, a new sensibility.

It had its own weakness. Where traditional taste had depended on the indoctrina-tion of painter and patron alike with concepts of the ideal and the beautiful, with norms supposedly sanctioned by the art of antiquity, the new sensibility emphasized more and more that aspect of art which rests upon the retailing of real experience—the imitation of nature. Consciously and unconsciously, it drew great support from the general drive of the century towards scientific description and explanation. Where the vice of an art of taste had been to repeat formulae which had no basis in immediate experience, the vice of an art of sensibility was to offer unselective, untransformed, even trivial accounts of immediate experience.

This vice, however, should not be allowed to obliterate the real gains made in the swift growth of the new sensibility, not least of which was the notion that art may and should be accessible to all. Just as the notion of art as presenting an objec-tive account of our visual experience was supported by the scientific bias of the period, so the notion of art as possible and desirable for all was supported by the general growth of democratic ideas. Everywhere—in the metropolis, in the expand-ing industrial centres—galleries and museums were being set up in which the general populace might see the wonders of art and science. Hunt's *Light of the World*, and Madox Brown's *Work*, were great popular successes: both were conceived in terms of the widest possible communication. These, and many other Pre-Raphaelite paintings, have qualities of order, form and colour which take them far beyond the naturalistic account, the religious, moral or social theme. Such works made a real breach in the dead tradition.

Perhaps, in the establishment of a new sensibility, it was the radical change brought about in responses to colour that was the most important and far-reaching. It was important not just because it was so marked, sudden and dramatic, but because it so immediately extended out of the field of painting into the decorative arts. One of the marks of the finest Pre-Raphaelite work was, and still is, the exciting and disturbing power of its colour—very much the least naturalistic aspect of the new painting. The painters of the Brotherhood, and their associates, went beyond the frank record of the green of trees and grasses, the bright pure hues of flowers, and reintroduced into painting ranges and relations of colour unused in European art since the Middle Ages—an alarming array of blues, greens, violets,

purples, used not simply because they were there to be painted, but chosen for their powerful emotional effect. It was not of course simply the colours, but their combination, that compelled attention and provoked these effects. It was a decisive move towards modern painting, where we expect art to disturb, to remake and extend experience, rather than to recapitulate perfected systems of form. All this concerns Pre-Raphaelitism as such, the painting of pictures; but once the new wave of responses was released and the old values thereby reduced, the way was open for further extensions of sensibility. It reached out into the field of decorative art, and made a revolution there too, perhaps more important and far-reaching than that in painting. It very powerfully affected and broadened the possibilities of the Arts and Crafts Movement; was at the heart of the Aesthetic Movement, and helped to fertilize the soil in which, later, Art Nouveau could grow.

The Pre-Raphaelite idea, and the association around it, made that small band of painters highly influential, but as the area of influence widened, and the close commitment of the original group relaxed, the influence can be seen to diverge into two quite different streams. In painting and illustration, the strict Pre-Raphaelite idea can be seen giving character to a considerable volume of English painting; but alongside this there developed painting, graphic design and decoration, stemming from the work of Rossetti and Ford Madox Brown, which is quite un-Pre-Raphaelite.

In the following pages, I attempt to show how Pre-Raphaelite painting, and the Brotherhood, came about, and what it meant to its originators; what antecedents it had; how the grouping of personalities which it brought about continued, over forty years, to be creatively effective, even though individuals changed course, found new commitments and finally abandoned Pre-Raphaelitism itself.

PRELUDE

1 Ford Madox Brown

Ford Madox Brown, probably the most important single influence in the Pre-Raphaelite movement, was never a member of the Brotherhood, the group of English artists who came together in 1848. Its three most influential members were William Holman Hunt, John Everett Millais and Dante Gabriel Rossetti; of the remaining four members William Michael Rossetti and F.G.Stephens became influential critics, Thomas Woolner the sculptor, a successful Academician, and James Collinson, who was a Roman Catholic, resigned in 1850 on religious grounds, going to Stonyhurst to study for the priesthood. Brown was indeed closely linked with the Brotherhood in the mind of the public so that he was often thought to have been a member, even its founder, but his association with the group came about simply through Dante Gabriel Rossetti, on whom he exercised a deep and lasting influence.

Brown was born at Calais on April 16, 1819, son of a half-pay naval purser; most of his early life was spent as a member of the numerous, migratory expatriate community of British ex-naval and military personnel and poor gentlefolk centred there. When he was fourteen, the family moved to Bruges where he became the pupil of Gregorius, himself once a pupil of David. Newly returned to his native city, Gregorius had just become director of the Academy. Brown was too young for the Academy schools, but Gregorius took him as a private pupil. The portrait of his father, done while studying under this master, shows astonishing ability within the current conventions; the head is well-constructed, there is nothing juvenile or awkward about it, and it conveys considerable character. After a year, a move to Ghent made it possible for him to become the pupil of yet another rising artist—Van Hanselaer, who had also studied in David's atelier as well as in Rome. Still developing his powers as a portrait painter, young Brown now began to paint genre and history pictures. By 1837 he had a high degree of professional skill, and in order to develop professional contacts he moved to Antwerp to study under Baron Wappers.

Gustave Wappers had established himself at twenty-seven as the leader of Belgian painting. Returning from his studies in Rome in 1830 as an exponent of the new romantic style that was everywhere ousting the classicism of David's followers, he had made a sensation with his topical picture, *An episode of the Belgian revolution*. Wappers was created a Baron, and made head of the Academy in Antwerp. Brown enrolled in the Academy and remained there for three years, making friends in the profession and establishing a growing practice as a portrait painter.

In 1839 his mother died in Calais, and his father and sister joined him in Antwerp. A cousin, a year or two older than himself, also joined the household—Elizabeth Bromley, who had just completed her education in Germany. Before the summer was over, his father also died, and the autumn saw the three young people keeping house together, living on an income of about £200 a year, inherited from Mrs

Brown, and on Ford's earnings from portraiture. A letter to Ford from his sister towards the end of the year not only tells us something of this portrait practice, but, more significantly, discloses Wappers' high regard for his abilities. 'Baron Wappers called over your name at the Academy, and Mr Slingeneyer then told him you was gone into Luxembourg to paint portraits. . . . He said he did not care about your going to paint portraits, but he did not like a *good student* to absent himself for any other reason when he had so much likelihood of gaining the prize.'[1] Evidently Wappers looked on him as a promising student, and would probably remind the young painter when he returned that fame was to be won in 'history paintings'. Such pictorial machines had begun to change in character. Where once they had taken themes from the Bible, ancient history or Homer or Virgil, the new romantic taste increasingly required them to be from modern literature or history, often, since the French Revolution, with marked libertarian or nationalist overtones. Everywhere in Europe there was a current of Anglophilia. The romanticism of Wordsworth, Coleridge, Shelley and Keats might not travel as yet, but Ossian, more than thirty years before, had begun to inspire French and German romantics, and now Shakespeare, Byron and Scott began to be drawn on, not only by English artists, but by Frenchmen like Girodet, Géricault, Delacroix and Delaroche. Delaroche indeed specialized in subjects from English history, especially of the seventeenth century, such as *Cromwell opening the coffin of Charles the First*. Delacroix had shown in the salon of 1827 his *Death of Sardanapalus* and *The execution of Marino Faliero*—both subjects taken from Byron, as had been his earlier *Massacres at Chios*. Ivanhoe, Don Juan and Hamlet, along with Werther and Faust, offered ample room for self-identification and high drama to a generation of poets and painters.

During his three years at Antwerp, Brown painted a number of subject pictures. Their titles read like the catalogue of any contemporary exhibition: *A blind beggar and his child*, painted when he was seventeen and sold to a London printseller; *A Flemish fishwife*; *Head of a page*; *A Fleming watches the Duke of Alba go by*; *Elizabeth at the deathbed of the Countess of Nottingham*; *The Giaour's confession* and *Colonel Kirk*. Kirk, whose 'Lambs' had gained notoriety for themselves and their commander after the battle of Sedgemoor, had died and was buried in Brussels. Finally, at the end of the Antwerp years, Brown began *The execution of Mary Queen of Scots*.

At the beginning of 1840 Brown moved to Paris with his friend Dan Casey, evidently thinking of settling there; but his sister's death brought him back to Antwerp. Returning to Paris, he took with him his cousin Elizabeth, to whom he was married in the British ambassador's chapel. He was not quite twenty; Elizabeth was twenty-one. For the next four years they lived in Paris, where other Belgian and English friends were already settled, but made frequent visits to England to the Bromley family at Meopham, or the Madoxes at nearby Foots Cray. He also kept up with the world of art in London, where, in the year of his marriage, his *Giaour's confession* was exhibited. It promised well for a successful career. There was no reason why he should not settle down, become an Academician and share the celebrity of the Wilkies, the Grants, the Friths. No reason; except that he had now discovered, in

1 F.M.Hueffer *Ford Madox Brown: A Record of His Life and Work* London, 1896, p. 22

painting and in himself, something incompatible with such a career, something profound and compelling.

In these still formative years, his work had changed character as new influences were brought to bear on it. The prettiness of the juvenile copies of Bartolozzi engravings with which he had begun to draw as a boy had given way to adult and highly professional paintings. In portraiture particularly, as the portrait of *Mr Pendleton* shows (pl. 8), he was thoroughly accomplished, but he had far wider ambitions as a painter of subject pictures, which no doubt played a part in his decision to settle in Paris. He soon, however, became disillusioned with what he found there, and refused to enter any of the big studios or work under any of the successful painters. 'Cold pedantic drawing and heavy opaque colour are impartially dispensed to all in those huge manufactories of artists' was his comment on the big Parisian ateliers. Not surprisingly he seems to have felt most sympathy with Delaroche and Delacroix.

A poem by Byron provided the inspiration for Brown's next two paintings: *Manfred on the Jungfrau* (pl. 10), and *Manfred in the chamois-hunter's hut*. The first was designed at the same time as *The execution of Mary Queen of Scots*, but while the *Execution* is wholly a studio picture, conceived and executed in terms of current fashion, the Manfred pictures aim at dramatic effects by presenting the event as far as possible in terms of physical actuality. It was with this aim that he began to study, and to introduce into his paintings effects of natural, open-air lighting. When *Manfred on the Jungfrau* was shown in his big retrospective exhibition of 1865, he wrote that though originally painted in 1840, it had been 'much touched upon as recently as 1861, so that the original scheme of colour has been obliterated . . . Such as it is, it was a first, though not very recognizable, attempt at an outdoor effect of light.' He further commented that of this, little now remains but 'the dramatic sentiment and effect of black and white'. But in fact much more remains. Manfred and the guide are carefully and vigorously drawn. They exist not only in dramatic relation to each other, as illustrative of the incident in the poem, but also in a spatial and atmospheric relation which is quite absent from the *Execution*. The theme might be fashionable and conventional; his way of rendering it was much less so.

But at the same time as studying open-air lighting, he was also spending much time in the Louvre, studying not French or Italian but Spanish painting, then little known except to those who had made tours in Spain like Wilkie (in 1827) and Roberts and J.F.Lewis (in 1832). Wilkie's *Maid of Saragossa* had been one of his greatest successes. In the Louvre, Brown could see paintings by Ribera, Velazquez, Murillo and others—but not Goya, who was virtually unknown except as an etcher to painters outside Spain. Rembrandt, too, claimed Brown's attention. The mastery of objective visual fact, combined with an ability to turn it to dramatic and psychological use, was clearly an important part of what he found in these artists, but he also showed, throughout his career, a marked interest in seventeenth-century history, which provided him with a number of subjects.

The next important painting which Brown produced was *Parisina's sleep*. Hueffer comments that the theme, calling for a lamplit interior, 'is not appallingly unsuited for the then conventional treatment; the drawing is fine, and the handling of oil-

colours showing a mastery to which he hardly afterwards attained'.[1] It was 'a really fine work in the older manner'; this 'older manner' being one derived from 'Rembrandt, and the Spanish masters—Velazquez, Ribera, Murillo'. This picture, rejected on grounds of impropriety from the French Salon of 1843, was hung in the Free Exhibition of the British Institution two years later. In another Byronic picture painted at the same time, *The prisoners of Chillon*, the dramatic possibilities of a limited source of light in a confined space were further explored: but of more significance is the small painting *Out of town* of the same year. Here, but on a tiny scale and with none of the trappings of drama or narrative, he showed his growing interest in painting, direct from nature, unmediated effects of light and colour. Unfortunately, like *Manfred*, it was very much repainted in 1858, so that the original vision has been completely overlaid by something more Pre-Raphaelite in character. Nevertheless, it survives, and its composition shows a complete emancipation from his earlier conventionalities.

But other work of a very different kind also survives from the same time, including a series of drawings on themes taken from *King Lear*, made in Paris in 1844. These designs were taken up at intervals later on and elaborated into paintings or large cartoons, but are worth study for their own sake. One of them was made the basis for an etching in *The Germ*, while *Cordelia's portion* (pl. 11) inspired Henry Irving's performance of King Lear. They bear a certain relation to the very fashionable folios and books of outline-engravings in circulation in the 1840s such as Moritz Retzsch's *Illustrations to Goethe's Faust*, of 1843 (pl. 4) and John Bell's *Compositions from the Liturgy* (pl. 6) of the same year. In style these derive from Neo-classical outline engravings most familiar to an English public from Flaxman's *Illustrations to Homer* of 1795, but by 1840 this austere style was deeply infected by the Romantic movement, and, in the German engravings especially, shows an element of the grotesque. Brown's drawings, in brown ink over faint pencil sketches, have a nervous, tremulous line, often broken—like a Hokusai or Kyosai drawing, which he certainly could not have been familiar with. At the opposite extreme in conception from his experimental naturalism these refer to no model, have nothing at all of description or visual illusion, but are imaginative projections, solely concerned with emotional expression. Like all expressionistic work, they are full of distortions and involuntary emphases. Later on, distortions, of which Brown was quite aware, played an important part in many of his paintings, making it much more difficult for the public to adjust to his vision than to the more naturalistic vision of the Pre-Raphaelites.

But the major work of the Paris years is different again, owing its existence not so much to any personal seeking on Brown's part as to an external initiative: the competitions of the 1840s for the decoration of the new Houses of Parliament.

These competitions, submissions for which were exhibited in Westminster Hall throughout the decade, were the most important event of the mid-century in the visual arts in Britain. Not since the commission for the painting of the dome of St Paul's early in the eighteenth century had there been a decorative project of comparable significance, which even attracted competitors from the Continent. That the

1 F.M.Hueffer *The Pre-Raphaelite Brotherhood: A Critical Monograph* London, 1907, p. 17

burning down of the old Houses of Parliament in October 1834 was seen as an opportunity for establishing a native school of mural painting was due in the main to the long-drawn-out efforts of one man: Benjamin Robert Haydon, friend of Wilkie, Hazlitt, Keats and Wordsworth, a heroically unsuccessful and tragicomical figure.

Haydon's enthusiasm for the Parthenon sculptures had brought him into sharp conflict with eminent dilettanti and connoisseurs of the time, notably Payne Knight, whose views he effectively and unsparingly demolished in a long letter to John Hunt's paper, the *Champion*, early in 1816. This, coupled with his differences with Sir George Beaumont, put a distance between him and many potential patrons; while his growing hostility to the Royal Academy, expressed openly, frequently and with violence, isolated him yet further. Like many other artists of the day, he saw the Academy as a clique of intriguers, bent on keeping their exclusive privileges, and lost no opportunity of saying so. This led him to give a great deal of thought to questions of patronage and the training of artists, and he played a considerable part in the agitation which finally brought about the Parliamentary Commission of Inquiry into the teaching of design and the responsibility of the Royal Academy. He also began, from 1812, to advocate a system of public patronage for painters which he hoped would once and for all break the monopolistic power of the Academy and the dilettanti who supported it, and by challenging painters to work on a more monumental scale for public buildings, would raise English art to the highest place, supplanting the traditional reputation of French, Italian and Dutch painters.

For many years his propaganda on these subjects was ineffective but the Commission of 1836 under William Ewart, MP for Liverpool in the new Reform Parliament, set up the Government School of Design; while the burning down of the Houses of Parliament in October 1834 eventually brought about the realization of his other dream—the decoration of the new House of Lords with paintings.

At one stage there was talk of the German Nazarene Cornelius, a Catholic, being invited to carry them out. There were several factors in his favour: he was experienced in the art of painting in fresco; Prince Albert, who was very enthusiastic about the whole project, was his countryman; and the influence of the Tractarian and Anglo-catholic movements was spreading, together with the Romanist ideas of the Gothic-revival architects.

Haydon himself was certainly not being considered, as was hinted to him very strongly in private. His pupil Eastlake, who was travelled, accomplished, enormously learned and diplomatic, and William Dyce, first head of the new School of Design, and even more learned and accomplished than Eastlake, were probably the only men in the country who had any serious knowledge of fresco painting. And it had been decided that fresco must be used. The decision would exclude those who could do no more than enlarge an easel picture, and would encourage those who understood painting in its *architectonic* sense. The word was a new one, taken from German criticism and art theory. It defined the formal existence of a painting in terms of coherent space and volume, an inner relation of forms which was distinguishable from the description of appearance or the sequential relations between a picture's parts as they told a story or defined a situation or held symbolic meaning. Count

von Rumohr, writing to Haydon on the subject, used the term, as well as insisting that an English painter, not a German or Frenchman, ought to be commissioned. But what English painter? There was no native tradition, experience or training to draw upon.

For this reason, when the first competition was announced and the conditions published, it was not outright in kind. In the first place, prizes would be given for skill and ability in design: the receipt of a prize did not mean the awarding of a commission, which would be the result of later competitions. At this stage, painters were asked to submit designs rather than paintings, with a specimen carried out in fresco. They were not paintings that were shown when the exhibition opened in May 1844, but cartoons, drawn on paper mounted on canvas; in effect, full-scale working drawings. One effect of this limitation was that it encouraged, as Haydon observed, the mistaken idea that a cartoon should be complete, so that all that remained was to transfer its outlines to the wall and colour within them.

Madox Brown, along with other friends from his Parisian circle, decided to enter the competitions. Dispensing with the dark tones and bravura brushwork of his Belgian manner, he aimed at clarity of outline, definition of form and a composition exposed to view in all its parts. That he was able to make so complete a revision of his work was due to his skill and intelligence, and the discipline gained from his earlier studies.

The first of the three designs which Brown submitted was *Adam and Eve*: a subject which Haydon (who entered the first competition) also chose. It was begun in 1842 and submitted in 1844 with the prescribed sample of fresco; only the cartoon survives. *The body of Harold brought before William the Conqueror*, designed in 1843, was submitted in 1844, with a quarter-size version in oil to show its colour. This smaller version may be the one later retouched for James Leathart and sold to him in 1861. His third submission, *The spirit of Justice*, designed in 1844, was exhibited in 1845: a watercolour of the complete design went with it, and a portion carried out in fresco—which was destroyed in 1851.

The *Harold* cartoon survives now in fragmentary form (pl. 12), and is a very substantial composition, firm and severe in drawing, well-composed and full of the wry incidental drama which Brown always loved; behind the Conqueror, in the distance, appears Beachy Head. This use of specific landscapes as background is something which he developed steadily. In this cartoon he was clearly influenced by what he knew of the Nazarenes, at this stage only through engravings, but the introduction of recognizable landscape backgrounds is his own invention. The colour version of the *Harold*—the Leathart painting—was the one shown in the artist's Piccadilly exhibition of 1865, and after a note in the catalogue about Beachy Head, he added the words 'The effect is after sunset'. Not only did he use a recognizable place; it was part of his endeavour, as he said in the same catalogue writing about his *Chaucer*, 'to carry out the notion of treating the light and shade absolutely as it exists at any one moment instead of approximately or in generalized style'. Diverse as his interests were, he could bring them together, pursuing his interest in *plein-air* painting at the same time as developing his new, architectonic style. And it was as architectonic that he himself described it. The years in Paris had made a complete revolution in his

1 William Mulready *The last in* 1835
Oil on wood, 24½ in. × 30 in.
In structure resembles Edward Calvert's small engravings and many of Rossetti's designs of the 1850s
and '60s
Tate Gallery, London

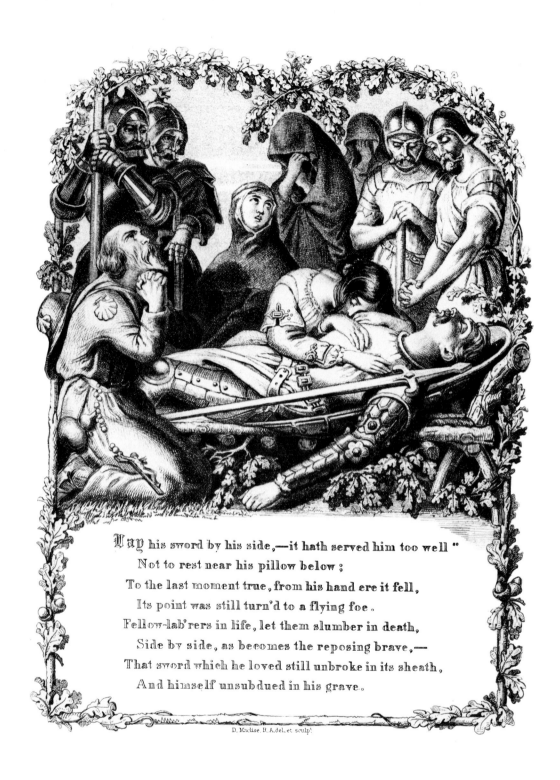

"Lay his sword by his side,—it hath served him too well"
Not to rest near his pillow below;
To the last moment true, from his hand ere it fell,
Its point was still turn'd to a flying foe.
Fellow-lab'rers in life, let them slumber in death,
Side by side, as becomes the reposing brave,—
That sword which he loved still unbroke in its sheath,
And himself unsubdued in his grave.

D. Maclise. R.A.del, et sculp!

2 Daniel Maclise *Lay his sword by his side c.*1840
Page of *Moore's Irish Melodies*, published by Longmans, entirely etched on steel plates,
with illustrations and borders by Maclise

There the weïrd lady of the woods
Had borne him far away;
And trained him up in feates of armes,
And every martial play.

3 William Bell Scott *The birth of St George* 1842
Illustration for S.C.Hall's *Book of British Ballads*

4 Moritz Retzsch *Faust enters the prison where Margaret is* 1843
Engraved by Henry Moses, from Retzsch's *Illustrations to Goethe's Faust*, Tilt and Bogue, London

5 Daniel Maclise *King Alfred the Great in the camp of the Danes* 1840
Oil on canvas, 48 in. × 85½ in.
Based on one of the themes set for the Westminster cartoon competitions of the 1840s

Laing Art Galley and Museum, Newcastle upon Tyne

6 John Bell *Morning prayer* 1843
Outline illustration from *Compositions from the Liturgy*, published by Longmans

7 Joseph Führich *Nativity*
One of a series of engravings of the life of the Virgin. Prints after Overbeck, Cornelius, and Führich were all published in England

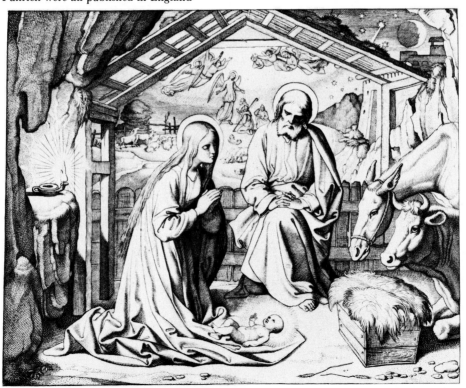

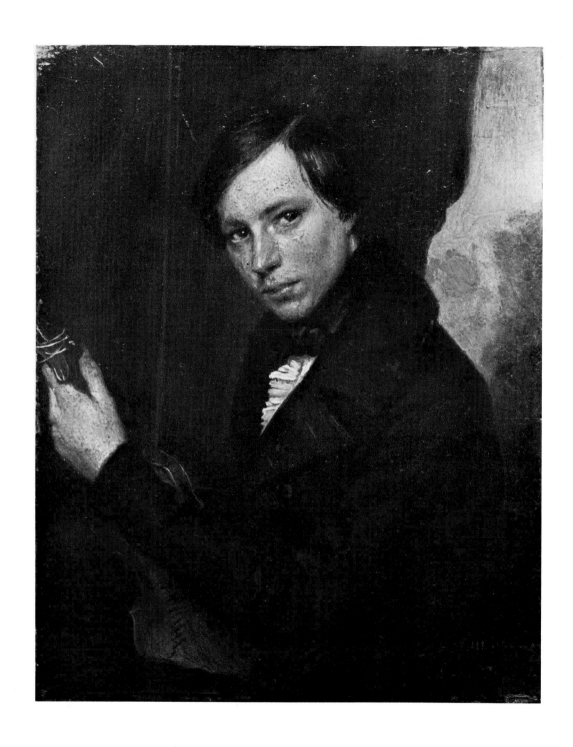

8 Ford Madox Brown *Mr Pendleton* 1837
Oil on panel, 6¼ in. × 5 in.
Painted in Ghent when Brown was sixteen
City Art Gallery, Manchester

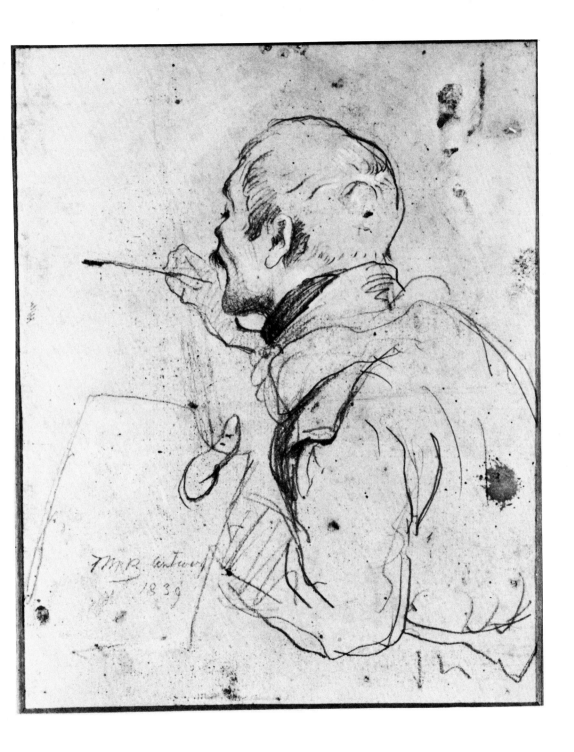

9 Ford Madox Brown *A man painting* 1839
Chalk drawing, 11 in. × 9 in.
Tate Gallery, London

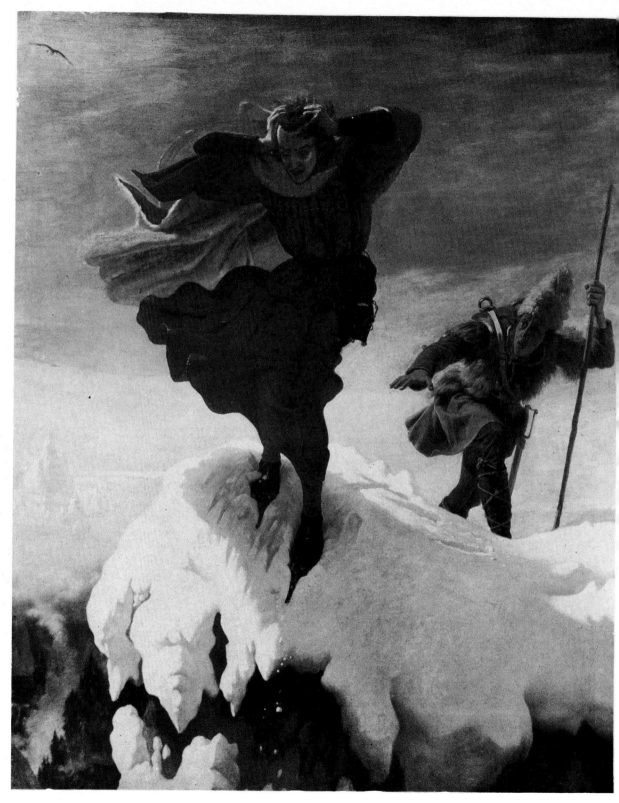

10 Ford Madox Brown *Manfred on the Jungfrau* 1840-1
Oil on canvas, 55½ in. × 45½ in. Theme from Byron's poem *Manfred*
City Art Gallery, Manchester

ideas of painting. The *Chaucer*, and the *Wycliffe* (pl. 20) two years later, both rest on the architectonic concept; and both make use of particular, recognizable landscapes.

None of his submissions won any award or even comment from the judges; but his *Spirit of Justice* received commendation from a significant source. Haydon noted in his journal for July 3, 1845: 'Passed the morning in Westminster Hall. The only bit of fresco fit to look at is by Ford Brown. It is a figure of Justice and is exquisite as far as that figure goes.' The *Art Journal*, too, praised this painting, but it was no more fortunate than the previous entries.

Brown did not send work to the later competitions. His wife's health had deteriorated. Like his mother and sister, she suffered from tuberculosis, and late in 1844 they returned to England, she to live in Hastings with their year-old daughter Lucy, while he worked in London, in the studio which his friend Charles Lucy had taken in Arlington Street, Camden Town.

During the second half of 1844 and the first half of 1845, Madox Brown's time was divided between his wife at Hastings or Meopham and his work at Tudor Lodge. He painted family portraits, and pursued his growing interest in landscape. In one painting at least these are combined; the group of men and women in the Manchester City Art Gallery is in fact a portrait of the Bromley family, signed and dated 1844; and its background is a stretch of country along the Thames estuary, in the region of Gravesend or Stone. Meopham, where the Bromleys lived, is fairly high on the edge of the North Downs, and the view behind the group is consistent with one looking over Greenhithe to Long Reach. A view from Shorne Ridgeway, near the Medway, was incorporated into the *Chaucer*: the glimpses of landscape which similarly form the background of *Wycliffe* show the tower of Sompting Church in Sussex; and though these two examples are of slightly later date, they illustrate his constant interest in open-air painting from very early in the 1840s. Had he not been so compellingly drawn into dramatic composition by the Westminster competitions, he might well have made himself a place in the English landscape school. What survives of landscape, whether in its own right or as part of figure compositions shows that he could have been very successful; just as he could in portraiture. But his diversity of talent, and his curiosity made him difficult to deal with. The orthodox painters and dealers found it hard to accept him in all his variety; you could not tell what he would do next.

Working in Lucy's studio he began to mix with a growing circle of artists and writers: Etty, John Martin, Cruikshank, Douglas Jerrold, Tenniel; John Marshall the surgeon; old Paris friends, Cross and Armitage; and Frank Howard, son of the RA, also a competitor for the decorations. The life of this world of journalists, illustrators and painters, was, says Hueffer, convivial; but it cannot have been a very happy period for Brown, with Elizabeth's health worsening, and a small child growing up who might soon be motherless. Rome was the recommendation of the doctors, as it had been for Keats a quarter of a century before. It had not only the supposed advantages of climate, and of relative cheapness, but it was still the traditional art centre, attracting large colonies of artists as well as the well-to-do of France, Britain and Germany. Moreover, of even greater significance, it was in Rome that the great leaders of the Nazarenes, Cornelius and Overbeck, lived.

They stopped at Basle on the way and Brown spent as much time as he could studying the paintings by Holbein. Holbein, of course, was one of the few German artists to claim any respect from the cultivated English gentlemen of the eighteenth and early nineteenth centuries, and his portraits would not be unfamiliar. But Basle gave Brown a new view of him. His recent paintings from nature, and the intellectual demands of the cartoons, enabled him to appreciate possibilities in Holbein's work which he would not have been ready for in earlier years.

From the turn of the century, partly encouraged by the development of the Gothic revival, an interest in 'primitives' both Northern and Italian had begun to show itself in England. Collectors like Horace Walpole, Ottley and Roscoe, had already pointed the way buying paintings and prints by or after early masters. Prints by Dürer, Schongauer, Mantegna, Marcantonio, were sold and sought after, and illustrated handbooks began to supplement the traditional portfolios of engravings, bringing some knowledge of such work to the untravelled middle class and the home-based artist, though few actual 'primitives' were yet to be seen in generally accessible galleries. Working on his cartoons and specimens of fresco, Brown would not neglect to seek out historic examples. Even in the most popular journals, like the *Penny Magazine*, the *Illustrated London News*, the *People's Journal*, as well as in more esoteric publications, these could be seen—alongside reproductions of the work of living foreign artists. Brown would probably have studied the contents of such important new books as Kugler's *Italian Schools of Painting* (translated into English in 1842 by Eastlake) in which what was known of early and pre-Renaissance art was made available.

Once arrived in Rome, we know, from Brown's own account, that he visited Overbeck and Cornelius. They were living lions, founders and survivors of the semi-monastic community which called itself the Brotherhood of St Luke. Overbeck, ascetic, puritanical, devout, aimed at the regeneration of a pure Christian (Catholic) art, untainted by any of the worldly and sensual qualities that had invaded painting with the Renaissance. Cornelius was no less devoted to the establishment of a glorious, national German art to rival that of Italy.

Forty years later in an article in the *Fortnightly Review*, Brown described the two as he had met them. Overbeck he found in his studio with a few visitors, to whom he was explaining cartoons of religious subjects. Brown noticed that the figures were not drawn from nature and were carefully made to look as little like flesh as possible. 'In spite of this, nevertheless, the sentiment—as depicted in the faces—was so vivid, so unlike most other art, that one felt a disinclination to go away.' Cornelius he also found 'explaining his great work [*Death on the pale horse*] to some ladies'. 'Some twenty years ago,' Brown writes, 'I saw this cartoon again in London, and it produced on me exactly the same effect it did at first. Full of action and strange character, it was everything reverse of that dreadful commonplace into which Art on the Continent seems to be hurrying back.'

It was not, however, the actual work of the Nazarenes that influenced him as he began work on a number of new paintings in Rome, as much as their sources of inspiration: the pre-Renaissance painters. Indeed, the two important paintings he conceived at this time, the *Chaucer* and the *Wycliffe*, are in some ways less Nazarene

than the cartoon of Harold, already completed. But even this shows what a big difference separated them. No painting by Cornelius would have given the figures such solid existence in space, or their gestures and faces such vivid expression. However, Brown's recorded reaction to a print after Cornelius over twenty years later, and the unequivocal references to the Nazarenes in lectures and essays composed late in life, are evidence enough of a deep engagement with their ideas which lasted well into the 1850s. He saw in them the only living examplars of a mural art, free of the mannerisms which had grown out of the Renaissance.

Despite Brown's association with the Nazarenes and Early Christian art he was never a painter of devotional pictures; even when he made paintings or designs for stained glass on religious themes, it was the historic, the dramatic and the moral aspects which interested him. If he could be said to have a typical programme, it could well be described in the terms in which Hogarth described his preferences— modern moral subjects. Brown would certainly have included themes from British history under such a description. And it is important that he placed Hogarth first as the real founder of English painting; as did Hunt and perhaps more surprisingly, Rossetti. The broad association of artists which they and many friends joined in the late fifties, was called the Hogarth Club after the man who above all had made the forms of life, not the conventions of past art, the guide to excellence.

Brown's experiments in fresco, his big cartoons, on which so much of the past three years had been spent, had not only helped to shake off the last traces of his Belgian-romantic style, but, combined with his landscapes, had aligned him at last with the new developments in English art. He was approaching (as were Hunt and Millais) the point of conviction that painting must rest on visual truth, not on style or on concepts of beauty; and that truth must be personal and renewed in individual experience. Its source was the real physical world, man in his environment, nature. The artist should not go to the great dead for authority. In the too-familiar process of imitation, the painter would only submit himself to the forms they had evoked; but *they* had evoked them by reference to the great fountain head—Nature. This was not, of course, a new doctrine. It was built into the most academic of teaching: any student who had heard or read Reynolds' *Discourses*; any student of the École des Beaux Arts of Paris or Antwerp would have been told the same thing. But any such student would have run some considerable risk if he had not 'seen' nature in terms of the accepted forms. Art, instead of being a re-creation of experience, its enrichment and enlargement, its conversion into a vehicle of ideas, seemed more and more like a great confidence trick. Raphael would be wound about your eyes like a bandage; you would be spun round in the Antique Class, the Life Class, and away you would go—an artist.

Brown was not long enough in Rome to carry out any complete work: he had to bring his dying wife back to England after only eight months. She died in Paris in the course of the journey, but was brought back to England and buried in Highgate Cemetery, then quite new, its buildings a medley of approximations to the Egyptian and the Assyrian. Brown designed and had carved an interesting monumental cross for her grave.

He did not attempt at first to pick up threads in London: sometimes he thought of

re-joining Casey in Paris. Nothing came of this nor did he return to his wife's family. After several restless months he moved to Milk Street, off Cheapside, painting there the portrait of a Mr Bamford which he liked to call *A modern Holbein*. Early in 1847 he moved again, to rooms in Kensington, and then towards the end of the year to Clipstone Street, where at No 20½ he 'occupied a studio in a range of stabling which had been converted to suit this purpose. Hither his household furniture, lay figures and the like were sent by Casey from Paris.'[1] The latter half of 1846 had been restless and unproductive; with the New Year he began to work again, taking up projects broken off by the move from Rome.

While there he had probably worked on a small, rather naïve and Early Christian painting called *The seraphs watch*, begun in England, and taken according to Hueffer, to Rome. It was never finished, though Rossetti in the early days of their association made a copy of it. He had also painted two small oval portraits, of Elizabeth and their daughter Lucy and begun *Chaucer at the court of Edward III*, the largest painting he ever completed. More than 12 ft tall, and nearly 10 ft wide, it is on the same grand scale as the Westminster cartoons: but the picture which survives (in the Art Gallery of New South Wales, Sydney) is only the centre panel of what was conceived and actually begun as a triptych. It was first planned in Rome, as a continuation but also as a complete revision of the mural ideas of the preceding two or three years. It is likely that ideas for two other pictures were also being turned over during this period, if not actually sketched in physical form; for two paintings, closely relating to the *Chaucer*, were carried out in 1847, and one, *Our Lady of good children* (or *Saturday night*) (pl. 15) was finished in time to be submitted to—and rejected from—the Academy's Summer Exhibition that May. The other, begun in November 1847 and finished in March 1848, was shown in the Free Exhibition under the title of *Wycliffe reading his translation of the Bible to John of Gaunt* (pl. 20).

The *Chaucer*, which was not finished until 1851, gives the fullest view of the artist's ambitions as a mural painter. A study for it (pl. 16) shows him at his closest to some of the most significant tendencies in contemporary English art. Its theme, Chaucer at the court of Edward III, is ostensibly of the same kind as the subjects from English history from which the Westminster competitors were invited to choose; but it was more than this to the painter. The idea had first come to him from reading Mackintosh's *History of England*, and had been developed in Rome, where its initial character was changed. From being simply an imagined incident bringing together a great English poet and a powerful English king, its scope was enlarged by his increasing appreciation of Chaucer's stature as a poet, and the parallel that might be drawn between him and Dante.[2]

With the *Chaucer*, Brown begins to identify himself as an English painter; the simple incident became the centre-piece of a triptych whose wings showed figures and heads of English poets—Spenser, Shakespeare, Milton in one compartment, Pope, Burns and Byron in the other, with roundels of Thomson and Goldsmith above, and cartouches below, held up by putti, with the names of other poets

1 F. M. Hueffer *Ford Madox Brown: a record of his life and work* London, 1896, p. 49
2 *Ibid.* p. 42

inscribed on them. All this was held together in a very elaborate architectural frame, Puginesque in style, and twined with a fruited vine.

Pencil sketches on these lines, and the first oil-sketch were made in Rome and a full-scale painting begun, but this was destroyed as being too big to bring home. When the painting was resumed on its full scale in London, his ideas were again modified by a growing familiarity with English poetry as it appeared in England, not as it appeared on the continent; modern English poets like Wordsworth and Coleridge, Shelley and Keats, Tennyson and Browning, upset his first conception, and the difficulty of incorporating all this new experience into the first scheme made him give up the wings and reduce the triptych to one large picture. But the title he had given to it, in its earlier state, before abandoning the wings, was *The seeds and fruits of English poetry*.

A painting like this was a very different undertaking from the *Execution* or even the *Manfred*. Splendid as it is, its arrangement is more completely intelligible when we know that it was at first a triptych, and that the elements of the centre panel were to be read as relating to others. In the *Manfred*, we are aware of two figures, both involved in one terrifying moment; there is a single, instantly apprehended moment for us to grasp; it works at a blow. Even in the later *Last of England*, a very much more complex work, the relationship of the man and woman, huddling under the umbrella as they gaze back over the ship's stern, makes an immediate impact: as we look, all the subsidiary parts begin to appear and intensify the situation, but the essence of the situation has already been grasped.

Not so with the *Chaucer*. The painting as it stands, the central panel, is itself a complex system of forms, each group within it linked with other groups, containing its own incident which is also a vehicle for the artist's statement and comment; no group finite, however independent; and even the figure of Chaucer, which is the only standing figure to be seen complete, is not isolated. The groups of figures in threes, in the wings, are of a type which Brown was to go on using in his portrait of Shakespeare; in the life-sized figures of worthies which belong now to the University of Manchester, and less obviously, in many of the figures for stained glass which he designed for the Firm in the sixties and early seventies. The figures in the side panels of the *Chaucer* were conceived as architectural, monumental supports, not dramatically; but in the centre panel there is, by contrast, life and movement. We see the poet as he reads, we see the groups who listen, we understand their responses; above all, we see the poet as a public, not a private figure.

This was the painting on which Brown had been at work when Rossetti first called on him. At that point, he had not yet abandoned the wings. No painting could have been more sympathetic and exciting to Rossetti at this stage in his career, and though in abandoning the wings Brown abandoned the attempt to include in his scheme the English poets since Chaucer, one modern poet, still unknown, but the most fertile influence of the next thirty years, does appear in it: Rossetti himself, who posed for the head of Chaucer.

2 Dante Gabriel Rossetti

Rossetti wrote to Brown in 1848 as a tyro desperately seeking to learn from somebody whose work he had seen and admired in exhibitions ever since he had first been taken to one in 1843. His letter spoke of the Westminster cartoons, referring to the 'outline from your Abstract Representation of Justice taken from one of the illustrated papers', and we have William Rossetti's word that it was not only the easel paintings (and the letter had listed almost every work of Brown's that had been exhibited in London) but the cartoons which his brother admired, 'at least as much as any of the paintings specified'.[1]

Rossetti was nineteen; a poet, and learned in poetry; ambitious to be a painter, but frustrated beyond measure by the barren teaching and the absence of imagination in the Antique School of the Royal Academy in Trafalgar Square.

Rossetti was born in the same year in which the University of London was founded by Henry Brougham. Three years later, in 1831, his father, Gabriele Rossetti, became Professor of Italian there. His father's Italian friends were mostly refugees like himself, Carbonari with liberal sympathies, while his English acquaintants were social and political reformers interested in such societies as the one founded by Henry Brougham in 1825 called the Society for the Diffusion of Useful Knowledge. This aimed to spread knowledge, particularly of science, throughout the community. The promoters of the Society were largely identical with the promoters of political reform, and it was in the year of the Reform Bill that, on March 31, 1832, the first number of the Society's *Penny Magazine* was published.

For the first ten years of his father's appointment, the family lived in modest comfort and security. Later, as Professor Rossetti's health declined and the fashion for Italian waned, they became poorer, and Mrs Rossetti (the sister of Dr John Polidori) and her two daughters, as teachers, and the youngest son William, a clerk in the Excise Office, provided the main income. It seems never to have been questioned in the family that the eldest son should be free to develop his exceptional talents, either as writer or as artist.

By the summer of 1842, when Rossetti was fourteen, his interest in drawing had resolved itself into a definite ambition to become an artist. The accepted course for the would-be painter was then to go through the Royal Academy's Schools; and the most favoured road to these Schools was through Sass's.[2] Founded by Henry Sass, it was now run by another minor painter, F.S.Cary, whose father, the Rev. H.F.Cary, translator of Dante and a former librarian at the British Museum, was a friend, if not a close one, of Gabriele Rossetti. The course of study was formal. 'The young

1 W.M.Rossetti *Dante Gabriel Rossetti: His Family Letters, with a Memoir* London, 1895. Vol. 1, p. 117
2 The best account of Sass's is to be found in W.P.Frith's autobiography London, 1887

30

student, beginning with Juno's eye, was compelled to copy outlines that seemed numberless; some ordered to be repeated again and again, until Mr Sass could be induced to place the long-desired "Bene" at the bottom of them.' The outlines from the antique satisfactorily rendered, progress was made to the drawing of a huge white plaster ball—which might take as long as six weeks! After this, a giant-sized bunch of grapes, also in white plaster; a hand . . . and so by long degrees to actual antique figures. The great advantage of Sass's was, however, not simply the extreme academic orthodoxy of its course, but the frequent social visits of influential Royal Academicians.

The importance of the antique was that it was held to provide access to the best style, the purest forms. A Venus or an Apollo was not just a figure; it was human form translated and elevated according to canons of beauty and *taste*. What students were required to undergo was not simply technical instruction leading to expert draughtsmanship, but indoctrination in a mode of thought, a pattern of formal ideas which, to be fully grasped, required them also to be conversant with classical literature and mythology. The student who was not able to acquire some ready system of reference to these sources of pictorial composition would have to get by as best he could in landscape or genre. Only in portraiture could he hope to succeed on the basis of his own perception; and even here, to be able to pose your sitter in such attitudes and with such trappings as made clear to the initiated that he or she was a person of culture—which meant very specifically classical culture—put one at a considerable advantage. In sculpture, classical reference was absolutely imperative.

But Rossetti's tastes were extremely romantic. It was not the glorious epics of Ilium or Rome that excited him, but the drama of Hamlet or Faust. He was an eager but discriminating reader of romances. Moreover, in the private world which the four young Rossettis created as naturally and completely as the Brontë sisters created theirs, all, from childhood, wrote their own poems and romances. Dante (he did not declare for Gabriel until he was grown up) illustrated some of these, as well as making designs, cribbed from the then fashionable 'outlines' for Monk Lewis's *Castle Spectre* and Bulwer's *Rienzi*. The most famous of Rossetti's poems, 'The Blessed Damozel', dates from April 1847; it had its origin in Poe's 'The Raven', a favourite poem to which, a little earlier, he had made drawings which though technically shaky, are apt and lively.

Dante Rossetti was no ordinary student, nor thought of as such by his fellow-students. He had wide interests, his mind brimmed with ideas, and underlying his ebullience was an acute critical gift, turned on himself as much as on others. Although he was frustrated by the deathly routines of the Antique School and more and more aware of the inanity of most of the painting to be seen in the Academy's Summer Exhibition, it was not of his external situation that he was most impatient, but his own limitations, and he reached out, in the winter months of 1847–8, to three strangers—William Bell Scott, Leigh Hunt, and Ford Madox Brown—for help to overcome them.

He wrote first to William Bell Scott, on the occasion of the publication of Scott's poem 'The Year of the World' in November. Rossetti had read and admired earlier poems of Scott's—'Rosabell' and 'A Dream of Love'. At this point, he was wondering

31

whether to abandon his hopes as an artist, which seemed as far as ever from realization, in favour of a career as a writer; he seems not to have known until Bell Scott answered his letter that Scott was also a painter and etcher, and at the time Head of the Government School of Design in Newcastle. Receiving this reply, Rossetti immediately sent off to Scott a number of poems, under a general title of *Songs of the Art Catholic*. William Rossetti comments on this: 'He decidedly meant something more than "poetic art". He meant to suggest that the poems embodied conceptions and a point of view related to pictorial art—also that this art was, in sentiment though not necessarily in dogma, Catholic, mediaeval, and un-modern.'[1] This does not mean, and William Rossetti is careful to point it out—that Rossetti was, even remotely, a Roman Catholic, Tractarian, Puseyite—or even a believer, in spite of the devotional piety of his mother and sisters. 'He was already a decided sceptic,' says his brother.

The effect of this communication was that Bell Scott met Rossetti and his family when he came to London for the New Year. For Rossetti to learn that Scott was the brother of David Scott, friend of Von Holst, painter of romantic pictures which he much admired, must have seemed the best of omens, and perhaps helped to reconcile him with the notion of still pursuing painting as his career. Scott was no lover of the Academy; he cherished in his brother's memory the figure of genius thwarted and neglected by the art world where the academics reigned, and his visit would hardly lessen Rossetti's impatience with the sterile Antique School. But Scott had to go back to his duties in Newcastle.

Rossetti next wrote to Madox Brown to inquire if he would teach him to paint. It is interesting that in writing to these two men, he had picked artists of extreme individuality, even oddity—backed, in Brown's case, by genius. They were exactly the sort of men who could help him, not merely technically, but creatively, to find his own identity and the means to give it expression.

When Brown called at Charlotte Street, therefore, armed with a stick in case this should turn out merely an offensive hoax, Rossetti had the experience of one similar and rewarding encounter fresh in mind. Suspicious and touchy, Brown evidently melted quickly in the warmth and enthusiasm of Rossetti's welcome. Invited upstairs to meet the family, he found himself kindly received; the fact that he spoke fluent Italian and had lived in Rome must have made it very easy for him to fall into the family circle. It did not take long to agree that Dante should come and work in his studio, only a few minutes walk away in Clipstone Street. And it was typical of Brown that he should refuse any fee.

What did Rossetti encounter when he first went to see Brown? At the back of No 20, a range of stables had been converted to make a very big studio. It was a great bare room dominated by the huge canvas of the *Chaucer*, temporarily abandoned while Brown worked on the newly-begun *Wycliffe* which he had invited Rossetti to come to see, and which had to be finished for the Free Exhibition before he could undertake any regular teaching.

Rossetti had already made one attempt at painting—a rather gothick pseudo-

1 W.M.Rossetti *Dante Gabriel Rossetti: His Family Letters, with a Memoir* London, 1895. Vol. 1, p. 114

drama entitled *Retro me Sathanas!*—which he had shown to his father's acquaintance, Eastlake, Secretary of the Fine Art Commission, and at that moment perhaps the most influential person in the art world. Eastlake's reaction had not been encouraging, and may have had a good deal to do with Rossetti's lack of confidence in his abilities as a painter. But now, in Brown, he had found just what he needed. And how welcome this animated, gifted, inspired young man must have been to Brown. It is not to belittle Brown's generosity to say that he must soon have been aware that he got better than money from such a pupil—just as the pupil got better than technical instruction. And even when he began to find Rossetti's moody and casual habits trying, and Rossetti the discipline of painting under his guidance trying in another way, nothing lessened the warmth between them.

What ideas had Rossetti about painting when he went to visit Brown? He had written saying that a wood-engraving of Brown's *Abstract representation of justice*, with another of Von Holst's (both cut out of the *Illustrated London News*) constituted the *sole* decoration of his study. He had already, while working in the British Museum, bought the Blake notebook, full of poems and sketches and derisory comments on Reynolds' *Discourses on painting*. His favourite artist was Gavarni, and he much admired John Gilbert, Phiz and Kenny Meadows. He visited what exhibitions there were, and it is clear from the long letter written to his mother as early as July 1843, that he was no casual visitor. His letter to Brown, cataloguing almost every painting of his seen in a London exhibition bears this out.

His own drawings were chiefly influenced by contemporary illustration. The new illustrated books and periodicals which exploited the medium of wood-engraving both pictorially and decoratively, and were not yet undermined by photography, had had a considerable general influence. Wood-engravings, with their rich tone pattern and sparkling black and white, and the severe outline drawings reproduced by steel etching or engraving, provided a model for romantic, macabre or sentimental designs. The 1840s were the heyday of this new illustration; the combination of wood-engraving as developed by Bewick and his pupils with the steam-powered press brought forth scores of more or less successful periodicals exploiting this graphic medium, of which *Punch* and the *Illustrated London News* are the best known—but the *Penny*, the *Saturday*, the *Mirror*, *Sharp's* and others more ephemeral all supplied the widest public with a constant flow of visual images. Even in London, these were the images most constantly before the young artist, when exhibitions were few, and the National Gallery, not a quarter of a century old, had a bare hundred paintings to show.

However, Brown's painting of *Wycliffe reading his translation of the Bible to John of Gaunt* made a challenge of a new kind to his discontented nineteen-year-old pupil. It was architecturally conceived in more than its broad-arched gold frame and its Puginesque reading desk and throne. It was composed on verticals and horizontals, not on the diagonals and spirals of the academics. Its colour was bright and pale, its atmosphere that of the open air. Its subject was such as to engage Rossetti's interest; in its mediaeval setting, so unlike the settings of the Academicians, Wycliffe's hearers were not only John of Gaunt and his wife, but Chaucer and Gower, parallels, in English poetry, of Dante and the early Italian poets in whose work Rossetti was so

much absorbed. He was attracted, too, by the 'Early Christian' element in it. The *Wycliffe* not only embodied the sort of ideas he found most moving in possible painting, but by its discipline and order, its lively realism, its clear colour, showed him a new way forward. When exhibited it even won a respectful notice from the critic of the *Athenaeum*:

> One of the very few works of high excellence of which the collection can boast is Mr Ford Madox Brown's *First Translation of the Bible into English*, obviously designed with a view to its execution in fresco . . . The merits of the picture are, however, much more in the manner than the matter—the painter's views . . . having been directed to a peculiar mode of execution. His judgment has been shown in having arranged much that can be done in a material where effect is to be obtained rather by opposition of colour than strong contrasts of light and shade, or the delicate gradations of half-tint. To his intention, realised in figures of half the natural size, we can well predict success, presuming that the artist, in revision of his work, will be induced to make some abatement of punctilious accuracy in the costumes—unfitted to the severity of historical treatment— in certain particulars which are the accidents of a bygone time, and when so much insisted on, subject their author to the imputation of pedantry.[1]

The kind of art which Rossetti still imitated was not only romantic and literary; it was also often vapidly elegant, imprecise in form, almost entirely without construction. But in the best of the Westminster cartoons, and now again in Brown's *Wycliffe*, he had been shown an art committed to an intellectual and formal order, and now began to understand that romantic themes, emotional gestures, could not of themselves make great painting; that painting conveyed ideas, induced emotional responses, by virtue of its conversion of the facts of vision into articulate formal arrangements, and that this creates style; not style, art.

Rossetti was not the unskilful draughtsman he is often thought to have been; but there was a gap between his capacity to draw objectively, and his use of drawing as a means of projection, which the endless routine of cast-drawing had done nothing to fill. Even the study of anatomy had not helped, for this was never, either at Sass's or the Royal Academy Schools, related to life; but in Brown's studio there were drawings made from living models in such a way that they became part of the intricate structure of the picture without losing their identity. They all bore witness to a patient observation, a relentless pursuit of attitude, form and action. Some drawings were taut and austere, under the influence of the Nazarenes or of Holbein; others, done in Paris or Antwerp, more animated and free; but all were very different in kind from the sweet shadings and hatchings favoured by those who watched over the Schools. Here Rossetti saw displayed and heard explained what is comprehended in the French term *dessin*, that is, however complete and beautiful a study might appear, its true completeness cannot be grasped except in its relation to others; each drawing is designed not only to convey the visual facts about a model, but to lift it into the invented visual world of the artist's creation, to make it at the same time an analysis and a projection. Nowhere in the country at that moment could Rossetti have found a better example of the continuous flow of objective drawing

1 The *Athenaeum* September 4, 1848

into imaginative expression; nor anybody better able to give the process patient and clear explanation. Brown, as talented and precocious as any artist ever was, had not rested on his precocity, but built on it a very powerful intellectual instrument. It was not an instrument which Rossetti would ever be able to use; but the insights he was given in that studio enabled him, within a few years, to construct the instrument on which he *could* play.

For the first time, here, Rossetti saw the processes by which paintings really came into being, and could discuss them with their maker. He saw that the work of art is more than a gesture, that mundane reality could be so worked upon as to lift us to another plane. Nobody was better able than Brown to analyse and clarify what it was that he had done, what he meant to do, and how and why. The contrast between this and the sterility of the Academy Schools was total. It is not surprising that, after this, Rossetti ceased attending the Antique School, and that he never attempted to enter the Life School. The only way for him was actually to commit himself to painting. With Brown's help, he could now do this with confidence.

But Brown's help proved to be not so easy a matter. Methodical and disciplined as well as imaginative and original, he set Rossetti to work at still-life, painting and copying. He had had a solid technical grounding in Belgium, and he would put all his knowledge at Dante's disposal; but Dante had no gift for this sort of steady application. 'As soon as a thing is imposed upon me,' he said at a later time to his brother, 'as an obligation, my aptitude for doing it is gone; what I *ought* to do is what I *can't* do.'[1] Nevertheless, to do the thing he wanted to do, he had to find his way to his own effective means of doing, and the fact that Brown's way could not be his does not mean that he learned nothing from it. He learned a great deal, as can be seen in his two first exhibited paintings—*The girlhood of Mary Virgin* (pl. 45) and *Ecce Ancilla Domini*.

1 W.M.Rossetti *Dante Gabriel Rossetti: His Family Letters, with a Memoir* London, 1895. Vol. 1, p. 93

3 William Holman Hunt

The chief source for William Holman Hunt's life is his autobiography *Pre-Raphaelitism and the Pre-Raphaelite Brotherhood*. Its reconstructed discussions with Millais and Rossetti, around the time of the formation of the Brotherhood, are not to be taken too literally; but there is plenty of other testimony to support their essential authenticity as to substance.

One might say that the book is a Pre-Raphaelite autobiography in manner as well as in matter, in view of the detailed treatment of the subject, the desire to leave nothing in doubt, to make the reader feel the experience which underlay the theory. By the time Hunt wrote, fifty years had passed since the days of the Brotherhood's first exhibited works, and great changes had overtaken the art world, changes to which the Pre-Raphaelite painters had contributed. In addition, the term Pre-Raphaelite was being applied to work quite different, often diametrically opposite in conception, from what the Brotherhood had set out to do, and the diverging aims of the originators had led them so far apart that rival claims were advanced by art critics and art enthusiasts and disciples, as to who, of the original band, was the leader. French and American writers in particular simply ascribed the leadership to Rossetti, with whose later work they were especially conversant. Hunt was impelled to correct the record; he set about it with his usual obsessive thoroughness. He could hardly, at any stage, have written in any other way than this.

No painter, however original and revolutionary, is without precedent, or his rebellion without its appeal to the past; but we can easily mislead ourselves by seeking for a painter's antecedents in terms of his own mature achievement, looking beyond him for painters whose work resembles his, and missing the men who really influenced him. This is particularly true of Hunt, whose models are not to be sought in terms of style. We must look at him in his domestic setting, consider what kind of boy, what kind of student, he was; see him as a child of his time, and look for a moral model if we want to understand him.

William Holman Hunt was born on April 2, 1827. His father managed a 'Manchester house', or warehouse dealing in cotton goods, in the City, and the family lived over it until Hunt was four years old, when they moved to Holborn.

From early childhood he drew, sometimes copying prints or the tickets gummed to the bales in the warehouse, sometimes trying to draw actual objects. His father, serious and harassed by the business, was by no means uninterested in painting, and Hunt tells how one day he took him to see an artist who was painting a picture of Herne Bay for him. It was the winter of 1834, just after the burning of the Houses of Parliament, and in the room was the artist's half-finished painting of the event. This so fascinated the seven-year-old that he begged to be allowed to stay and watch the painter at work. Once back at home, he immediately set out to reproduce as

much as he could of the picture from memory. But his father discouraged any idea that he might ever become an artist, and though he bought him paper and brushes and would even draw with him, would only regard this as a relaxation. The cotton business was suffering from a trade recession, and he feared to see his son embark on a life even more precarious than his own. At the age of twelve and a half Hunt was judged old enough to leave school and start a job. To avoid the warehouse, he found a place for himself in the office of a Mr James, estate agent and surveyor. He stayed there for four years. James turned out to be a sympathetic employer and a keen amateur painter, so that Hunt was allowed to go to drawing classes at the Mechanics' Institution in Chancery Lane in the evenings, and was even taken one Sunday to see John Varley, who gave him prints to copy, cast his horoscope and gave him characteristic encouragement. Later, he was allowed to spend his wages on lessons from an elderly minor portrait painter in the City—lessons which he afterwards regretted. At the end of 1840 his sympathetic master retired, and he was out of work. He used the brief freedom between jobs to draw from casts and copies at home, and to make his first visit to the newly opened National Gallery in Trafalgar Square; he was not a little baffled by the paintings he saw. Then he found himself a new job, working in Richard Cobden's London office. He had not worked there long before he found that, from time to time, there appeared a man who was neither clerk, manager or customer, but would settle down at a desk and, with pencil, brushes and colours, make designs, patterns for calico-prints. This was not 'art', but it was not keeping ledgers either, and, fascinated, he began to experiment, using all his spare time in designing. He seems to have had a good deal of this, for he describes how he painted the office panels with scenes from Dickens and Shakespeare. He was an earnest reader, exactly the sort of young man for whom the new illustrated periodicals catered. These included the *Mechanic's Magazine*, which carried regular articles on art and architecture and *Arnold's Magazine of the Fine Arts* (or *Library of the Fine Arts*, as it was originally) from which it is clear he derived much of his thought about painting and the status of the painter. He also read Reynolds' *Discourses*, and learned as much about the history of the subject as he could. On Sundays, he would visit a picture restorer in the City and study the paintings there; or go with his paints and sketchbook along the river towards Chingford, to paint the old church. Showing his picture of Chingford Church to Rogers, from whom he was taking lessons, he was told that green in nature must on no account be painted green—and Constable was cited as a dreadful example, not to be followed. Gradually he began to meet more people connected with the world of art, and despite his father's warnings he eventually decided to give up his job and study to enter the Academy Schools, supporting himself by painting portraits. Most of the portraits came to nothing; but he did find enough work in copying to earn a few shillings and keep him busy for two or three days of the week. The rest of his time was spent drawing in the British Museum, the National Gallery or, in the winter months, in the British Institution Gallery in Pall Mall. The Academy was housed, at this period, in the eastern half of the new National Gallery building, so that in studying or copying there he got to meet some of the Academy students, and attended their lectures. His first application to the Antique School was unsuccessful, as was his second six

months later. His father took him to task for his failure, but Hunt begged another six months; if at the end of that time he were rejected again, he would go back to a warehouse job.

Looking at his work in the light of advice from Nursey, a pupil of Wilkie's, he decided that it was not serious enough: there was too much reliance on an 'artistic' manner, not enough care and discipline. He tried to cure these faults.

> I tried to put aside the loose, irresponsible handling to which I had been trained, and which was nearly universal at the time, *and to adopt the practice which excused no false touch.* I was not able to succeed completely in all parts of my work, but the taste for clear forms and tints, and for clean handling, grew in me; while at the same time I wished to guard myself against a slavish imitation of the quattrocentists, which was then becoming a seductive snare to certain English painters. Notwithstanding that I was out of sympathy with the fashion then raging in England for making facsimiles of ancient Gothic architecture, yet the unaffected work which I saw in Francia, Ludovico Mazzolini, and their schools, also the new Van Eyck (then in its dignified ebony frame) became dear to me, as examples of painting most profitable for youthful emulation . . . While in the mood for battling with myself, careful observation and the reading of Lanzi were convincing me that all the great Italian artists, including the cinquecentists, had grown in a training of patient self-restraint . . . I had to find out a path for my own feet, and for mine only. By nature and the encouragement of my early painting master, slovenliness was my besetting sin, and I was too impatient for result.[1]

One day, he found Millais, the recognized genius of the Schools, looking over his shoulder. Later, he went to see what Millais was doing; they talked, and Millais cheered him by his enthusiasm, saying that he ought to be in the Schools. Hunt worked away, and when the agreed six months came to an end, found himself admitted.

Teaching in the Academy Schools was free; but Hunt still had to copy and make portraits to earn his keep which meant that he could not always be there. At first he felt that this put him at a disadvantage compared with students who could attend every day; but after a while he began to think that in some respects these hours lost were hours gained. 'Many students who made excellent specimen drawings did them without profit for the end of study, and later they had all the difficulty of painting to encounter, as quite a strange and complicated mystery.'[2] His bread-and-butter copying in the National Gallery taught him a great deal about techniques and made him study the work of Rembrandt and Titian closely, while in the British Museum, not only could he draw from the Elgin and Townley marbles and other works of antiquity, but he discovered and explored a much wider range of European art in the Print Room.

When he had satisfied the authorities with his drawings from the Antique, he proceeded to the Life School. As the models only posed in the evenings, he had much more time for his bread-and-butter work, and began to work on compositions which might be sent to exhibitions. His subjects were not at all revolutionary either in

1 W.H. Hunt *Pre-Raphaelitism and the Pre-Raphaelite Brotherhood* London, 1905–6
2 *Op. cit.* p. 38

conception or execution but fell into the generally accepted categories. There was a great fashion for illustrative genre, and when he chose *Little Nell and her grandfather* as one of his subjects, he made nobody stare.

A firm friendship soon developed with Millais. Millais, already a prolific painter, was appreciably better off than Hunt, not only because he was able to paint and sell a good deal of work for a better price, but because his family gave him wholehearted support, both moral and financial. The two students spent a good deal of time together, discussed work and plans and confessed ambitions. The winter of 1847 wore by, their paintings for the next Summer Exhibition were finished, and Hunt decided that he might take a month in the country. Near Ewell, in Surrey, he had a well-disposed uncle and aunt with whom he might stay, and there, in the early summer, he would paint landscapes, direct from nature. It turned out that Millais also intended a visit to Ewell, though later in the year; his family had an old Jersey acquaintance, Captain Lemprière, living there.

This was an important venture for Hunt, whose practice in landscape was so far slight. He began a painting of one of the river pools; but soon found that it would take more than the two or three days he had innocently allotted. He began a painting of the old church, commissioned by the Rector, Sir George Glynn; and while working on it, had an offer of twenty pounds for his painting of a scene from Woodstock, then hanging in the Summer Exhibition. He decided to invest his earnings in painting a really important picture. One can hardly doubt that he was encouraged in this more ambitious thinking by his friendship with Millais. But he found another kind of encouragement about the same time. One of his fellow-students, named Telfer, had just read and been much impressed by Ruskin's *Modern Painters*, which he had borrowed from Cardinal Wiseman; it was borrowed again on Hunt's behalf. Hunt sat up through the night to read it. 'Of all its readers,' he writes, 'none could have felt more strongly than myself that it was written expressly for him.'[1] Here was Nature, not the antique, not the old masters, real or sham, held up for guide; perception, not authority. And this is just what had brought him to Ewell.

Back in London, payment for his pictures carefully hoarded, he decided on the subject of a new painting: *Christ and the two Maries*. He set to work; but he made no preparatory drawings; he was not used to working on the scale of life and the composition got out of hand. Realizing that he had started something which was going to take him far longer to finish than he had bargained for, and that he might not be in time to send in to the Royal Academy, he made a design for another, smaller painting, of a very different kind. His new subject would be from Keats' 'The Eve of St Agnes'. It was to be a significant painting for Hunt. He had found his theme in a poet whose writings were a personal discovery, discarding the obvious advantages of a subject from Scott, Shakespeare, Byron, Sterne or Dickens. By that much more, the painting must speak to people as painting, not as illustration. In it we begin to see that choice of colours, blue-greens, purples, violets, which came to be one of the marks of much Pre-Raphaelite painting; colour which, however naturalistically rendered, was selective, aimed at producing certain emotional

1 *Op. cit.* p. 73

effects. This painting was begun on February 5, 1847; it had to be finished by the end of March if it was to be submitted to the RA. The *Christ and the two Maries* was abandoned, and in his account of this Hunt takes occasion to give us, in the form of a long reconstructed conversation with Millais, useful insights into his thinking.

His despair of finding any older painter who could really show the way, and his relentless curiosity, had led him to question not only the paintings which hung in the exhibitions, but the system on which they were composed. At first he had not questioned; to get into the Royal Academy Schools was all-important. But it was rather different from inside; besides, he had read Haydon's attacks on the Academy, and like many others, had been shocked by his suicide of the previous year. For Haydon, despite his real limitations, had been responsible for the retention of the Elgin marbles, the Government's invitation to British artists to compete for employment in the decoration of the Houses of Parliament and had originated the idea of establishing Schools of Design, 'yet he received no sort of recompense or honorarium, although rewards were given to his adversaries'. Hunt was ambitious, he had had to work hard and, it seemed to him, without support; everything was open to question. He lays bare the lines along which his questioning proceeded.

> When art has arrived at facile proficiency of execution, a spirit of easy satisfaction takes possession of its masters, encouraging them to regard it with the paralysing content of the lotus eaters; it has in their eyes become perfect, and they live in its realms of settled law. Under this miasma, no young man has the faintest hope of developing his art into living power, unless he investigates the dogmas of his elders with critical mind, and dares to face the idea of revolt from their authority.[1]

Hunt had already questioned and dared, and his having been twice rejected had played an important part in inducing this questioning frame of mind. It had started with questioning himself. He had to take stock, to pull to pieces and remake his manner of drawing; he was not to be deterred from questioning others just as rigorously.

'Let us go on a bold track,' he reports himself as saying to Millais, 'some one must do this soon, why should not we do it together? We will go carefully and not without the teaching of our fathers: *it is simply* fuller nature that we want. Revivalism, whether it be of classicalism or mediaevalism, is a seeking after dry bones. Read, my dear fellow, the address of Oceanus in Keats' "Hyperion".'

And so Hunt goes on to elaborate his case against subservience to convention, ending with a eulogy of Ruskin and *Modern Painters*.

One more important point is to be extracted from this account. Still speaking of his *Eve of St Agnes*, he says: 'I am limited to architecture and night effect, but I purpose after this to paint an out-of-door picture, with a foreground and background, abjuring altogether brown foliage, smoky clouds, and dark corners, direct on the canvas itself, with every detail I can see, and with the sunlight brightness of the day itself.' This was really going the whole hog; not merely to paint out of doors, which after all landscape painters had been doing for most of the preceding century, but to paint out of doors on the canvas of the finished picture, not making sketches for later

1 *Op. cit.* p. 82

transcription. And what Hunt was proposing was not simply to paint a landscape, but a figure composition, of which the landscape should be the setting. It was like him to push the idea to its extreme conclusion. It hardly appears that he had a firm preconception of what sort of art might emerge from this; essentially it was a therapeutic exercise, a purgation of all convention.

It is unlikely that Millais had pushed the idea of painting from nature to this point, nor were his ideas ever really much deeper than the notion that an artist's business was to find beautiful things and paint them as faithfully as he could. Certainly the *Cymon and Iphigenia* on which he was working at the time, looks to a modern eye extremely conventional and vapid, and in view of Hunt's vehemence, Millais began to see it as such. 'You shall see in my next picture,' Hunt reports him as saying, 'if I won't paint something much better than *Cymon and Iphigenia*; it is too late now to treat this more naturally.'

Hunt pressed on with his *Eve of St Agnes*, painting everything from models except the architecture, on which he may well have taken advice from a visitor whom his friend Stephens would sometimes bring to the studio, a Mr Bridger, whose 'discourse was of country places, of old churches and their architectural features, of brasses, monuments, and other antiquarian matters'. Both Hunt and Millais knew that they could only finish their pictures in time by working well into the night. To have a painting in the Academy exhibition was the *sine qua non* of success (until the Pre-Raphaelites broke the spell) and they agreed to work together, Hunt moving his small picture into Millais' large studio, where they relieved the hours of work by endless talk and by taking turns on the duller bits of each other's pictures. At last, early in April, the two paintings were finished and delivered. 'The first use which Millais and I made of our release . . . was to accompany the noted Chartist procession.' This was on April 10, 1848, to Kennington, where Feargus O'Connor was to address an immense meeting; at this stage, Hunt was very radical and republican in his views; it is unlikely that Millais shared them.

Cymon and Iphigenia was rejected by the Academy, which must have been a real blow to the pride of the hitherto invariably successful prodigy; Hunt's *Eve of St Agnes*, on the other hand, was hung; a little high, but in a good light; and before the exhibition was over, it was sold for £70 to the Mr Bridger who had watched it through its early stages. Millais could take consolation from the fact that he had won a competition for a series of decorations in Leeds; but the success of Hunt's bold venture, and the rejection of his own conventional work, must have inclined him to take Hunt's ideas more seriously than perhaps he had done so far.

Hunt's painting not only brought him seventy pounds, but an equally precious friendship. Rossetti was enchanted by a painting so much after his own heart, taken from Keats, whose poems he also admired, well-drawn and painted, and using a range of colour already different from the run of exhibition pictures. He now sought Hunt out loudly declaring that his 'picture of *The Eve of St Agnes* was the best in the collection'.[1] Hunt and Rossetti were not quite strangers. They had been, according to Hunt:

1 *Op. cit.* p. 105

on nodding terms in the Schools, to which Rossetti came but rarely . . . He had always attracted there a following of clamorous students, who, like Millais' throng, were rewarded with original sketches. Rossetti's subjects were of a different class from Millais', not of newly culled facts, but of knights rescuing ladies, of lovers in mediaeval dress, illustrating stirring incidents of romantic poets; in manner they resembled Gilbert's book designs. His flock of impatient petitioners had always barred me from approaching him.

Rossetti came to see Hunt in his studio—still a room in the family home in Holborn. Hunt, made confident by his success and warmed by sympathy, showed all his work, old and new. 'My last designs and experiments I rejoiced to display before a man of his poetic instincts; and it was pleasant to hear him repeat my propositions and theories in his own richer phrase.' And he showed him the newest work of all.

> I showed him my new picture of *Rienzi*, in the painting of which at the outset I was putting in practice the principle of rejection of conventional dogma, and pursuing that of direct application to Nature for each feature, however humble a part of foreground or background this might be . . . I justified the doing of this thoroughly as the only sure means of eradicating the stereotyped tricks of decadent schools, and of any conventions not recommended by experienced personal judgement.

Hunt's use of the term 'experienced' is critical. He is posing the notion of experience in its immediate personal sense, as unmediated sensory perception, against the notion of experience as historic accumulation of ideas and practice. His new method was far from being a system of submissive copying; every colour and tone, every shape and relation that marked the canvas was as much question as statement: there must be no ready-made answers to the questions, no presumptions of style. And Hunt knew very well that it meant long exacting labour, costly in effort, but costly too in time. He was really gambling with his future; but he was convinced that he was right: there was no other way forward.

Rossetti would have been more surprised at Hunt's doctrine of complete reference to nature if he had not already had some insight into similar ideas from Madox Brown.

It was only at the beginning of May that he had begun to go to the studio in Clipstone Street to work in the shadow of the huge picture of *Chaucer*. He had gone fired with enthusiasm. The sight of the *Chaucer*, the designs and drawings for it, must have increased the excitement, for this was not only going to be a magnificent painting; it was a tribute, a monument, a shrine to English poetry. Rossetti's two first completed paintings show how much he was impressed by this and the *Wycliffe*. But he had come to Brown for practical help, and practical help, such as he would have given to any young painter, Brown gave. Like God, he could best help those who would help themselves. Rossetti had no experience in painting; his drawing was dubious. Ford Madox Brown gave him *The seraphs watch* to copy. Of course it was difficult, but it was interesting, and working alongside Brown Rossetti began to get some insight into Brown's method of work and the medium of oil paint. Brown overseeing this laborious copying, realized the limits of Rossetti's capacity. He could hardly fail to note, from this and from drawings of Rossetti's own, that inspiration

ran a long way ahead of a sense of form. So he set him a more mundane task: a simple still-life painting, a couple of stoneware jars, two medicine bottles, a palette with two or three brushes. It was too much for Rossetti. The task was completed, but he would risk no more like it. No room for inspiration here, just observation and discipline; no Faustian dreams, no bravura borrowed from Gavarni. Rossetti began to neglect Brown's studio and stayed in Hancock's where he had been before, trying to paint again on his own—but the difficulties remained. He could not paint, and he must learn. He had committed himself, and his family, to his career as a painter. His new friendship with Hunt was opportune. In mid-July, news of the revolution in France decided Brown to go and see for himself what was happening, and in particular, how his Paris friends were faring. He stayed with Dan Casey, whose portrait he painted, and came back on August 6, having enjoyed three exhilarating weeks and bought a new lay figure. During his absence Rossetti, finding himself without support and instruction, sought help from Holman Hunt, who was more than willing to step into Brown's place as teacher. When Rossetti brought Hunt round to Clipstone Street on the last day of August Brown thought Hunt a clever young man. So Hunt and Rossetti developed their friendship, exploring and sharing enthusiasms and hates in art and literature while Hunt propagated his new gospel. His theme of *Rienzi* would be one sympathetic to Rossetti, for though Hunt's source was Bulwer Lytton's novel of that name, Rienzi was a real person, one held in honour by the patriots of Gabriele Rossetti's world.

As Rossetti grew more intimate with Hunt and more enthusiastic about his gospel, whose success was being demonstrated on the new canvas, he began to preach it on his own account to a young sculptor, Woolner, who had the studio next to Hancock. Woolner had been a contemporary of Millais' at Sass's; he was a year or two older than Hunt and well-experienced professionally, having worked as a boy for the successful sculptor Behnes ('Behnes' Tyger' is the inscription on an amusing drawing of him by a friend). Like Hunt, he was poor and had come up the hard way; like Hunt, he was something of an iconoclast, a strong radical, even a republican. There was every reason why Hunt and Woolner should get on together. Half the reason for Hunt's choice of theme from *Rienzi* lay in its 'appeal to Heaven against the Tyranny exercised over the poor and helpless'. 'Like most young men, I was stirred by the spirit of freedom of the passing revolutionary times.' And Woolner, in this revolutionary year of 1848, had just come back from a visit to Paris. Rossetti brought him to Hunt's studio. He was full of enthusiasms likely to rouse the latter's suspicions—for Ary Scheffer's painting, for Caporal tobacco—but he *had* worked for Behnes, and delighted Hunt with his story of how he had once held open the studio door for Haydon himself. He knew some of the rising men, too, Watts and Pickersgill, and shared Hunt's own admiration of old Mulready (pl. 1). So another friend was added to the group, and the sense of moral support and comradeship so important even to the most independent of young artists grew more secure.

4 John Everett Millais

John Everett Millais was born in Southampton on June 8, 1829. He was the youngest son of a gentleman of St Helier, Jersey, who had married an attractive, well-educated, energetic widow, Mrs Hodgkinson, mother of two sons already by her first marriage. It might be truer to say that Mrs Hodgkinson married Mr Millais; certainly she was the dominant partner, and it was her ambition for her youngest son that brought the family to London and caused the whole household to revolve around young Johnnie. She set the pattern of her son's life in more ways than one: when he eventually married he found in Effie Gray just such a capable, ambitious, energetic partner —shrewd, determined, socially accomplished and set on success for him.

In 1833 the family moved back to Jersey; then in 1835 to the French mainland, living for two years at Dinan in Brittany. Mrs Millais, who seems to have had all the accomplishments of a lady-like education, educated her precocious child at home; her husband, gentle and modestly talented, made a less formal contribution. Johnnie was possessed by a passion for drawing from a very early age, copying prints with skill and accuracy, and making remarkably good drawings too from actual things and people. He could make elaborate pictures, modelled on the fashionable engravings and illustrations of the albums and magazines, and when they lived in Dinan he created a sensation among the officers of the regiment stationed there by his drawing of the drum-major. When Johnnie was eight years old, it was decided that he should go to London to become a painter.

They crossed the water to Southampton, and, true to form, in the London coach Johnnie's cleverness astonished a gentleman who was then well known as the Duke of Devonshire's chief gardener, but became famous fifteen years later as the designer of the Crystal Palace: Paxton gave them an introduction to the President of the Society of Arts. They had already received an introduction to Sir Martin Archer Shee, President of the Royal Academy, from the Governor of Jersey. So, at the age of nine, young Johnnie had leave to draw in the British Museum, and presently joined Sass's school in Bloomsbury, to draw from the antique, to study anatomy and perspective, and prepare himself for the Academy Schools. During this first year in London, he won the Silver Medal of the Society of Arts for a drawing of *The battle of Bannockburn*. He was so small that when he went up to receive the medal from the gracious hand of the Duke of Sussex, who was both stout and short-sighted, the Duke did not see him as he came up to the platform.

The family settled in Gower Street where a large downstairs room was made over as Johnnie's studio. In the autumn of 1839 he was admitted to study in the Royal Academy's Antique School, the youngest student ever to enter. He won the prize for drawing from the antique at thirteen, together with every other conceivable award, until, at seventeen, an age when most students were just attempting to enter

44

the Antique School, he won the Gold Medal for his painting of *The Benjamites carrying off their brides*—a thoroughly accomplished piece of pure academy convention.

He had already been painting in oils for some time, and selling what he painted. In 1845 he met Ralph Thomas, the Chartist lawyer, who was also a collector and something of a dealer. He agreed to paint small pictures for him regularly, for a fee of a hundred pounds a year and his Saturdays were devoted to this occupation for many months. The first cheque Millais ever received was from Thomas, for five pounds: it was dated February 28, 1846. Millais was fifteen and a half.

A few months later he met Wyatt the Oxford picture dealer. One of Wyatt's friends and clients was Thomas Combe, then Director of the Clarendon Press. It was an important introduction for Millais, who found in Combe a few years later a very sympathetic patron and friend.

Millais became friendly with Hunt in 1846 and the next two or three years saw an astonishing progress from his child prodigy status to one of masculine maturity. Everything from Millais' hand up to and including *Cymon and Iphigenia* had been strictly conceived in terms of fashionable and academic expectation. Even in academic terms his range was restricted: Haydon, Etty, Hilton, Hayter, Leslie, E.M. Ward, gave the forward limit to his vision. In spite of the Westminster Cartoons competitions, he had not even begun to think in terms of the most advanced aspects of the art as exemplified by men like Dyce, Maclise and Herbert. This is not surprising. A talented boy coming from a family with an amateur tradition in the arts is quite likely to have very conservative ideas, to see painting as a system of manual skills operated according to rules of taste; and no boy could have had a more complacently conventional background than Millais. His very facility and success would, certainly while he was still young, tend to confirm this conservatism. The contact with Hunt's much tougher mind, harder experience and greater independence was exactly what he needed; just as the ease and friendliness of Millais' own manner, the kindness of his parents, was valuable to Hunt in helping him to relax. Millais provided Hunt with a responsive listener and collaborator, while Hunt showed Millais, at least for a time, how to use his own eyes and judgement.

But Hunt was not the only influence on Millais, however potent his effect on him in that first year of close contact. The association was brought about by Millais' initiative: his attraction to Hunt was a mark of his own readiness to grow up; and soon after the two had become really friendly, perhaps because of the contrast between Hunt's puritan independence and his own domestic child-situation, Millais turned Mamma out of the studio, tea-cups, work-basket and all. But it is clear from drawings and letters by Millais of the years between 1848 and 1854, that he was also awakening to the new movement in English art which linked it with contemporary German art—to what he and Rossetti, as well as Ford Madox Brown, called Early Christian art, and Hunt, suspiciously, described as Overbeckian, German, antiquarian. Millais was more affected by it than Rossetti, despite Brown's influence, and for a longer period. It was Millais, not Rossetti, who was to produce at the famous Gower Street evening the portfolio of engravings, who said of the Orcagna and Gozzoli paintings they represented, 'Now look here, this is what the Pre-Raphaelite clique should follow.'

Hunt inveighs strongly against Early Christian art in his account of his first relations with Rossetti; he is, of course, making his case against the foreign seductions of Ford Madox Brown, whom he regarded with some jealousy not only as being the first to teach Rossetti, but also as having preceded him, Hunt, in the advance into the new art in which studio conventions were to be rejected in favour of immediate visual experience. In the case of Millais, Hunt ignores the Early Christian element entirely, yet it is clear, from the letters of Millais to Mr and Mrs Combe in Oxford, that between 1848 and 1854 Early Christian ideas were influencing his religious ideas as well as his style of painting. Through the Combes he came to know other people in university circles in Oxford, including Marriot, and Hungerford Pollen, then still a High Anglican, busy with the restoration of Merton Chapel, but soon to go over to Rome. A frequent companion on Millais' painting visits to Oxford was Charles Collins, brother of Wilkie Collins, also an academy student, and at that time as devout a ritualist as Collinson. It appears from one reference in these letters[1]—to Mrs Combe, of December 1850—that, perhaps under Collins' influence, he had been discussing the idea of a closed community of artists such as the Nazarenes had had in Rome. 'Get the Early Christian [Mr Combe] in his idle moments, to design the monastery and draw up the rules.'

However, there was nothing in Millais' upbringing or temperament to give his ideas the depth and intensity that marks those of Hunt, Rossetti and Brown. Though the letters to the Combes are lively and well-written, they show no trace of concern with fundamentals of belief such as preoccupied Burne-Jones even at the age of fifteen; and his incessant teasing of Collins during the summer which the two spent painting with Hunt near Ewell shows him as rather insensitive.

Millais' advantage over the rest of the Brotherhood—at the outset it was an enormous advantage—lay in his very clear and complete visual memory. He had not merely hand and eye skill far above the average, an easy command of the formal elements of drawing, colour, pictorial construction, but the capacity to visualize complete, to establish in detail in his mind's eye the whole of his intended composition, and thence to project it on to the canvas. His son quotes an account of Millais at work by his old friend Benest which illustrates this clearly. 'Once when I asked him how he could possibly paint and talk at the same time, and throw such energy into both, he said, tapping his forehead, "Oh, that's all right. I have painted every touch in my head, as it were, long ago, and have now only to transfer it to canvas."'[2]

Hunt could only achieve this documentary immediacy painfully, and Rossetti hardly at all. Such different artists as Richard Dadd, Blake and Cruikshank had the same faculty, all using it in personal ways to quite different ends. It can be a valuable faculty in a painter, but it is not the secret of creation. It was enormously useful to the baroque decorator, and in a different way to the Victorian narrative painter; coupled with his complete accord with the comfortable values of the English middle class, it made Millais an admirable illustrator of contemporary novelists like Trollope. But it was a faculty that remained at the level of imitation

1 J.G.Millais *Life and Letters of Sir John E. Millais* London, 1899, Vol. 1, p. 93
2 *Op. cit.* p. 77

until Hunt's example and argument set Millais free to use it for himself. He must have felt the greatest elation as he set to work in the new way, keeping strictly to Hunt's doctrine of 'getting back to nature'. Nothing he had attempted so far had really tapped his true talent.

But Hunt's commitment was not only to a method of painting, it was to an art of ideas. This, too, had its stimulating and liberating effect on Millais. It was not only the technique of such pictures as his *Widow's mite*, *The Benjamites carrying off their brides*, *Pizzarro* and *Cymon and Iphigenia* that was imitative and banal, remote from experience; their structure and their utter vacuity as to content reflected the sterility of the academic tradition, a tradition now simply of stereotypes. When Poussin had taken a scene from biblical or classical literature he had dealt with his subjects with profound empathy and a rigorous understanding of their meaning in relation to the traditions of European culture. Themes from these sources were now handled without any such moral or intellectual force. The idea of a dramatic theme from Keats, subject to none of the deadly sanctions of academic precedent, never worked on before by any artist, with the opportunities for rich decoration, colour, costume and setting suggested by the story's origins in Boccaccio, was far more stimulating than any rehearsal of familiar subjects, all of which would conjure up some totally exhausted style-model. For the discovery of Keats' poetry, Millais was deeply indebted to Hunt; and the *Lorenzo and Isabella* (pl. 33) which was the first outcome of his acceptance of the new doctrine and the virgin theme is the most significant painting of his whole career. At a stroke, in a few months, his whole work was revolutionized. There were no fumblings, transitions, half-measures. Thanks to his genius for visualization, the new picture gave brilliant proof that something new was possible. It restored him to his accustomed place of leadership, of conspicuous triumph.

5 The formation of the Brotherhood and its first successes

During the summer and early autumn of 1848, while Hunt and Rossetti were working together, Millais had been out of London for most of the time, staying either in Oxford with his half-brother Henry Hodgkinson, or in Yorkshire, where he was carrying out a commission he had won in competition for a series of decorative lunettes. Four of these paintings (in monochrome) were reworkings of designs of *Infancy*, *Youth*, *Manhood* and *Age*, made in 1845; the other two were on themes of *Poetry* and *Music*. They showed no sign of any new gospel, but were completely conventional, even old-fashioned. His absence had left a temporary vacuum for Hunt, which Rossetti had filled in an exciting way, with his original turn of mind, his wit and eloquence, and his ability to give expression to Hunt's ideas better than Hunt himself—or to ideas that seemed very like them. Rossetti and Millais had also become acquainted, but there were undertones of rivalry in this relationship, for both Millais and Rossetti had their personal following in the Schools; nor did Millais respond half so deeply as Hunt to Rossetti's ideas. Much as he had admired some of the latter's designs for the Cyclographic Folio, he knew that Rossetti had not yet painted anything; and it was practical success, not ideas, that interested him.

But, in spite of Millais' absences, the three had met and talked sufficiently about art and their aspirations to have reached the point before September of regarding themselves as the leaders and first practitioners of a new art. Rejecting as far as possible all the traditional conventions, this art should seek above all to project ideas in terms of a scrupulously faithful visual account of whatever figures, settings, details or circumstances might be needed to add up to a projection of the chosen incident, occasion, relationship, whether literary, illustrative or historical. In this respect their ideas about possible themes for paintings were not materially different from those of other painters: the critical difference was their joint insistence on regard for visual truth. For Rossetti, poetic or symbolic significance of some sort was most important; for Hunt, a moral idea; for Millais, the content was not deeply significant as long as the ostensible subject was appealing: but as to how they should work, the way in which their paintings should attack the public eye and win recognition away from the 'old gang', they were quite agreed.

Discussions between Hunt and Rossetti continued while Millais was away, and began to change their tone. Hunt, always a little deferential with Millais, had the advantage of taking the lead. Rossetti, listening, responding, elaborating, already excited by the impact of Brown's new paintings, was carried away by the idea of a dazzling regeneration of art, with Hunt, Millais and himself as the leaders of a new

school of English painting, a genuinely English school based on Nature, untainted by the dregs of post-Renaissance style; an art not of the past, but of the present and the future. Here was a cause which had leaders; it needed more adherents, a band of dedicated brothers like the Nazarenes about whom Brown had talked. Back in Woolner's studio, Rossetti would pour out this new inspiration in his own way; it appealed very much to Woolner, no less ambitious than Hunt and Millais. Deverell and Collinson were also subjected to his propaganda. Deverell lively, entertaining, generous, skilful; Collinson sleepy, devout, solemn, but with an eye as good as Millais' own. Even William Rossetti fell under the spell. He had begun to go to the Maddox Street school with Gabriel to make stiffly correct life drawings, and, if Gabriel said the word, was ready to give up his clerkship and become a painter too—though what Gabriel, let alone William himself, would then have done for money, is very doubtful.

Hunt found it hard to resist Rossetti's enthusiasm, and the idea of leading such a band of devotees; indeed, if he did not undertake to lead, Rossetti might sweep on regardless, and he, the originator, be left in the lurch. Millais' reaction, however, was a matter of concern. He would not mind about the Nazarene taint but he would refuse to be mixed up with anything amateur or technically inadequate.

Millais was used to being out on his own, the shining leader, the *victor ludorum*. He had been heard to criticize Collinson with some scorn; Woolner was after all no painter; William Rossetti nothing at all; they had all been drummed up by Gabriel who had yet to prove himself. All Millais had ever seen from his hand were the drawings in the Cyclographic Club Folio. Hunt, feeling that something must be done to redress the balance and forestall Millais' possible anger, enlisted his own pupil Frederic Stephens, a student in the Antique School who, even before Rossetti, had come to him for advice on painting.

When Millais did return, he was *not* pleased. He was no longer the sunny golden-curled boy with the lace collar, but a very self-confident young man, who had been painting professionally for four years, not merely winning medals. What advantage would he see in an association with half a dozen unknown, unproved enthusiasts? It had been one thing for Hunt and himself to come to an understanding, even for Rossetti to be included in it, but what was now proposed could do their reputations a lot of harm. He invited them all to visit him in Gower Street, early in September. It was more of an examination than a social evening. If Hunt's flock, as Millais called the new recruits, did not seem to have the right ideas, if they did not respond to the prints he had to show them, he would have nothing to do with them. There were really two things in question. First, the attack on the entrenched position of the old. Millais and Hunt both knew that only outstanding painting would serve for this, and such as would be intelligible to as many people as possible. The new painting must engage the interest of those who came to the Academy or British Institution to buy. Increasingly this meant people who would respond to romantic scene and dramatic incident, with or without moral: modern literature, native history, rather than the traditional themes of classical art, would provide subject matter, and the more the paintings explained themselves in terms of recognizable familiar experience, the better.

The prints which Millais had provided for this examination were not all that Hunt himself might have chosen: those of the frescoes in the Campo Santo at Pisa were, after all, archaic and Roman Catholic, but at least they were genuine Italian and not modern German imitations, and were very different indeed from the average academy painting. Other prints were after a contemporary German artist, associated with the Nazarenes, Joseph Führich, and these, surprisingly, Hunt liked because of the modernity of their drawing (pl. 7). Everybody was enthusiastic about the prints, their innocence, their Chaucerian invention and their unmannered observation. Millais pointed out their excellence; this, he told the rest, was what they must aim at. In the end, finding himself very much the key to the situation, he relaxed. He was, after all, good-natured; everybody else was deferential to him, as well as being properly enthusiastic about the prints—there would be no practical challenge to his and Hunt's leadership. But no more recruits. Best to close the door on the flock already in the fold. Seven was a good number. And so, for the moment nameless, the Brotherhood was agreed: seven young men united in the sacred cause of art.

For Millais that was enough. The regeneration of art with himself recognized as the supreme painter was what he wanted; it was a purely professional matter. Hunt wanted more. He was anxious for personal success but he wanted such a success to extend beyond professional achievement. It was not just the triumph of art he was after. He had not needed Keats to convince him that 'Beauty is truth, truth beauty' but he wanted to take this further: art was a potent means of conveying ideas and there was a sacred duty upon the artist to use his powers. Collinson also wanted art to promote ideas—ideas of piety and goodness, specifically Christian. Woolner wanted art to express ideas of individual liberty, moral and intellectual power. Rossetti wanted art anyway; art as a key to the expression and discovery of ideas, universal or personal, poetic, dramatic, rich, strange, mysterious; art as a medium in which the individual could develop and expand emotional responses, emotional states, otherwise circumscribed. William Rossetti, if he did anything at all, would paint conscientiously, painfully, following where Gabriel led: and Stephens would as faithfully, more skilfully, follow Hunt's example. All would set themselves to choose good subjects, to do the most scrupulous drawings for them, and paint everything in the pure light of nature.

A regular monthly meeting was instituted to take place in different studios in turn. Inadvertently, an organization had been set up. It is very difficult for a group, however tenuously organized, to continue without taking some sort of name, and Hunt explains how it was chosen.

In my own studio, soon after the initiation of the Brotherhood, when I was talking to Rossetti about our ideal intention, I noticed that he still retained the habit he had contracted from Ford Madox Brown, of speaking of the new principles of art as 'Early Christian'. I objected to the term as attached to a school as far from vitality as was modern classicalism, and I insisted upon the designation 'Pre-Raphaelite' as more radically exact, and as expressing what we had already agreed should be our principles. The second question, what our corporation itself should be called, was raised by the increase of our company. Gabriel improved upon previous suggestion with the word Brotherhood, over-ruling the objection that it savoured of clericalism. When we agreed

to use the letters PRB as our insignia, we made each member solemnly promise to keep its meaning absolutely secret, foreseeing the danger of offending the reigning powers of the time.[1]

The idea of a Brotherhood had particular appeal for Rossetti, especially after his acquaintance with Brown: Club would be commonplace, Society distant and cold. Brotherhood had all the necessary immediacy and warmth and its echoes of the past gave it rich overtones. If in addition it was to be secret (a matter of prudence for Hunt and Millais) what could be more heart-warming to the son of a proscribed Carbonaro and Freemason? Millais, working in Oxford with Charles Collins, had begun to feel a temporary attraction to the notion of a mediaeval fraternity; and even Hunt, working on his painting of *Rienzi*, was in another way celebrating the idea of fraternal loyalty.

It was standing practice of the day to plan the most important painting for the Academy a year ahead. Every painter concentrated his chief effort in this way on the work which was, by winning a good place 'on the line', to enhance his reputation and bring him cash and clients. A painter in successful practice could devote most of his time to such pictures; if less successful or unknown, he had to spend a good deal of time copying, or on portraits, design work, illustrations, drawing on the wood for the engravers—all things which Hunt had done from the age of fifteen.

The *Rienzi* was an extremely important painting for Hunt. So far he had been groping his way in self-examination and argument more than in practice, towards his conviction of the need to paint from nature and to make nothing but nature, the actual experience of the eye, his guide. In the new painting he determined to follow his new principle absolutely. Not only would he paint everything direct from nature, without obeying any of the rules, but in order to push the process to its extreme, he chose to set the dramatic moment out of doors, in broad daylight and bright sunlight, so that colour and light effects should be as fresh and real as possible. It must have been disconcerting for him, when later in the year he first saw what Brown had been about, and particularly the *Wycliffe*, to realize that Brown had been moving independently in the same direction and was already ahead of him. It is this which gives so sour a tone and such exaggerated weight to his criticism of Brown's Early Christianism.

Painting in the open air and in sunlight was not necessarily a part of the Pre-Raphaelite gospel, though to do this helped to push the idea to its limit and moved the painter as far as could be from the prescriptions of Sir Joshua: the essential thing was to break through the traditional conventions. Hunt was to abandon daylight for the yet more difficult challenge of the night and lantern light, in *The Light of the World*, but neither Hunt nor any other Pre-Raphaelite was committed to *plein-airisme* as a doctrine.

He elaborated his design from sketches, settled the number of figures in his group and arranged their appropriate attitudes—that of Rienzi himself is substantially borrowed from the chief figure in the Millais lunette of *Manhood* (pl. 39). This done, he had to decide on where to paint the important elements; which out of doors,

1 W.H.Hunt *Pre-Raphaelitism and the Pre-Raphaelite Brotherhood* London, 1905–6, Vol. 1, p. 141

which in the studio. Working in his new way (and it *was* his new way, arrived at independently from any other artist and setting a model for Millais as well as the other brethren) he must paint the background first; the summer was therefore largely given to this. The distant background of the picture is occupied by a rising slope with young trees against the open sky; there are thin clouds and a slip of moon; a woman comes over the crest of the slope to the left; to the right, and more distant, we see the walls of the city. The middle distance is taken up by half a dozen horsemen who ride away; the immediate foreground by Rienzi who kneels raising his hand to heaven, vowing vengeance for the murder of his young brother, whose body lies on a stretcher put together from shields and spears of Rienzi's three companions. Just beyond this group, at the left, the hanging boughs of a young fig tree sweep into the picture; the left foreground has a patch of meticulously painted turf, with growing plants, a dandelion clock, pebbles. The painting is well-composed, if a little static, but this is largely because Hunt is careful to avoid the easy theatrical gestures which so often filled contemporary figure painting to the exclusion of true observation.

The fig tree was painted in Stephens' father's garden; the landscape on Hampstead Heath, during June and July, while his studio was still in the family home. While the new studio was being got ready, Hunt and Rossetti took a holiday—a day at Rochester, another at Greenwich, another at Blackheath, where, while Hunt sketched diligently, Rossetti gave up his drawing for poetry. Back in London, in Cleveland Street, the two settled down again. Hunt, attracted and fascinated by Rossetti, scraped out the head of Rienzi already laid in, and repainted it from this authentic Italian head and expressive face. More studies from the nude had to be made for the figures; studies of drapery, studies of arms and armour—these borrowed, as Haydon had borrowed them, from the Tower of London. The new doctrine of painting all direct from nature in no way absolved the serious Pre-Raphaelite from the obligation to make these rigorous studies; an exhaustive understanding of what one painted had to inform the act. Rossetti worked alongside him.

Rossetti had made designs for three subjects for the Summer Exhibition. Two of them certainly, were ideas he had worked on before for the Cyclographic Club Folio: *Margaret in church*, a theme from *Faust*, and one from Coleridge, *Genevieve*, but he gave up these two romantic subjects in favour of a religious theme, *The girlhood of Mary Virgin* (pl. 45). In view of the way he set about this, of its structure and feeling, it is obvious that though working on it under Hunt's eye, the inspiration came initially from Madox Brown; timid and thin as the execution is compared with Brown's own painting, there is no doubt that it was the *Wycliffe*, the studies for *Chaucer*, and *Our Lady of good children* that gave Rossetti his model for the painting. In taking the girlhood of the Virgin, he was able to develop his subject in intimate domestic terms, another idea borrowed from Brown. There were precedents for a painting of the young Virgin working at embroidery: in the Stafford (formerly Bridgewater) Gallery, one of the largest and most accessible of the great collections in London, was what Anna Jameson in her *Legends of the Madonna* (published three years later) describes as 'a small but very pretty picture by Guido. The Virgin, as a young girl, sits embroidering a yellow robe', but in the tradition of the Life of the Virgin, she would always, except as a very small child, be shown in the Temple.

Rossetti, in the spirit of Brown's *Our Lady of good children*, designed his picture showing her at home with St Anna. Who better than his own sister Christina and their mother for models?

This element of homely domesticity probably helped to reconcile Hunt to the picture. Hunt's respect for Brown, whom he came to know through Rossetti, was limited by his dislike of 'Early Christian' painting, or any sort of painting which seemed to be based on a desire to return to the Roman Catholic Middle Ages. 'To Rossetti's occasional expressions of unbounded enthusiasm for Brown's past works I could not always give unmodified approval,' says Hunt, proceeding to a thorough but negative account of such of Brown's paintings as he had seen.[1] All of them seemed—not altogether unreasonably—too foreign in character for Hunt's taste, and he noted with the greatest hostility that Brown had fallen under the influence of 'the new school under Overbeck and others, who set themselves to imitate all the child-like immaturities and limitations of the German and Italian quattrocentists'. When Rossetti took him to Clipstone Street his worst fears were realized. Half filling the studio with its vast window and skylight was the largest Early Christian painting he had ever seen. 'Impressed as I felt by his work as the product of individual genius,' says Hunt, 'I found nothing indicative of a child-like reversion from existing schools to Nature herself . . . Thus this Chaucer design failed to represent the unaffected art of past time, and it stood before me as a recent mark of academic ingenuity which Pre-Raphaelitism in its larger power of enfranchisement was framed to over-throw.'[2]

Millais, back from the North, was also settling down to his big picture for the next Academy exhibition. He was later than usual in starting, and it was not until October that he began a design on a subject from Keats' poem, 'Isabella and the Pot of Basil'. It had originally been meant for one of a projected portfolio of etchings but short of time, Millais enlarged it on his new canvas and set to work, pressing family and friends into service as models. He was fully committed to the new doctrine, and the *Lorenzo and Isabella* (pl. 33) is his first Pre-Raphaelite picture. It bears very distinct traces of the influence on Millais of the Early Christian tendencies Hunt so distrusted in Rossetti's picture. Nothing could be less like Millais' academy painting of the previous season. Against the cool patterned wall that stretches across two-thirds of the background, the two rows of diners eat, drink and stealthily watch each other. At the far end of the right-hand row, Rossetti's own lifted profile shows against the wall; at the near end of the same row, Lorenzo, pale and intense, has the features of William Rossetti, while the demure Isabella was painted from Millais' half-brother's wife. On the carved leg of her chair appear the initials, PRB; the same initials which were inscribed also on Rossetti's picture and Hunt's. Committing himself to the new style liberated Millais' extraordinary gifts in an astonishing way. It is difficult to believe that the painter of the coarse and banal *Cymon and Iphigenia* could, twelve months later, have produced this painting, crisp and beautiful in its drawing, subtle in colour, superbly observed. It is true that as one looks into it, it becomes apparent that only between the four figures in the foreground is any situation realized; the

1 *Op. cit.* p. 120 2 *Op. cit.* p. 125

other figures or heads are no more than superlative still-life, as much background as the patterned wall or the passion flowers that twine the pergola. But they *are* superlative still-life and the painting is a triumph. By the end of March it was well on the way to being finished, and, with Hunt's *Rienzi*, it was hung in the Academy at the end of April.

Rossetti's picture was not there. Following Brown's example, and without doubt glad to avoid the possibility of rejection from the RA, he had sent his *Girlhood* to the Free Exhibition, where it hung with Madox Brown's newly finished *Cordelia at the bedside of Lear*. It was seen by the public a week sooner there than if it had gone to the Academy; for in the Free Exhibition there was no selection, the artists simply ballotted for places. All three paintings bore the initials, but, separated, did not have the same impact as if they had all been in Trafalgar Square.

Rossetti's painting received favourable notices in at least six journals, that in the *Athenaeum* being long and considered, commending the picture in just such terms as would raise in Rossetti the confidence he still so much needed. Contrasting it with the 'mass of commonplace, the record of mere facts or the extravagant conceits exhibited in the illustration of some of our most cherished writers', the critic (almost certainly the same, Frank Stone, who next year was to attack the Brotherhood) commended the picture as a 'work which for its invention and for many parts of its design, would be creditable to any exhibition', and 'its spiritualized attributes, and the great sensibility with which it is wrought, inspire the expectation that Mr Rossetti will continue to pursue the lofty career which he has here so successfully begun'. The two sonnets written for the painting, and displayed, printed on gold, on its frame, were also praised. Altogether, no artist exhibiting a first picture could well have had a better reception; he even managed to sell the picture.

Hunt and Millais found it trying that Rossetti should, by the advantage of that one week, get the credit for originality which they at the very least were entitled to share. 'While our pictures were shut up for another week at the Royal Academy, Rossetti's was open to public sight, and we heard that he was spoken of as the precursor of a new school.'[1] However, they too in time attracted the notice of the critics, and not altogether unfavourably, though it is noticeable that the gentle warning against 'Overbeckianism' is rather sharper in the review of their pictures. The *Athenaeum* notice was a long one, and it is evident that in spite of his condemnation of their antiquarian mannerism, the writer recognized that these were two important works, and that there was some concerted effort implied in them. 'There is so much ability and spirit in two works by men young in age and in fame, mixed up with so much that is obsolete and dead in practice, that some remark is demanded on a system whose tendency may be hurtful to our growing artists and to our School.' So the notice begins, and most of it is devoted to a solemn warning against the very things which Hunt so suspected in Ford Madox Brown. Later, in July, *Fraser's Magazine*, in the course of a much more favourable notice of Millais' picture, as one which 'stands out distinguished from the rest', actually names Madox Brown. 'The colour of the picture is very delicate and beautiful. Like Mr Brown, however, this

1 *Op. cit.* p. 174

artist, although exhibiting unquestioned genius, is evidently enslaved by the preference for a false style.'

This might not be unmitigated praise, but on the whole the three could be satisfied with their press. Millais sold his painting quickly, for £150 and a suit of clothes, to three Bond Street tailors who dabbled on the side in picture dealing, but Hunt, though a number of Academicians congratulated him on his *Rienzi*, was less lucky, and had to take the unsold painting back to Cleveland Street in August. However, the compliments of the Academicians were not all empty, and a little while later, Augustus Egg called on him to look at the picture again, then had Hunt take it to the house of a collector, Gibbons, who at his instance bought it for a hundred guineas—just in time for Hunt, who was threatened with distraint by his landlord against his unpaid rent, Rossetti having abandoned the studio at the March quarter day, leaving Hunt to pay everything. Hunt had not yet quite grasped Rossetti's very arbitrary way of resting his financial obligations on other shoulders, but despite his astonishment at Gabriel's casual behaviour, seems not to have held it against him at all. On the contrary, the last week of September saw the two off on a visit to Paris.

6 Paris, Bruges and *The Germ*

Despite the concentration of interest on preparing pictures for the Academy Exhibition of 1850, there were other developments in which the Brotherhood was involved. Early in the summer, Rossetti had been approached by an elegant young architect in very fashionable practice as a restorer and decorator, Nockalls Cottingham, who was anxious to buy Rossetti's *The girlhood of Mary Virgin*, perhaps seeing it as ideal for the private chapel of some wealthy Roman Catholic convert. Too late to buy it, he commissioned another painting on which he gave Rossetti an advance. He also approached other members of the group: Woolner carried out at least four of a series of heads of famous artists for him; Hunt began two of a series of four paintings, *Morning, Afternoon, Evening* and *Night*, but hard up and asking Cottingham for an advance, and mentioning that he meant to take them to Paris to finish, received a very sharp letter in answer, withdrawing the commission immediately. It reached Hunt on July 13, the very day on which he had to move out of his studio.

Hunt's quarrel with Cottingham was evidently made up, for on August 26 the *Journal* records that 'Hunt has been making the designs for the *Morning* and *Evening* commissioned by Cottingham, which he intends to complete tomorrow morning and present to him. He says it is his intention, after leaving his present lodging (which he will do some three weeks hence) to go for a fortnight into the country, and work on the landscape of his *Early Britons* picture, and from there to Paris for about three months to paint the commissions.' Woolner had by this time done a small figure of Euphrosyne for Cottingham, who was also pressing him to carve a marble figure of St Luke, from a design of Gabriel's—but the new suggestion was evidently meant to dissuade the sculptor from pressing for payment for work already done; he never was paid, and the statuette appeared in ceramic form in the shops as Cottingham's own work.

By the end of the year he had bilked them all, except Rossetti who had got his advance and (typically) not completed his commission: but even as late as mid-October a letter from Gabriel[1] shows that they regarded him as a likely subscriber to their projected magazine.

Hunt did in fact manage to spend some time in the country working on his new picture, and chose the Lea marshes as providing a suitable background. This painting had been planned before *Rienzi* was finished. The Royal Academy's Gold Medal competition subject had been announced in general terms, as 'An Act of Mercy', and Hunt conceived a picture in which Christian missionaries, hunted by Druids, should be seen sheltered by their converts. On the marshes, he sought a

1 O.Doughty and J.R.Wahl *Letters of Dante Gabriel Rossetti* London, 1965–7, Vol. 1, p. 82

suitable hut, open on one side, in which the priest could be shown hiding. This setting painted, he was prepared to venture across the Channel to Paris.

The 27th of September saw Rossetti and Hunt on their way to Paris, via Folkestone and Boulogne; they stayed there until October 15, going on to Brussels, Ghent and Bruges, and returning to London at the end of the month.

It is difficult to realize how little was then known in England about any French painting except that of Claude and Poussin. The English gentleman making the Grand Tour might visit Fontainebleau and Versailles, but he, or his agent, would buy works of art in Venice or Rome. In only one of the great collections, that of the Duke of Sutherland, could a modern French painting be seen—the quite recent *Execution of Charles I* by Delaroche. In Samuel Rogers' collection there was a single Watteau; in Buckingham Palace, a Greuze and a Le Nain. Almost the entire content of the large collections—and there were a good dozen—consisted of Italian, Dutch and Flemish paintings, chiefly of the sixteenth and seventeenth centuries, or English works of the eighteenth century. Only by crossing the Channel could a young artist see French paintings, other than the few pictures shown in London by such Anglophile painters as Delaroche. Very possibly Ford Madox Brown's summer visit to Paris in the previous year helped to stir Hunt to action, especially as at this period both he and Rossetti were sympathetic to political events in Paris.

They explored Paris very thoroughly, going to theatres, cabaret, the opera, seeing the sights, buying prints—Gavarni and Albrecht Dürer—and spending hours in the Luxembourg and Louvre. It is typical of the two that Hunt, who went determined to admire as little as possible, was anxious to see as much modern work as he could; while Rossetti responded more widely and particularly to the old masters. He wrote a good deal of poetry while in France and Belgium, including sonnets on pictures by Giorgione, Mantegna, Leonardo and Ingres. Ingres was of course still alive, and Rossetti's sonnet was written for the thoroughly romantic *Roger and Angelica*, a subject which he might well have taken himself.

Hunt was much impressed by Géricault's *Radeau de la Méduse*:

> a striking example of the French school after it broke with dead but powerful classicism. It represented the crew of maddened men, famished and dying, aroused to contending desperation by the sight of the passing sail. The trained draughtsmanship and the colouring of the figures defied disrespectful criticism, and it struck us as being an admirable illustration of the incident . . . It presents that kind of heroism which is perhaps too often forgotten, and the painter in recording it performed a noble service.[1]

But the work of Paul Delaroche also appealed to Hunt—probably because of his preoccupation with English historical subjects. His great decoration, the Hémicycle, at the Beaux Arts, on which at least one of Brown's old friends had worked, had just been finished, and Rossetti wrote on October 4 to William: 'Delaroche's Hémicycle in the Beaux Arts is a marvellous performance.' He went on, 'Now for the best. Hunt and I have solemnly decided that the most perfect works, taken *in toto*, that

1 W.H.Hunt *Pre-Raphaelitism and the Pre-Raphaelite Brotherhood* London, 1905–6, Vol. 1, p. 186

we have seen in our lives, are two pictures by Hippolyte Flandrin . . . in the Church of St Germain des Prés. Wonderful! Wonderful!! Wonderful!!!'

Hunt, at least when writing forty years later, was not so sure as Gabriel on the subject of Flandrin.

> Gabriel, with greater respect for dogma than myself, did not at the time recognize the real limitation of their excellence to be in the combed and brushed condition of the holy persons represented, and in the frequent expedient adopted of cutting out the handsome profile of a patently dignified saint against the flat plate of glory encircling his head. It was this characteristic that impressed me, and made me class the designs, although of high rank, as belonging to those marred by theatrical taste.

He was even less warm towards the work of Ary Scheffer:

> F. Madox Brown, on our return, still retaining his prejudice of earlier days, was quite outraged when Gabriel and I declared our verdict on Ary Scheffer. The younger man proclaimed his rebellious opinion too abruptly to convert the elder, and perhaps the suspicion that the heresy had begun with me made Brown angry.

It is also possible that the knowledge that Brown admired Ary Scheffer had not commended that painter to Hunt.

Delacroix, whose *Crusaders entering Constantinople* they saw at Versailles, did not appeal to Hunt, though Rossetti admired some of his work, while being puzzled by it. 'Delacroix (except in two pictures which show a kind of savage genius) is a perfect beast, though almost worshipped here.' Ingres too was difficult: some of his work they admired, some they hated. Both admired *La source* and his ceiling in the Louvre, but 'he has others there for which I would not give two sous—filthy slosh'. Hunt mentions their having visited 'certain paintings of the new Realistic School. Full evidence existed that the masters drilled their pupils to their own efficiency, but it seemed to us that the type of ideal art was stilted and stagey, and that the revolt against this was coarse and ugly; Naturalism was in fact a repudiation, rather than a purgation, of art.' Unfortunately Hunt gives none of the names of these new 'Realists', and Courbet, though he had already painted some significant pictures, *Le hamac*, *L'homme à la pipe* and the portrait of Baudelaire, had not quite achieved the notoriety which came eighteen months later with the *Enterrement à Ornans*, nor does Hunt or Rossetti speak of him.

Hunt liked particularly a *Virgin and Child* by Van Dyck; works by Titian, whose *Bacchus and Ariadne* had been one of his first revelations; and others by Tintoretto. Rossetti, on the other hand, gaily dismissing much of the contents of the Louvre as 'slosh', commented with delight on

> a most wonderful copy of a fresco by Fra Angelico, a tremendous Van Eyck, some mighty things by that real stunner Leonardo, some ineffably poetic Mantegnas (as different as day from night from what we have in England), several wonderful Early Christians whom nobody ever heard of, and a stunning *Francis I* by Titian. Géricault's *Medusa* is also very fine on the whole.

Hunt certainly did not have it all his own way, and though in many things the two tried to accommodate each other's point of view, these remained quite distinct. One

of the paintings which most moved Rossetti was the Giorgione *Concert Champêtre*. He wrote to William on October 8:

> There are very few good things in the Louvre besides what I mentioned in my last. There is a wonderful head by Raphael, however; another wonderful head by I know not whom; and a pastoral—at least, a kind of pastoral—by Giorgione, which is so intensely fine that I condescended to sit down before it and write a sonnet. You must have heard me rave about the engraving before, and I fancy have seen it yourself. There is a woman, naked, on one side, who is dipping a glass vessel into a well; and in the centre two men and another naked woman, who seem to have paused for a moment in playing on the musical instruments which they hold.

The sonnet was later published in *The Germ*, and the picture is to be taken as one of the pointers to Rossetti's later development. However, the themes of his pictures of the 1850s bear a more obvious relation to the fifteenth-century work which he and Hunt saw in Belgium.

Here again, as in Paris, they could see, not simply a few examples, but numbers of paintings of a kind virtually unknown in England. Roscoe had had a few Flemish 'Primitives' in his now-dispersed collection in Liverpool; the former Wallerstein Collection, at Kensington Palace, consisted of early Italian, German and Flemish work, and was unique in England. But apart from the Arnolfini portrait in the National Gallery this was Hunt's and Rossetti's first experience of Flemish Primitives except in engraved form. Their reactions once more displayed their different temperaments. Hunt found nothing by Rubens, here or in Paris, to compare with the familiar ones in the National Gallery; and though he admired the workmanship of Van Eyck and Memling, he preferred Van Dyck. Perhaps Hogarth's admiration for Van Dyck (of whose private life Hunt could hardly approve) helped to prompt this admiration. Of Memling and Van Eyck, Hunt says revealingly, '*The adoration of the spotless lamb* did not satisfy my expectations, although there was much suggestion derived from the *Apocalypse* which affected Rossetti to write of it. The same applies notably to Memling; he was led to love these paintings beyond their real claims by reason of the mystery of the subjects.' And mystery, and especially the religious mystery of Catholic art, was neither what Hunt sought for himself, nor wished Rossetti to seek.

Rossetti on the other hand was carried away by what he saw in Belgium. Writing from Bruges on October 25, in a letter addressed to the whole Brotherhood, he says that he thinks they have seen everything that is remarkable in the city

> but I assure you we shall want to see much of it again. This is a most stunning place, the best we have come to. There is a quantity of first-rate architecture, and very little or no Rubens.
>
> But by far the best of all are the miraculous works of Memling and Van Eyck. The former is here in a strength that quite stunned us—and perhaps proves himself to have been a greater man even than the latter. In fact, he was certainly so intellectually, and quite equal in mechanical power . . . I shall not attempt any description; I assure you that the perfection of character and even drawing, the astounding finish, the glory of colour, and above all the pure religious sentiment and ecstatic poetry of these works, is not to be conceived or described.

Soon after this letter was written they returned to England to resume work on their paintings for the Academy, and to take up the idea of the journal which they had discussed in July. Rossetti came to the fore in any discussion of literature. Not only was he busy with research into early Italian poets, and studying Dante closely; he was well read in English poetry, and had his own sharply defined tastes, among which the work of Keats and Browning stood highest. When, in the first day or two of sharing the Cleveland Street studio with Hunt, they pasted up on the wall their list of Immortals, it consisted largely of poets admired by Gabriel. But an interest in literature was not confined to Rossetti. Woolner, already a devotee of Shelley's poems and personality, was captivated by Rossetti's recital of Coventry Patmore's 'Woodman's Daughter'. Indeed, unable to find the book, he wrote on Rossetti's advice to the poet—and so Patmore became, for a number of years, the very close acquaintance if not close friend, of the group. The same poem captivated Millais too, and provided him with themes for a number of possible pictures—one of which was presently to be painted in woods near Oxford. Deverell was not only a fine painter, but an accomplished actor and he too wrote poetry; all the Rossetti family wrote, and Ford Madox Brown, who could give a very lucid account of his own paintings and shrewd criticism of others', also wrote poetry on occasion. It had been Bell Scott's poem 'The Year of the World' that had provoked Rossetti to write to him at the end of 1847 and so made him, though at the other end of the country, a member of the circle. Stephens was already moving towards criticism, for which he abandoned painting before well launched. The Tupper brothers, Hannay, William North, all wrote. Even sleepy Collinson was persuaded to try.

By the beginning of August 1848 Rossetti had already promoted a Literary Society, rather ill-defined. When it came to the founding of the Brotherhood, Millais' very practical professional views had strictly limited Rossetti's exuberance, but no such professional caution could limit this. 'I should like gradually to include all the nice chaps we know who do anything in the literary line,' Gabriel said. He was disappointed that Christina would not even let her poems be read at their meetings, and was much too shy to join them. The project was renewed in a more significant form in July 1849 with the proposal to start a magazine.

William Rossetti's first record of this scheme was on the same July day as Hunt was turned out of his studio, and stands thus:

In the evening Gabriel and I went to Woolner's with a view of seeing North (whom however we did not find at home) about a project for a monthly sixpenny magazine, for which four or five of us would write, and one make an etching—each subscribing a guinea, and thus becoming a proprietor. The full discussion of the subject is fixed for tomorrow at Woolner's.

It was first intended to call the magazine, solemnly, *Monthly Thoughts in Literature, Poetry, and Art*; and 'it was immediately projected', says William, 'to increase the magazine to forty pages, two etchings, and a price of one shilling'. By September, negotiations had begun with possible printers and publishers. Gabriel's letters to William show very clearly how practical a dreamer he was. One of the circle, John Tupper, had two brothers who were printers. They undertook to print, and Aylott

and Jones of Paternoster Row to publish; William was firmly told that he was editor, and the first issue was to appear in the New Year. The title chosen was *The Germ: thoughts towards nature in poetry, literature, and art.* It was at first to carry the words 'conducted by artists'—a phrase which looks forward to the Firm of 1861, but because of William's conscientious scruple, this was dropped. A printed prospectus was circulated, and helped to bring in poems from Bell Scott and Patmore, though the latter would not have his name printed to his poem.

The first number did indeed appear in the New Year, with an excellent etching by Hunt as frontispiece; Woolner's poems, 'My Beautiful Lady' and 'Of my Lady in Death'; a sonnet by Madox Brown; an essay by Tupper on 'The Subject in Art'; Patmore's 'The Seasons'; Christina's 'Dream Land'; Gabriel's 'My Sister's Sleep', and his prose story, 'Hand and Soul', the latter half of which was written when copy for the first pages of the magazine was already set. The other etchings, by Hunt, Ford Madox Brown, Deverell, Collinson, are good examples of their work. Millais made four or five designs, one of which was etched, but before they were ready for printing, *The Germ* had ceased publication.

The title page bore a sonnet by William Rossetti, and at the back a short programme was set out. 'The endeavour held in view throughout the writings on Art will be to encourage and enforce an entire adherence to the simplicity of Nature; and also to direct attention, as an auxiliary medium, to the comparatively few works which Art has yet produced in this spirit.' The journal was thus clearly conceived not simply as an outlet for the literary works of the members of the Pre-Raphaelite Brotherhood and their friends, but as a publicity organ, a vehicle for the exposition of the work of Pre-Raphaelite painters and criticisms of other work from the Pre-Raphaelite standpoint. At one stage *The PRB Journal* was suggested as a title, but, as William Rossetti pointed out to the rest, more than the seven members of the Brotherhood would be needed to provide a sufficient flow of material, and the idea was discarded.

Sales of *The Germ* were small, even of the first issue, and they dwindled fast. By the time the fourth issue appeared, the Academy's Summer Exhibition of 1850 was open, and some of the contributors paraded with billboards in front of the building in Trafalgar Square. The fourth issue was the last, and *The Germ* disappeared, leaving a debt of more than thirty pounds to be met by 'the proprietors'. But if it seemed to be lost on the general public, there is no reason to think that it failed in its purpose; it went largely into the hands of people most likely to be affected by and respond to it. It was seeing a copy of the magazine brought into the painting School of the Royal Academy, hearing it strenuously discussed, that excited Arthur Hughes and made him a truly Pre-Raphaelite painter and a friend of the circle: and five years later it was rediscovered by Burne-Jones, Morris and their friends at Oxford who were no less excited by it.

7 The Brotherhood under attack

The Brotherhood had not neglected their entries for the Academy Exhibition of 1850. Millais had three pictures hung: *Christ in the house of his parents* (pl. 41), *Ferdinand and Ariel*, and the *Portrait of Mr Drury and his grandchild*. Hunt's *A converted British family sheltering a Christian priest from the persecution of the Druids* and Collinson's exquisitely painted *Answering the emigrant's letter* were also exhibited, while in the Free Exhibition Rossetti showed his *Ecce Ancilla Domini*, the second of a projected, but never completed, series of three paintings on the life of the Virgin. The disclosure of the meaning of the initials, well publicized by Angus Reach of the *Illustrated London News*, together with the impact of *The Germ*, meant that the Brotherhood was anything but a secret association, but no one could have suspected the storm which broke over the heads of its members in May and June.

It is well described by William Rossetti, who was keeping the journal of the Brotherhood at this time:

> Millais' picture[1] has been the signal for a perfect crusade against the PRB ... The *Athenaeum* opened with a savage assault on Gabriel [looking back after fifty years, William thought it had hardly been savage] who answered in a letter which the editor did not think it expedient to publish; and a conversation which Millais had with Frank Stone, and in which the latter, speaking of the picture, introduced several of the observations of the *Athenaeum* coupled with some other circumstances, make it tolerably evident that he was the author of that and subsequent critiques ... In all the papers—*The Times*, the *Examiner*, the *Daily News*, even to Dickens' *Household Words*, where a leader was devoted to the PRB and devoted them to the infernal gods—the attack has been most virulent and audacious; in none more than in *A glance at the exhibition* published by Cundall, and bearing manifold traces of a German source [William believed it was Dr Waagen]. Indeed the PRB has unquestionably been one of the topics of the season. The 'notoriety' of Millais' picture may be evidenced by the fact, received from undoubted authority, of the Queen's having sent to have it brought to her from the walls of the RA, which her recent accouchement had prevented her from visiting.[2]

Let us examine the criticisms in more detail. Rossetti's work was again seen and noticed a week ahead of the others, and the *Athenaeum* reviewed it at length:

> But what shall we say of a work hanging by the side of Mr Newenham's historical picture —which we notice less for its merits than as an example of the perversion of talent which has recently been making so much way in our school of art, and wasting the energies of some of our most promising aspirants? We allude to the *Ecce Ancilla Domini* of Mr D.G.Rossetti. Here a certain amount of talent is distorted from its legitimate

1 *Christ in the house of his parents*
2 W.M.Rossetti *Praeraphaelite Diaries and Letters* London, 1900, p. 273

course by a prominent crotchet. Ignoring all that has made the art great in the works of the greatest masters, the school to which Mr Rossetti belongs would begin the work anew, and accompany the faltering steps of its earliest explorers. This is archaeology turned from its legitimate uses, and made into a mere pedant. Setting at nought all the advanced principles of light and shade, colour, and composition, these men, professing to look only to Nature in its truth and simplicity, are the slavish imitators of artistic inefficiency.

It is plain that this was a counter attack on the group, not a critique of particular paintings; and when the RA Exhibition opened, it was carried further.

We have already in the course of our Exhibition notices of this year come into contact with the doings of a school of artists whose younger members unconsciously write its condemnation in the very title which they adopt (that of Pre-Raphaelite), and we would not have troubled ourselves or our readers with any further remark on the subject were it not that eccentricities of any kind have a sort of seduction for minds that are intellectual without belonging to the better orders of intellect . . . The idea of an association of artists whose objects are the following out of their art in a spirit of improved purity, making sentiment and expression the great ends, and subordinating to these all technical consideration, is not new. The difference between the proceedings of a band of German painters who in the early part of the present century commenced such an undertaking in Rome, and those of the English Pre-Raphaelites, is nevertheless striking . . . This school of English youths has, it may be granted, ambition, but not of that well-regulated order which, measuring the object to be attained by the resources possessed, qualifies itself for achievement. Their ambition is an unhealthy thirst which seeks notoriety by means of mere conceit. Abruptness, singularity, uncouthness, are the counters by which they play for game. Their trick is to defy the principles of beauty and the recognised axioms of taste . . . In point of religious sentiment Rossetti stands the chief of this little band. Mr Hunt stands next in his picture of *A Converted British Family* (No 553). There is a sense of novelty in its arrangement and of expression in its parts, and a certain enthusiasm, though wrongly directed, in its conduct. Mr Millais, in his picture without a name (518) which represents a Holy Family in the interior of the carpenter's shop, has been most successful in giving the least dignified features of his presentment, and in giving to the higher forms characters and meanings, a circumstantial Art Language from which we recoil with loathing and disgust. There are many to whom his work will seem a pictorial blasphemy. Great imitative talents have here been perverted to the use of an eccentricity both lamentable and revolting. *Ferdinand lured by Ariel* (504) by the same hand, though better in the painting, is yet more senseless in the conception, a scene built on the contrivances of the stage manager, but with very bad success. Another instance of perversion is to be regretted in *Berengaria's Alarm for the Safety of her Husband* (535) by Mr Charles Collins.

The attack was pointedly directed at two things; the German-antiquarian style, with its suspect Roman Catholic overtones (how painful for Hunt), and the existence of an identifiable group of young men who had consciously set themselves against what would now be called the 'Establishment'. Nothing could be allowed to challenge the role of the Academy and those critics and dealers who directed public taste. It was not much more than a decade since a committee of Parliament had inquired into the Academy's affairs; it had a long history of intrigue, and was the subject of continuing suspicion and jealousy in the profession. The youth of the Pre-

Raphaelite Brotherhood, and the knowledge that its members were all Academy students, intensified the bitterness of the critics. Nor was the attack left solely in the hands of professionals. Stone, in the *Athenaeum*, made valid points in his articles. When he said that 'Abruptness, singularity, uncouthness, are the counters by which they play for game. Their trick is to defy the principles of beauty and the recognised axioms of taste', he was stating, if crudely, the literal truth. But when Dickens, in his paper *Household Words*, added the weight of his reputation to the attack (the Pre-Raphaelites believed at the instance of Solomon Hart), he relied on mere vulgar abuse. It was not an accident that he should choose Millais' *Christ in the house of his parents* (pl. 41) for his main target. A philistine in the realm of painting, he was an experienced journalist. This picture was the one in respect of which crude prejudice could be most easily converted into righteous indignation in the minds of readers of quite different views, and express itself in public derision. The often quoted passage contrives at once to appeal to religious sentiment and prejudice, outraged taste, social snobbery and moral rigour.

> In the foreground of that carpenter's shop is a hideous, wry-necked, blubbering red-haired boy in a night gown who appears to have received a poke in the hand from the stick of another boy with whom he has been playing in the gutter, and to be holding it up for the contemplation of a woman so horrible in her ugliness that (supposing it were possible for any human creature to exist for a moment with that dislocated throat) she would stand out from the rest of the company as a monster in the vilest cabaret in France or the lowest gin-shop in England.

Dickens' abuse was the lowest level of the attack; but apart from the *Critic*, in which F.G.Stephens had succeeded William Rossetti, and William Rossetti's own articles in the *Spectator*, of which he had become art critic, the general reception given to the Pre-Raphaelite Brotherhood came somewhere between the measured attack of Stone and the mud-slinging of Dickens. The PRB became a byword for the season. Rossetti, though he had come off better than others, vowed never again to exhibit paintings in public. His picture remained unsold, even though he brought his price down to forty guineas. Millais, on whom the weight of the attacks fell (after all, he had been the star student of the Academy) was, luckily for him, already beforehand with the market. He had begun to establish his own connections with dealers such as Farrer and Wyatt, even with cautious White of Maddox Street, and had sold the as yet unnamed *Christ in the house of his parents* to Farrer the day before sending it in; *Ferdinand and Ariel* had been sold some weeks earlier, and his third, the *Mr Drury and his grandchild*, was in any case a commission, while as a portrait it escaped the abuse which was aimed at the big subject pictures. But Hunt suffered considerably. He had no resources but what he earned; he worked far more slowly than Millais, and he had not yet begun to build his own circle of patrons. His Druid picture remained unsold; he was beginning to run into debt, and had not Millais generously lent him money, he could not have afforded to begin a new painting for the next year.

The situation marked the lowest ebb of their fortune, but it was not wholly black. Some of the senior Academicians admired their work and were prepared to give

their sympathy practical effect. Dyce admired Millais' *Christ in the house of his parents*, and made Ruskin go back to look at it again. He also offered material comfort to Hunt, commissioning him to make a copy of his own *Jacob and Rachel* for fifteen pounds. Augustus Egg helped again. Disappointed of what he had believed to be a firm commission for fifty pounds by another RA, Hunt showed him the rejected designs of what were to be two of his most famous paintings: *Claudio and Isabella*, from *Measure for Measure*, and *The Lady of Shalott*. Egg admired the sketches; commissioned Hunt to begin the first, and gave him an advance. Off Hunt went, anxiety at least relieved, to Lambeth Palace, to paint the prison cell.

Millais, whose parents were shocked and outraged that their Johnnie should be so ill-treated, was not to be put down by any journalistic hack or any clique of old guard painters. He was furious, of course, and with reason; but he had money in his pocket, and all the confidence of success. He knew that he could outpaint the lot of them, and he would. He went off to Abingdon with Charlie Collins to work on the background of *The woodman's daughter*, or on the setting for *Mariana in the moated grange* at Oxford, where they often stayed with his friends the Combes. He made other friends in University circles there, and without much difficulty got the Combes to buy both Collins' new painting, *Convent thoughts*, and Hunt's Druid picture. He began work on a third painting. At the top of his form, full of energy, though he was not going to court more abuse by another painting so Early Christian as the *Christ in the house of his parents*, he had an idea for a religious picture no less original, if less aggressive in its originality, *The return of the dove to the ark*.

Dyce had come up with more help for Hunt. Thirty years before, he had cleaned and restored the wall-paintings by Rigaud at Trinity House; now they needed attention again, and he saw to it that Hunt got the job. With the loan from Millais, the advance from Egg and the thirty pounds from the Trinity House work, Hunt could get on with his new picture—and find time for mad midnight excursions up the river with Rossetti, Hannay, John Tupper, Blanchard Jerrold and Bell Scott whom he now first met. When Mr Combe bought the *Druids* for £160, the worst was over. Hunt and Rossetti went off to Sevenoaks, there to paint the landscape backgrounds of their next Academy pictures: Hunt's was again a Shakespearean theme, *Valentine rescuing Sylvia from Proteus* (pl. 24), and Rossetti's a subject from Dante. Hunt stayed until late in October; Gabriel had good enough reason to return to London sooner—but not to finish the Dante subject. It was never finished; long after, cut down and touched up, it became the background of *The bower meadow* (pl. 50). Back in London, he worked on a different painting, a theme from Browning's 'Pippa Passes' entitled '*Hist!*' *said Kate the Queen*. It was to contain a great many figures, but it, too, was never finished. Finally it was cut up and only one or two fragments survive.

In the Academy Exhibition, in May, Deverell had shown a painting, *The Duke with Viola listening to the court minstrels*, in which he himself appeared as the Duke, Rossetti (with whom he was sharing a studio in Red Lion Square) as the Jester, and a new model, a tall, pale, red-haired girl, as Viola. Her name was Elizabeth Siddal, and she had been discovered by Deverell in a milliner's shop off Leicester Square. His mother had negotiated with her for sittings. Hunt, Rossetti, all the Brotherhood

thought her beautiful. Rossetti began to paint from her too, and when Hunt came back from Sevenoaks, she was his model for Sylvia. The Pre-Raphaelite Brotherhood had set out to break the old moulds of beauty. With Lizzy Siddal they began already to make a new set of moulds of their own.

Hunt's and Millais' pictures went to the Academy in 1851, and, as before, they were hung, if not quite where the artists would best have liked them. *Valentine rescuing Sylvia from Proteus* had apparently been finished in a great hurry, Hunt being seduced into too gay a life by the flash friend of a friend whom he refers to as Warwick. The attacks were resumed, in part because, to the alarm of Frank Stone and his friends, not only were the upstart PRB persisting in their course, but they were gaining followers. Other painters, in spite of the abusive warnings of last year, were following the example of their bright and luminous colour, their crisp observation and Mulready, Maclise, Dyce, Egg, Linnell and Anthony all praised them. If Dickens had lent himself to the attack, Meredith and Thackeray both wrote admiringly to Millais, Meredith calling to leave a copy of his newly published book as homage. Farrer bought *Mariana in the moated grange* for £150 and Combe *The return of the dove to the ark.*

A letter from Ruskin himself appeared a few days later in *The Times* of May 13. Coventry Patmore, urged by Millais—or perhaps by Woolner who had first made his acquaintance—had gone to see Ruskin and persuaded him to reply to the adverse criticisms. If Ruskin still had any idea—as at first he had—that these young men, with their Nazarene leanings, were Puseyite or Roman Catholic, Patmore energetically disabused him of it. Although some years later he became a Roman Catholic, Patmore was at this time as vehemently anti-papist as Ruskin himself and knew Hunt, the Rossettis and Woolner—especially the latter—to be sceptical. Millais, a respectable if 'high' Anglican, could point to the fact that Collinson resigned from the Brotherhood, precisely because he *was* a Catholic. Patmore's appeal, coupled no doubt with the obvious fact that Pre-Raphaelite practice so beautifully exemplified his own doctrines of art, made Ruskin a powerful ally. In two letters to *The Times*, and a subsequent pamphlet which appeared in August, Ruskin made a counter-attack on behalf of the PRB so strong as to put an effective end to the press campaign against them.

Ruskin's replies focused attention particularly on Hunt and Millais, but at this stage Rossetti had no notice whatever from him. Rossetti had, after all, avoided the Royal Academy, the main battleground; his paintings—and perhaps his name—were more easily suspected of Romanism, and in 1851 he was exhibiting nothing at all. His dealings with Ruskin had to wait for three more years to pass, by which time 'the whole Round Table was dissolved'.

Hunt and Millais, after the two letters to *The Times*, wrote jointly to Ruskin to thank him. Ruskin's response was immediate. The next day his carriage drove up to 83 Gower Street, and he and Effie swept Millais off to Camberwell. 'My dear Mrs Combe,' Millais wrote to his Oxford friend on July 2, 'I have dined and taken breakfast with Ruskin, and we are such good friends that he wishes me to accompany him to Switzerland this summer . . .' The Ruskins kept Millais at Camberwell for a whole week, and the two men got on famously, though Turner remained an un-

resolved point of difference in taste. But Millais was not to be persuaded to abandon his painting for any trip to Switzerland, even at the behest of so engaging and influential a friend and patron as this. He and Hunt had already arranged to go into the country to paint the backgrounds for their new pictures, and at Surbiton, through that summer and autumn, they worked in the open on two beautiful landscapes—Millais painting at nearby Cuddington the lush background for *Ophelia* (pl. 42), Hunt the shady willows and cornfields of *The hireling shepherd* (pl. 34). In the evenings they talked and wrote letters and designed new pictures or entertained friends when they came out from London to see them. Millais had an idea that a painting of two lovers, vaguely based on a line from Tennyson—'Two lovers whispering by a garden wall'—might turn out well. Hunt thought this sentimental, lacking in real purpose; his arguments soon had the subject of Millais' second picture settled. In *The Huguenot* the historic occasion of the Massacre of St Bartholomew combined with the tension supposed between Catholic girl and Protestant man quite met Hunt's objections, and the recent performance of the opera *Les Huguenots* in London made it certain that the painting would, when finished, have the widest possible appeal. In the event policemen had to be put in front of the painting in the Royal Academy when it was exhibited, to keep back the admiring crowds.

Hunt himself had already settled on a second theme in a text from the Book of Revelations—'Behold, I stand at the door and knock.' In it, standing outside a closed door, all overgrown with ivy, its hinges rusted from being long closed, the crowned figure of Christ, lit from below by the lantern in his hand, would stand, as he knocked and waited. A second setting had to be found for this new picture, and Hunt's evenings began to be occupied as well as his days, since it was essential to his idea that it should be a night-piece. This had, of course, symbolic meaning, but part of its attraction to him was that, having mastered the problems of painting in the sunlight, he could set himself a more difficult one—how to paint equally faithfully by night, and combine natural with artificial light. Moral and religious meanings apart, he had set himself one of the classic painter's problems of his beloved seventeenth century. He was a rebel with his roots deep in history.

8 The development of Holman Hunt

Hunt was concerned as a young man to make a reputation, and his zeal for reform in painting was inseparable from this; but he took himself and the whole development of English painting much more seriously than the average ambitious youngster. All his decisions as to theme, location, treatment were taken very deliberately, after much argument internal and external, and this often led to a harshness of treatment which may be somewhat repulsive, because deliberate and self-conscious. But simple spontaneity could never have won the battle which these young men won under his leadership, and he consistently threw away immediate advantage in order to win a long-term objective. His rejection of Overbeckian painting is an example of this; his insistence on the laborious and exacting practice of open-air painting, when he might much more easily have produced three or four studio paintings with no more effort, is another.

Radical as Hunt's attack on tradition was, he, Millais and Woolner are to be regarded as rebels within the system, aiming at its reform, rather than revolutionaries aiming at its overthrow. Hunt does not belittle or ignore the teaching he got at the Royal Academy Schools. His attack was against the entrenched position of the elders and the way in which their work emptied the tradition of meaning, not against the system of teaching through which he went diligently and which had cost him very dear to enter. The same would be true of Millais, who certainly had no occasion to complain of the Schools, whose mechanical routines had suited him and had, naturally, been less hampering to him as a child prodigy than they would have been had he entered at a more normal age, and with creative pressures already building up as part of adolescence. Woolner, too, was rebel only, not revolutionary: his career, after his return from Australia, was one of steady success.

In his insistence on 'going back to nature', Hunt made no pretence that the artist can by this begin absolutely anew. On the contrary, even at his most aggressive, he was quite consciously a traditionalist, fighting for the recovery and revitalization of a tradition he regarded as having been debased by those who claimed to uphold it. He was fully committed to the objectives which had guided European art ever since the earliest days of the Renaissance, not to the aims of pre-Renaissance art. Nor, though he insisted on the technique of exact naturalism, would he be content with the term 'naturalism' to describe what he and his colleagues did.

Every art adventurer, however immature he may be in art lore, or whatever his tortuousness of theory, declares that Nature is the inspirer of his principles. All who call themselves *self-taught* are either barbarians, or else are ignoring indirect teaching. Life is not long enough in art for any one who starts from the beginning, to arrive beyond the wide outposts. Wise students accept the mastership of the great of earlier ages. True judgment directed us to choose an educational outflow from a channel where the stream

had no trace of the pollution of egoism, and was innocent of pandering to corrupt thoughts and passions. We drew from this fountain source, and strove to add strength to its further meanderings by the inflow of new streams from nature and scientific knowledge [1]

Hunt may well have had Courbet in mind, who with his immediate followers had, in the 1840s and early fifties, also conducted an assault on academic sterility based on the appeal to nature.

Hunt's first important painting shown in the Academy, *The eve of St Agnes* (1848), was in many ways a straightforward essay in a manner quite like Mulready's, except for his deliberate exploitation of certain colours—blues, greens and purples— which were not in common use. The *Rienzi* (1849), though the new open-air technique was used, was also in many ways still close to the accepted conventions as regards pictorial structure and choice of theme. But the *Druids* (1850) is both in theme and spirit different, and its visual structure declares that difference instantly.

In *The Eve of St Agnes*, the space in which the main action—the flight of the lovers —occurs, gives us a foreground deeper at the left than the right, where there is an exit towards which the two move; a secondary space is seen through the rear wall, which contains the banquet. Thus we see the flight of Madeline and Porphyro, united in one frame but already separated from the revellers, while the page, the sleeping bloodhound and drunken man create around them the tension of the immediate moment. None of the academic prescriptions as to the 's' plan of the grouping and the proportions of light and shade are followed, but the attitudes of the figures are within the conventions of good dramatic painting and would create no difficulty for the average spectator. The picture was well received, and bought by Mr Bridger whose taste, as a later anecdote of Hunt's shows, was not only conventional but very conservative. The *Rienzi* was more novel: it was painted in the open air and its figures were realistic. But there is little in their attitudes, or even in the structure of the main group, to cause an outcry.

The *Druids* is conceived on somewhat different lines, and draws no advantage from a recognized literary theme; it is a visual invention without a precedent text, which calls upon the viewer to work a great deal harder. It is also complicated by its double use of space; for although set in the open air, the main group, with far more figures than Hunt had ever tackled before, is contained within the three-sided hut or shed in which the missionary is sheltering; timber and thatch as this is, its strong verticals and horizontals give it a truly architectural value, reinforced by the glimpse under its eaves of the temple and the menhirs which stand around it. We feel ourselves included in this space, which contains one half of the action; beyond it, we see, in the narrow strip down the right-hand side of the canvas, and the long horizontal strip under the eaves of the shed, the open space in which the other element of the drama is contained. The composition not only enabled Hunt to exploit his new ideas and techniques in terms of the visual account, but gave a very powerful dramatic setting, utterly different from the threadbare theatrical conventions inherited from the eighteenth century.

1 W.H.Hunt *Pre-Raphaelitism and the Pre-Raphaelite Brotherhood* London, 1905–6, p. 137

Like *The girlhood of Mary Virgin*, this painting has a structure based on rectangles parallel to the picture plane and it is largely the contrast between the stability given by this device and the angular movements of the figures, which creates tension. The shed in which the group of Christians hides contains them in a sort of bower, just as in Rossetti's picture the vine-trellis across the back encloses Mary and Anna while allowing us to look beyond into a secondary space. In the *Girlhood*, that secondary space is merely a relief or foil; in the *Druids* it is essential to the action. The plank wall of the shed does not come up to the eaves, and through the open strip below the edge of the roof, we see the Druid exhorting the naked Britons as they run down the temple steps and spread out into the fields to seek the Christians, while the war-arrow is shot over their heads by a man who kneels just below the Druid. Beyond them menhirs mark the avenue that leads towards the temple from the wood that closes off the distance; at the far right, one of the searchers looks round suspiciously at the hut, whose door is just being closed. All this is beautifully painted, and in rendering the shed, the pebbled stream which flows across the immediate foreground at our feet and the field beyond where the search and pursuit begin, Hunt's eye begins to rival Millais'. The distant figures are small, and done from drawings; but the nine figures which occupy the hut were all painted from models posed in the studio, in carefully controlled light. They are very firmly drawn and painted. The little boy with ear to the ground at the right, for instance, is well-defined, well-modelled, showing no trace of deliberate primitivism but scrupulously observed painting from life. It is to be remembered that Hunt had been commissioned by Dyce not long before, to copy his *Jacob and Rachel*. It is also to be recognized that Hunt, having been expelled from his Cleveland Street studio, took refuge in Brown's. Between the early designs for this painting, and its finished appearance, there are considerable changes and improvements all of which would be consistent with Brown's influence. The preliminary drawings have all the angularity and awkwardness which Millais cultivated at the time, but Millais was away painting near Oxford when Hunt had to move out of his own studio and accept Brown's hospitality. The effect of chill in the colouring of the taut skin of thigh and knee of the boy, the diligent searching out of bone and muscle, which Dyce would have subdued within a simpler general effect, bespeak Hunt's now very considerable skill in his pursuit of natural appearance. The combination of this thoroughgoing drawing and the rectangular structure of the shed with its fringing thatch and leaves, suggest that Hunt had been more influenced by Brown than he cared to admit, and, since he and Brown were following a common path, probably more than was apparent to him at the time. The device of the open landscape seen beyond the main action, and yet important to it, which is not really present in the drawings but very finely worked out in the finished picture, may also owe something to Brown, who at the time was working on his big *Chaucer*, and, a fortnight before Hunt moved in, had been to Shorne in Kent to paint the landscape background for it.

None of this makes Hunt's picture any less original. He succeeded in finding a religious theme which allowed him to treat Christianity in a historical, not a devotional or dogmatic way; as part of the national history, and with emphasis on moral commitment, devotion, on the modest domestic heroism of the priest and his

little flock. It was a subject in which all mediaevalism, all obvious antiquarianism, all such revivalist historicism as he deplored in Collinson's *Renunciation of Queen Elizabeth* (pl. 74), could be at least minimized if not absolutely avoided. The mediaevalism of *The eve of St Agnes* and *Rienzi*, he would have argued, was legitimate, because both subjects were taken from works set in the past; but in the *Druids*, by assuming the Britons to be 'naked savages' and clothing the men in loincloths, the women in indeterminate long gowns and by putting the priest legitimately in Roman robes, he could avoid the obvious antiquarianism that beset a more fashionable historical theme. He made, as it happens, just the sort of mistake here for which he was to be attacked in the case of the *Valentine rescuing Sylvia from Proteus* (1851); for while one Briton wears thrust through his belt a dagger obviously based on a late Bronze-age piece in the British Museum, another carries an unmistakably oriental dagger. Hunt did not particularly avoid mediaeval or historical themes; but he was determined to treat them in a modern manner, to paint them as if they were in fact subjects of contemporary reality. *Rienzi* was a mediaeval theme; Hunt describes how he went to the Tower of London to study arms and armour and how he had to spend time in research into architecture and costume. Nevertheless, he says of this picture, 'Like most young men, I was stirred by the spirit of freedom of the passing revolutionary time. The appeal to heaven against the tyranny exercised over the poor and helpless seemed well fitted for pictorial treatment. "How long, Oh Lord!" many bleeding souls were crying at that time.' Since topical events played this part in his choosing the Rienzi theme, mediaevalism of *manner*, which was the thing he so abhorred, would have been decidedly out of place.

In *Valentine rescuing Sylvia from Proteus* (pl. 24), the quality of Hunt's painting changes. It is curiously dry and thin, often remarkably broken in application, so that the white ground not only induces luminosity in the colour, but is directly seen between touches of colour. To some extent, this may due to haste in finishing the work; but its rawness has its origin in something more fundamental than a summer spent in too much boating and pistol shooting, and it is interesting as showing more of his method than it might have done had it been finished in a more leisurely way.

The paint structure does not attempt to produce equivalents for form, or to make use of tone values as Brown might have done. Essentially the picture is built up by a careful drawing, with local colour applied in a mosaic of small individual touches, without any sensuous quality (painterliness was one of the continental vices which Hunt particularly abhorred). The clothes of the two women illustrate this technique clearly. In Julia's skirt, for instance, blue, pink and crimson mingle in thin, dry, troubled patches which become quite expressionistic in their accumulation. The texture and substance of the fabric is only to be seen as a result of the optical unification of this mosaic. Had Hunt been a less able draughtsman, less rigorous in his observation, this technique would have failed him; only when such a mosaic of local colour is accurately mapped on a scaffolding of no less accurate drawing can it provoke visual responses corresponding to those set up by actuality, and so bear the painter's larger meaning. Ruskin, although he admired this technique for the rendering of objects, found it very disturbing when applied to faces. There are other paintings which make it clear that Hunt's technique is very deliberate: he had in

11 Ford Madox Brown *Cordelia's portion* 1844
Sepia line drawing on tracing paper, 8½ in. × 10⅞ in.
Basis of the painting of 1875 now in Southampton
Whitworth Art Gallery, University of Manchester

12 Ford Madox Brown *The body of Harold brought before William the Conqueror* 1843
Monochrome cartoon, 15 ft × 13 ft
South London Art Gallery

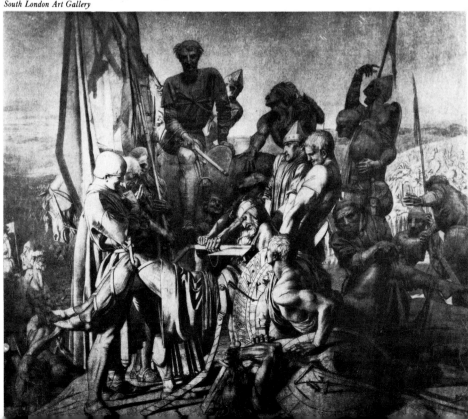

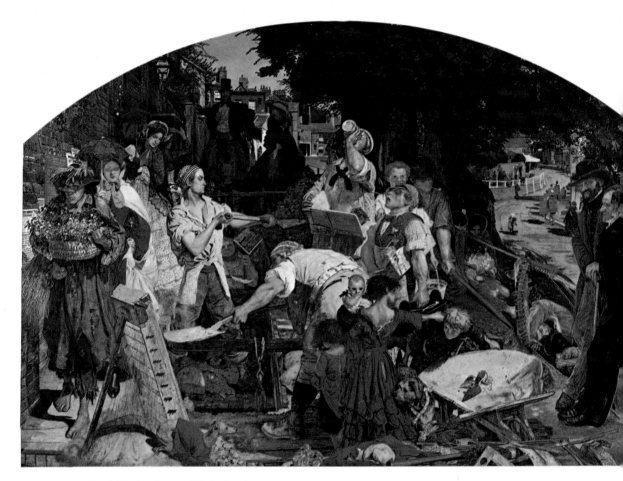

13 Ford Madox Brown *Work* 1852-65
Oil on canvas, $54\frac{1}{2}$ in. × $77\frac{1}{8}$ in.
City Art Gallery, Manchester

14 Detail from *Work* (plate 13)

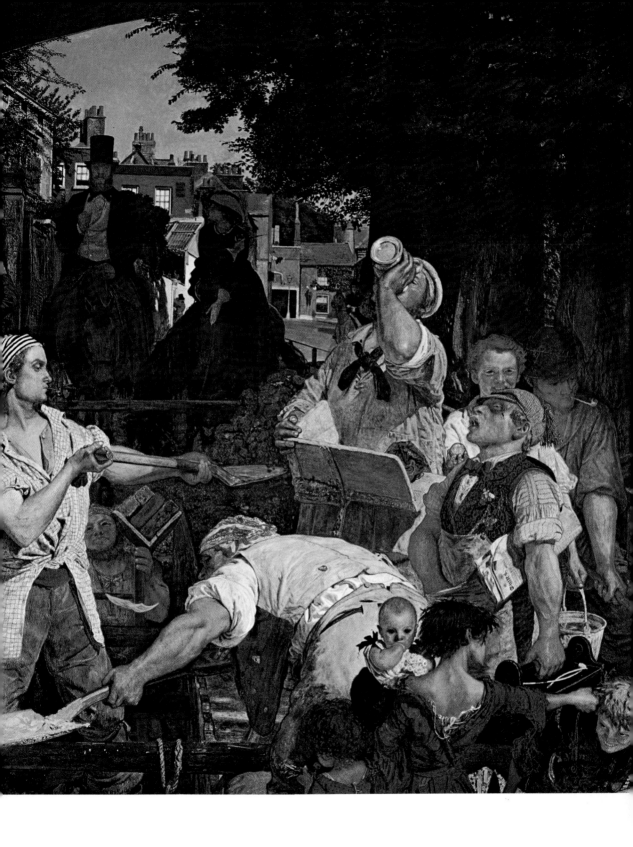

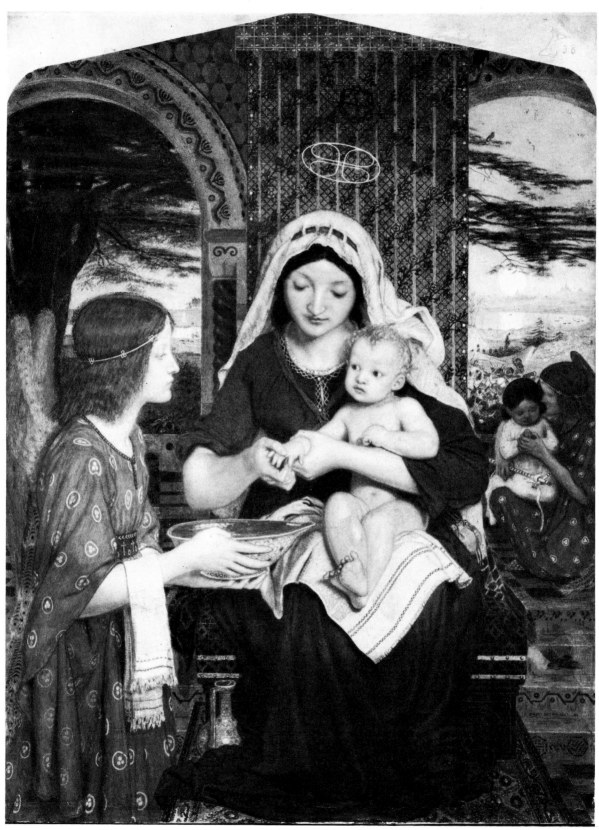

15 Ford Madox Brown *Our Lady of good children* 1846-7, retouched 1861
Watercolour and pastel, $30\frac{3}{4}$ in. \times $23\frac{1}{4}$ in.
Tate Gallery, London

16 Ford Madox Brown *Seeds and fruits of English poetry c.*1846
Pencil, 13⅛ in. × 20 in.
Early design for *Chaucer at the court of Edward III*
Cecil Higgins Art Gallery, Bedford

17 Ford Madox Brown *Crabtree observing the transit of Venus, 1636* 1881-3
Oil, 10½ in. × 22 in.
City Art Gallery, Manchester

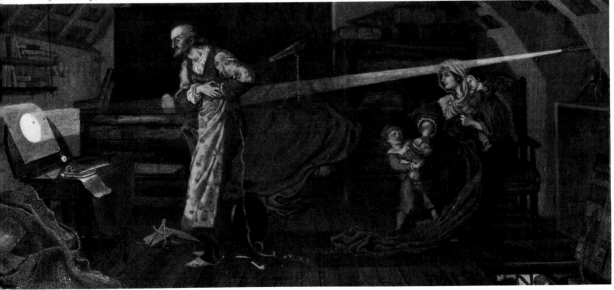

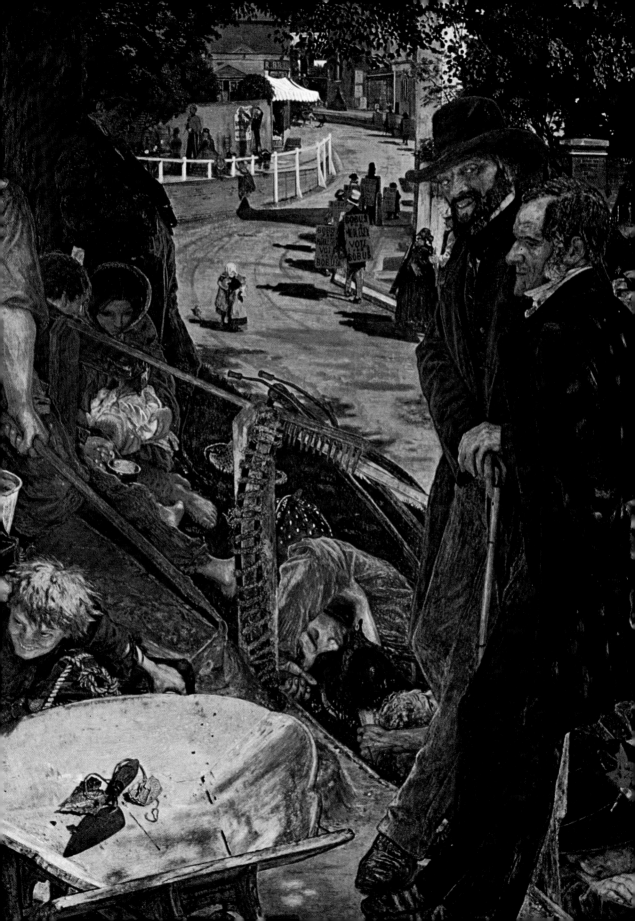

18 Detail from *Work* (plate 13)
Leaning on the railings are Carlyle and
Frederick Dennison Maurice; Brown was closely
associated with the latter in the work of the
Workingmen's College, recently founded in Great
Ormond Street

19 Ford Madox Brown *James Leathart* 1864
Oil on canvas, 13½ in. × 11 in.
Painted as a companion to Rossetti's portrait
of Mrs Leathart
In the collection of the Leathart family

20 Ford Madox Brown *Wycliffe reading his transla-
tion of the Bible to John of Gaunt* 1848
Oil on canvas, 47 in. × 60½ in.
Painted on a white ground to keep a high key,
its background is a view of the Adur valley
looking SW from Sompting church
City Art Gallery, Bradford

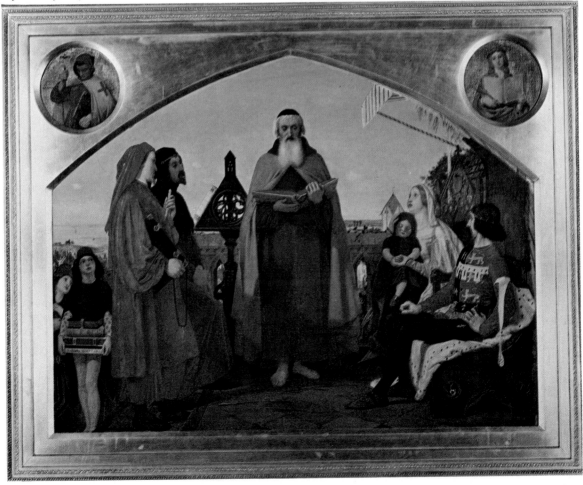

21 Ford Madox Brown *The coat of many colours* 1864-6
Oil on canvas, 42½ in. × 40⅝ in.
Development from Brown's illustration for the Dalziel Bible Gallery.
The landscape is taken from a watercolour by Thomas Seddon painted in Palestine
Walker Art Gallery, Liverpool

22 Ford Madox Brown *The Entombment*
1867
Wood-engraving
An illustration for *Lyra Germanica*
1867, published by Longmans

23 Ford Madox Brown *Downstream* 1871
Wood-engraving
One of two illustrations for Rossetti's
poem of the same name

24 William Holman Hunt *Valentine rescuing Sylvia from Proteus* 1851
Oil on canvas, 38¾ in. × ·52½ in., arched top
Background painted at Knole, the figures in the studio using Elizabeth Siddal as model for Sylvia
City Museum and Art Gallery, Birmingham

25 Ford Madox Brown
The miraculous draught of fishes
Stained glass
Installed at Llandaff by Morris, Marshall, Faulkner & Co. in 1874, but designed much earlier
Llandaff Cathedral, Glamorgan

26 William Holman Hunt *The triumph of the Innocents* 1876-87
Oil on linen 62 in. × 97½ in.
The smaller of the two, painted in Jerusalem
Walker Art Gallery, Liverpool

27 Furniture designed by Madox Brown and made by Morris, Marshall, Faulkner & Co. in the early 1860s

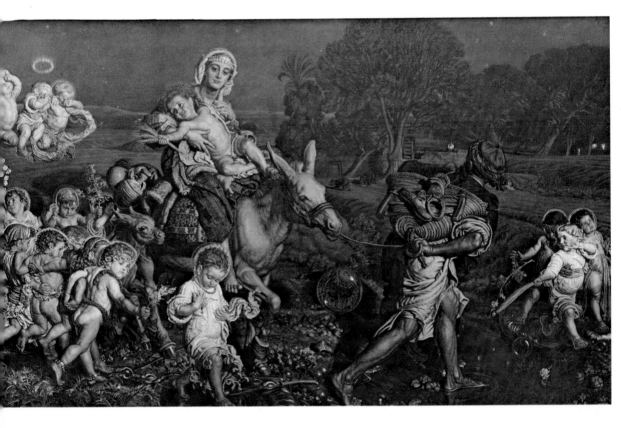

Two loving women, lingering yet
Ere the fire is out, are met,
Talking sweetly, time-beguil'd,
One of her bridegroom, one her child
The bridegroom he, They have received
Happy letters ***

They think him housed, they think him blest,
Curtained in the core of rest,
Danger distant, all good near,
Why hath their "Goodnight" a tear?

Behold him! By a ditch he lies
Clutching the wet earth, his eyes
Beginning to be mad. In vain
His tongue still thirsts to lick the rain,

That mocked but now his homeward tears;
And ever and anon he rears
His legs and knees with all their strength,
And then as strongly thrusts at length.

Raised or stretched, he cannot bear
The wound that girds him, weltering there
And "Water" he cries, with moonward stare.

Leigh Hunt

28 William Holman Hunt *Master Pen and Master Sword* 1848
Pencil on paper. Illustrations to a poem by Leigh Hunt
Cecil Higgins Art Gallery, Bedford (as War and Peace)

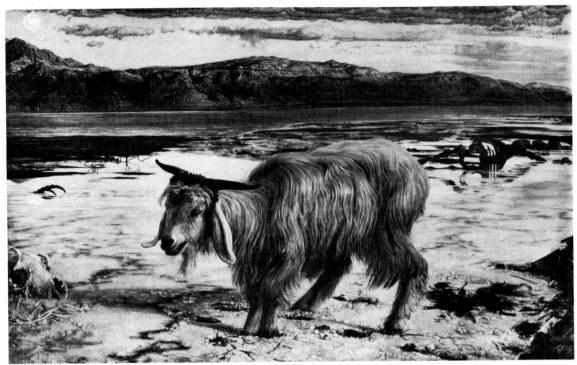

29 William Holman Hunt *The Scapegoat* 1854
Oil on canvas, 33¾ in. × 43⅛ in.
Lady Lever Art Gallery, Port Sunlight

30 William Holman Hunt *Fishing boats by moonlight*
Watercolour, 4 in. × 6 in.
Cecil Higgins Art Gallery, Bedford

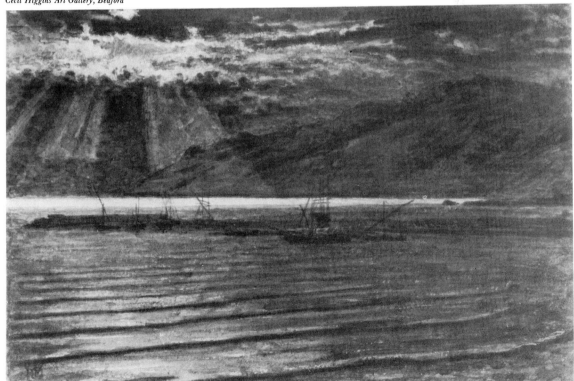

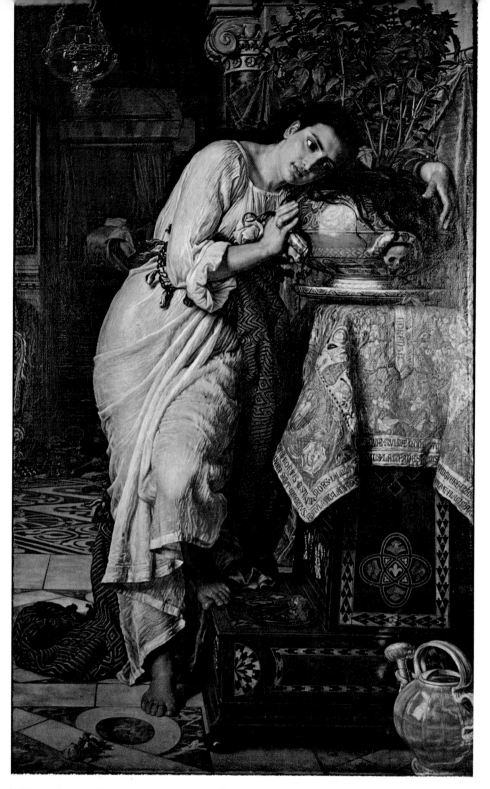

31 William Holman Hunt *Isabella and the pot of basil* 1866
Oil on canvas, $72\frac{3}{8}$ in. \times $44\frac{1}{2}$ in.
Painted in Florence, it shows a revival of the Keatsian themes which engaged both Hunt and Millais *c.* 1848

Laing Art Gallery and Museum, Newcastle

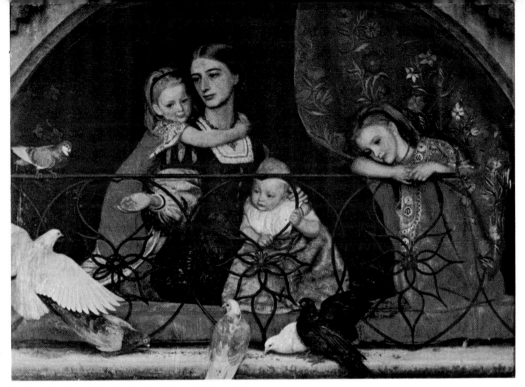

32 Arthur Hughes *Mrs Leathart and three children* 1865
Oil on canvas, 30½ in. × 41 in.
In the collection of the Leathart family

33 John Everett Millais *Lorenzo and Isabella* 1849
Oil on canvas, 40½ in. × 56¼ in.
The first painting in which Millais follows the tenets of the newly formed Pre-Raphaelite Brotherhood
Walker Art Gallery, Liverpool

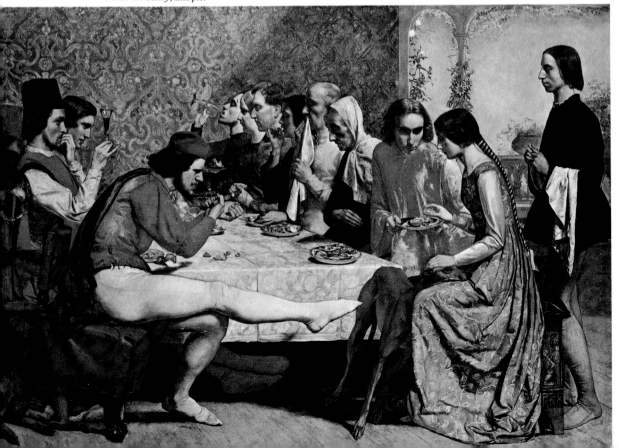

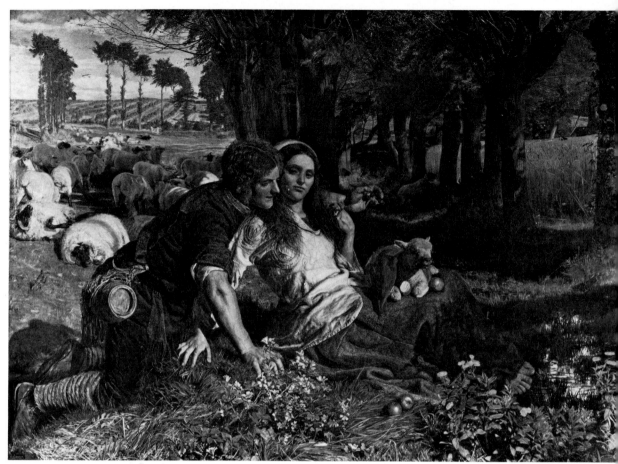

34 William Holman Hunt *The hireling shepherd* 1851
Oil on canvas, 30⅛ in. × 43⅛ in.
The background was painted at Ewell, while Millais worked nearby at Cuddington on *Ophelia*. Sold from the 1852 Academy Exhibition for 300 guineas.
City Art Gallery, Manchester

35 William Holman Hunt *The shadow of death* 1870-3
Oil on canvas, 83½ in. × 66 in.
City Art Gallery, Manchester

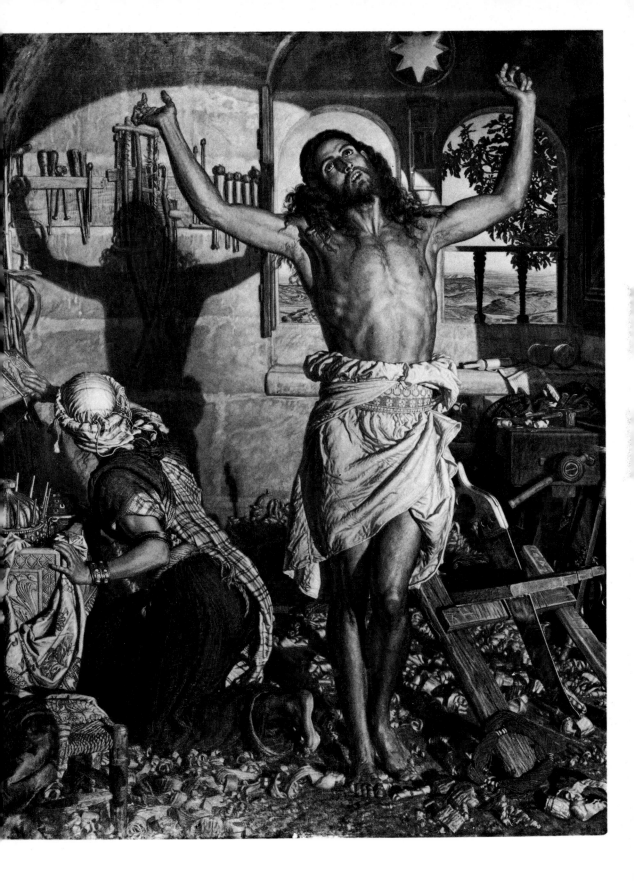

W Holman Hunt. 1876

36 William Holman Hunt, study for *The triumph of the Innocents* (see plate 26) 1876
Chalk on paper
Walker Art Gallery, Liverpool

37 William Holman Hunt
The Lady of Shalott 1858-9
Wood-engraving
Illustration for Moxon's
Poems of Alfred Tennyson 1859
Compare with Rossetti's illustration for
same (plate 59)

38 John Everett Millais
Two lovers with a greyhound 1848
Pen and ink, 10½ in. × 6½ in.
Designed to illustrate Woolner's poem
'My Beautiful Lady' in the first issue of
The Germ, but never used
City Museum and Art Gallery, Birmingham

39 John Everett Millais *Manhood* 1848
Oil on canvas, 51 in. diam.
City Art Gallery, Leeds

40 John Everett Millais, finished studies of the heads of Isabella and one of her brothers,
for *Lorenzo and Isabella* (see plate 33) 1848-9
Pencil on paper, $13\frac{11}{16}$ in. × $9\frac{7}{16}$ in.
City Museum and Art Gallery, Birmingham

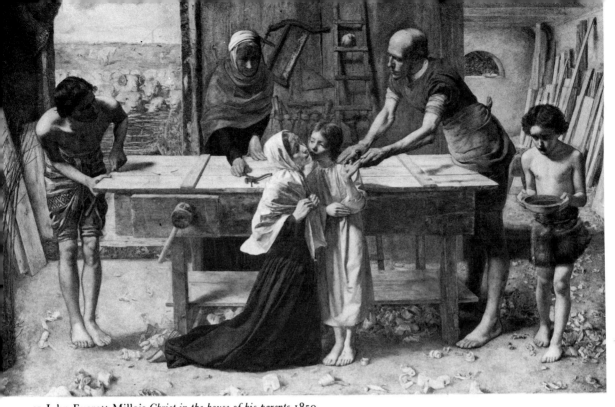

41 John Everett Millais *Christ in the house of his parents* 1850
Oil on canvas, 34 in. × 55 in
Tate Gallery, London

42 John Everett Millais *Ophelia* 1851-2
Oil on canvas, 30 in. × 44 in.
Tate Gallery, London

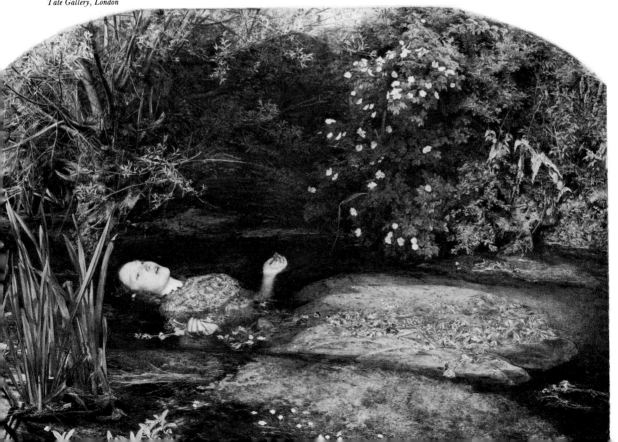

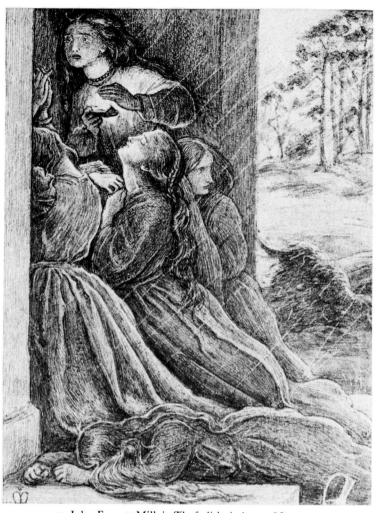

43 John Everett Millais *The foolish virgins c.* 1860
Pencil and watercolour on paper, $5\frac{1}{2}$ in. × $4\frac{1}{4}$ in.
Whitworth Art Gallery, University of Manchester

44 John Everett Millais *The miller's daughter* 1858-9
Wood-engraving
Illustration for Moxon's
Poems of Alfred Tennyson of 1859

OPPOSITE

45 Dante Gabriel Rossetti
The girlhood of Mary Virgin 1848-9
Oil on panel, $32\frac{3}{4}$ in. × $25\frac{3}{4}$ in.
Signed *Dante Gabriele Rossetti PRB 1849*,
it was the first picture to be shown with the initials
Tate Gallery, London

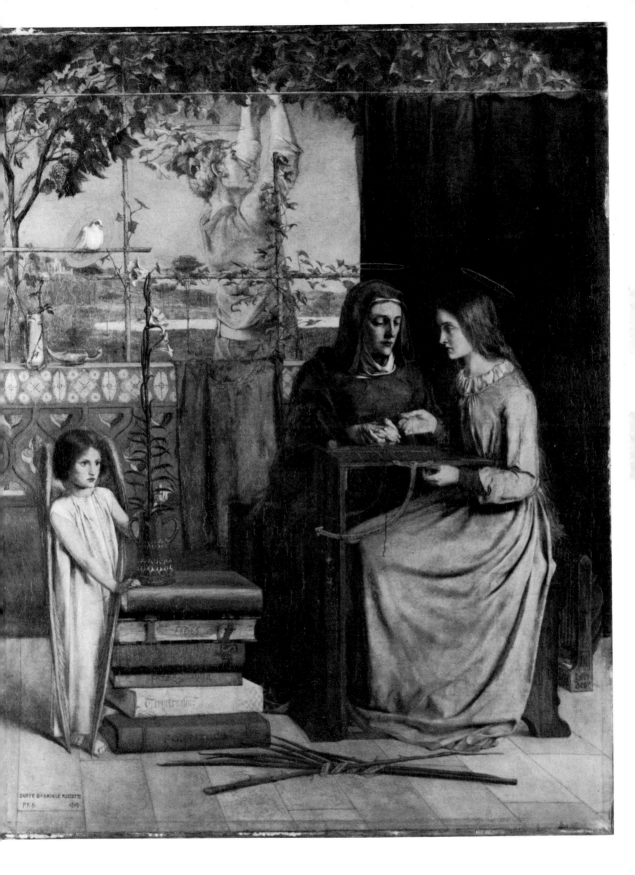

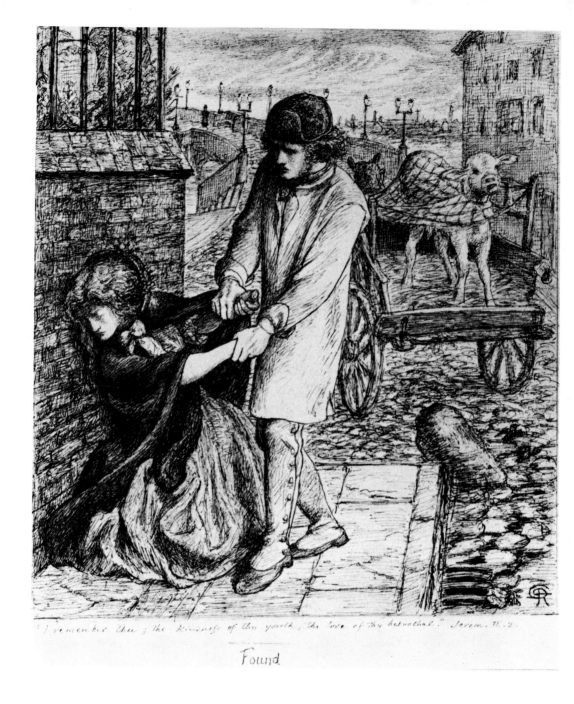

"I remember thee; the kindness of thy youth, the love of thy betrothal." *Jerem. II.2.*

Found

46 Dante Gabriel Rossetti *Found* 1853
Pen and ink, 9¼ in. × 8⅝ in.
Final design for painting now in Bancroft Collection, Wilmington, Delaware, USA
City Museum and Art Gallery, Birmingham.

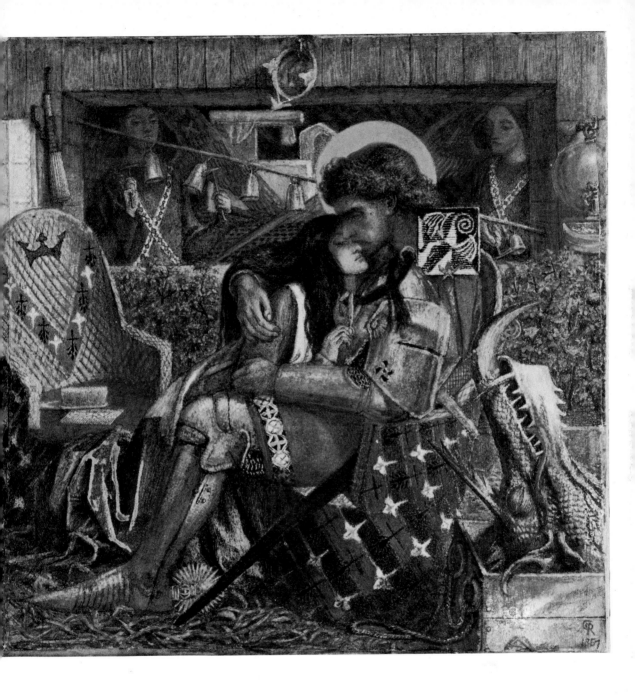

47 Dante Gabriel Rossetti *The wedding of St George and the Princess Sabra* 1857
Watercolour, 14 in. × 14 in.
Tate Gallery, London

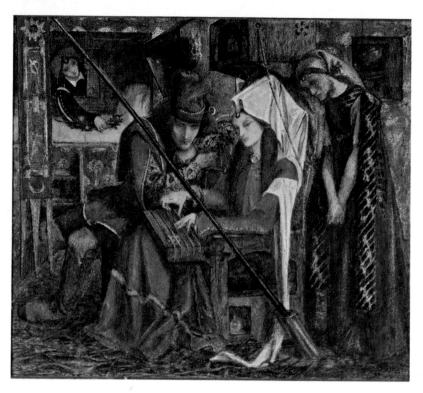

48 Dante Gabriel Rossetti *The tune of seven towers* 1857 Watercolour, 12⅜ in. × 14⅜ in.
Tate Gallery, London

49 Dante Gabriel Rossetti *The seed of David* 1860-4 Oil on canvas, centre panel 94 in. × 60 in., wings 73 in.× 28½ in.
Llandaff Cathedral, Glamorgan

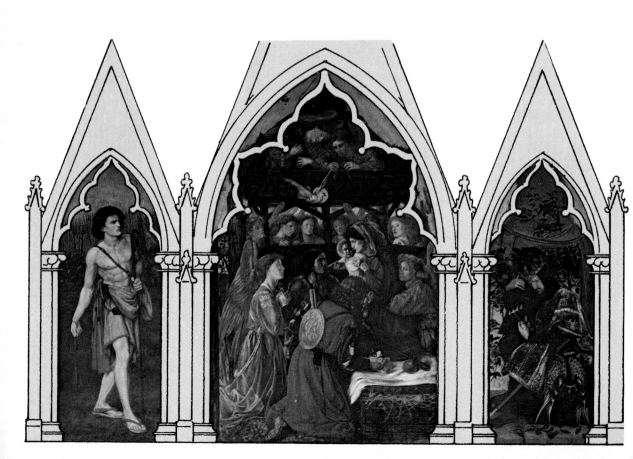

50 Dante Gabriel Rossetti *The bower meadow* 1872
Oil on canvas, 33½ in. × 26½ in.
The landscape was painted near Sevenoaks in 1850, the figures added in 1871-2
City Art Gallery, Manchester

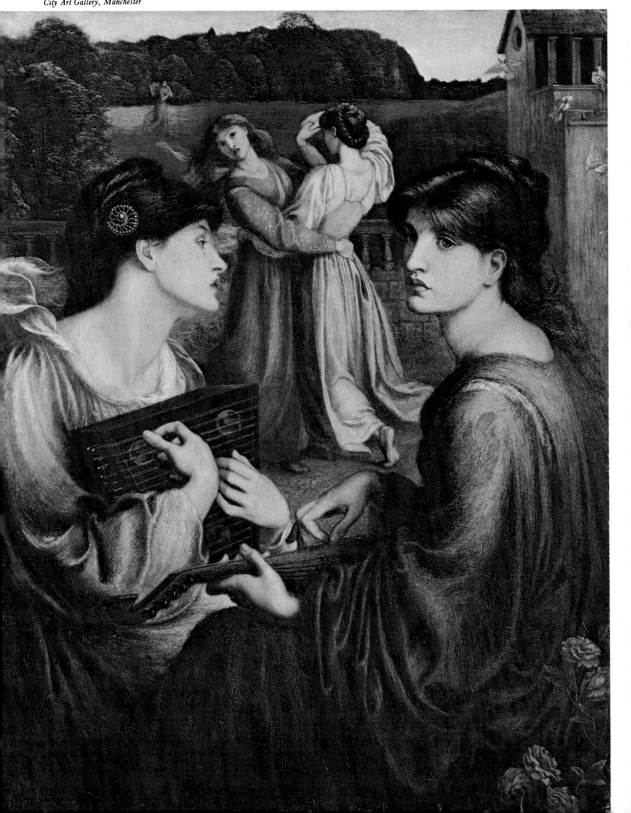

51 Dante Gabriel Rossetti *Hesterna rosa* 1850-3
Pen and ink, $7\frac{1}{2}$ in. \times $9\frac{1}{4}$ in.
Tate Gallery, London

52 Dante Gabriel Rossetti *The Princess Sabra taken to the dragon* 1861-2
Cartoon for stained glass, $19\frac{1}{2}$ in. \times 24 in.
Second of the series on the St George legend designed for Morris, Marshall, Faulkner and Co.

53 Dante Gabriel Rossetti, design for a couch, 1862
Pen and ink, and pencil, 10 in. \times $13\frac{7}{8}$ in.
Made for the Exhibition of 1862 by Morris, Marshall, Faulkner and Co. Pencil annotations are by Morris
City Museum and Art Gallery, Birmingham

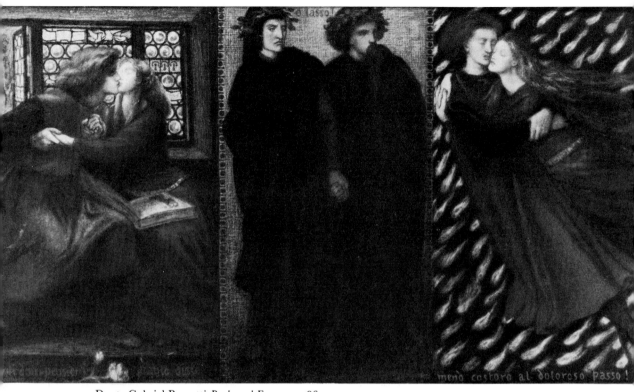

54 Dante Gabriel Rossetti *Paolo and Francesca* 1862
Mixed media, $12\frac{1}{2}$ in. × $23\frac{3}{4}$ in.
Rossetti began designs for this subject as early as 1849. There is a watercolour version in the Tate
Gallery
Cecil Higgins Art Gallery, Bedford

55 Dante Gabriel Rossetti, design for title-page of Christina Rossetti's *Poems*, 1866
Pencil, $6\frac{5}{16}$ in. × $4\frac{5}{16}$ in.
The illustration, here squared up for the finished drawing on the block, was later used separately

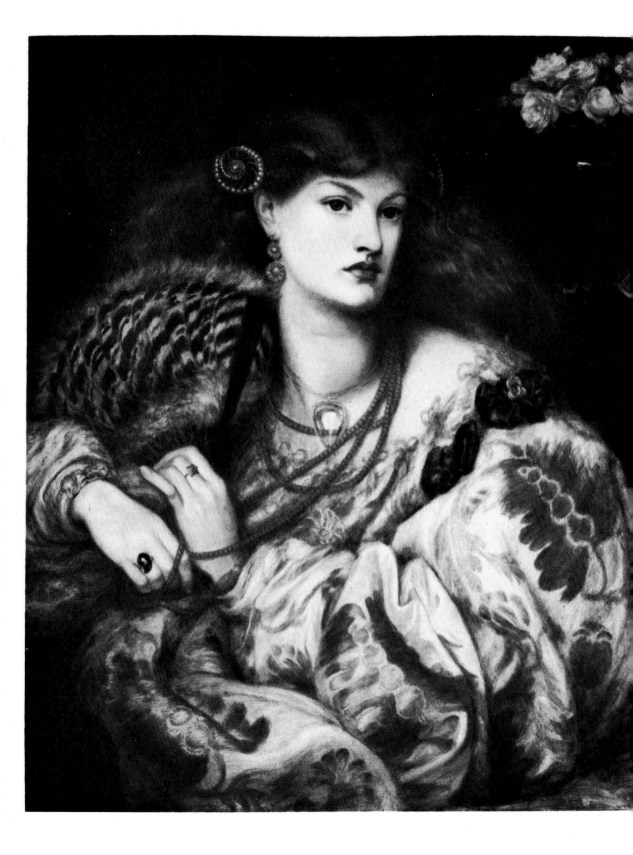

56 Dante Gabriel Rossetti *Monna Vanna* 1866
Oil, 35 in. × 34 in.
Tate Gallery, London

57 Dante Gabriel Rossetti *Dante's dream* 1871-81
Oil, 85 in. × 126½ in.
Walker Art Gallery, Liverpool

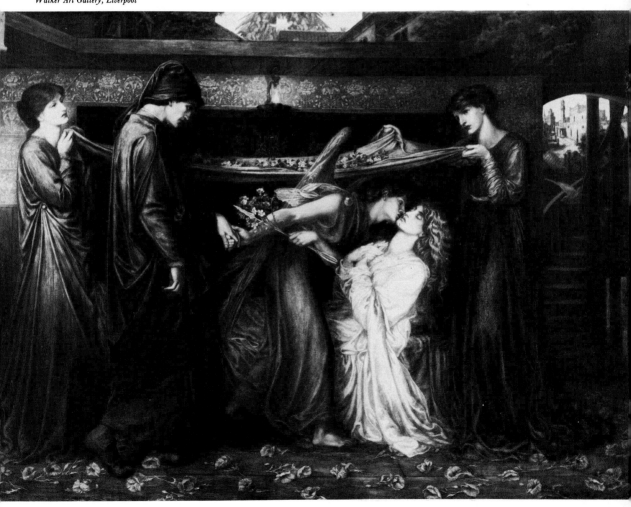

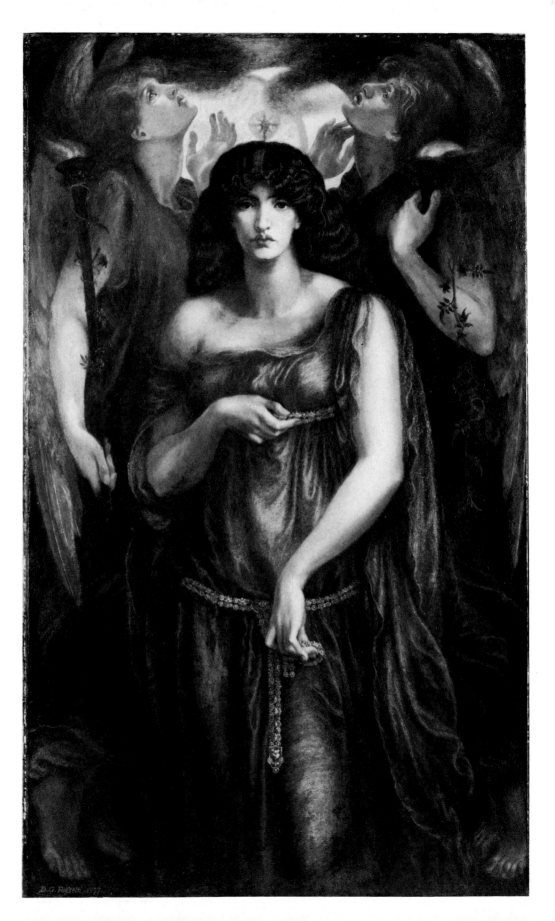

58 Dante Gabriel Rossetti *Astarte Syriaca* 1877
Oil, 72 in. × 42 in.
City Art Gallery, Manchester

59 Dante Gabriel Rossetti *The Lady of Shalott* 1858-9
Illustration for Moxon's *Poems of Alfred Tennyson* 1859
Compare with Hunt's illustration for same (plate 37)

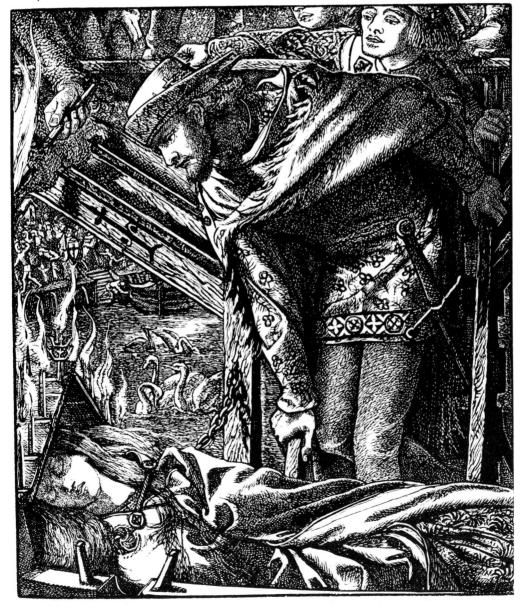

60 Dante Gabriel Rossetti. Sketch for wallpaper design for 13 Chatham Place, from a letter to William Allingham of January 1861

61 Dante Gabriel Rossetti *Amor c.* 1866
Pen and ink, 12⅝ in. × 5 in.
Drawing for the figure of Love standing between the two panels of *Dantis Amor* (second version)
City Museum and Art Gallery, Birmingham

62 Dante Gabriel Rossetti *Golden head by golden head* 1862
Illustration for *Goblin Market* by Christina Rossetti, engraved by W.J.Linton

63 Edward Burne-Jones *The Countess of Plymouth* 1893
Oil, 78½ in. × 37 in.
National Museum of Wales, Cardiff, reproduced by permission of the Earl of Plymouth

61

"Golden head by golden head"

6

63

64

65

64 Edward Burne-Jones, sketch for hangings, 1862
To be found on the back of a study for Burne-Jones' design, 'Noah entering the ark'. Compare with the embroidered figure once part of the hangings of Red House, now in the Victoria and Albert Museum
Whitworth Art Gallery, University of Manchester

65 Edward Burne-Jones, *Two lovers* 1862
Charcoal and pencil, 8¾ in. × 13 in.
City Museum and Art Gallery, Birmingham

66 Edward Burne-Jones *King Sigurd the Crusader* 1862
Illustration to a poem of the same name, *Good Words*, April 1862

67 Edward Burne-Jones, painted decoration on the panel of an upright piano, 1860
Victoria and Albert Museum, London

68 Edward Burne-Jones *Adoration of Kings and Shepherds* 1861-2
Oil on canvas, $42\frac{3}{4}$ in. \times $61\frac{1}{2}$ in.
Painted for St Paul's, Brighton, but never hung there
Tate Gallery, London

69 Edward Burne-Jones *The sleeping knights*
Oil, $23\frac{1}{4}$ in. \times $32\frac{1}{2}$ in.
A study for the *Briar Rose* series
Walker Art Gallery, Liverpool

70 Edward Burne-Jones *Voyage to Vinland the Good* 1883
30¼ in. × 30⅜ in.
Cartoon for window
City Art Gallery, Carlisle

71 Edward Burne-Jones *Venus Discordia*
Oil, 50 in. × 80 in.
National Museum of Wales, Cardiff

72 Edward Burne-Jones *The wizard*
late 1890s
Oil, 36 in. × 21 in.
City Museum and Art Gallery, Birmingham

73 Edward Burne-Jones *Venice*
Pen, $3\frac{1}{2}$ in. × $3\frac{1}{2}$ in.
Design for catalogue of the
exhibition of Venetian art at the
New Gallery

74 James Collinson *The renunciation
of Elizabeth of Hungary* 1850
Pen and ink over pencil,
12 in. × $17\frac{13}{16}$ in.
Finished design for the painting,
exh. Portland Gallery, 1851
City Museum and Art Gallery, Birmingham

76 William L. Windus *Too late* 1859
Oil on canvas, $37\frac{1}{2}$ in. × 30 in.
Exhibited three years after Windus' first Pre-Raphaelite picture
Tate Gallery, London

75 William L. Windus *Bishop Shaxton and Ann Askew* 1849
Oil, 34 in. × $43\frac{3}{4}$ in.
Exhibited Liverpool Academy, 1849; the following year he saw Millais' *Christ in the house of his parents*
and was converted to the new manner
Walker Art Gallery, Liverpool

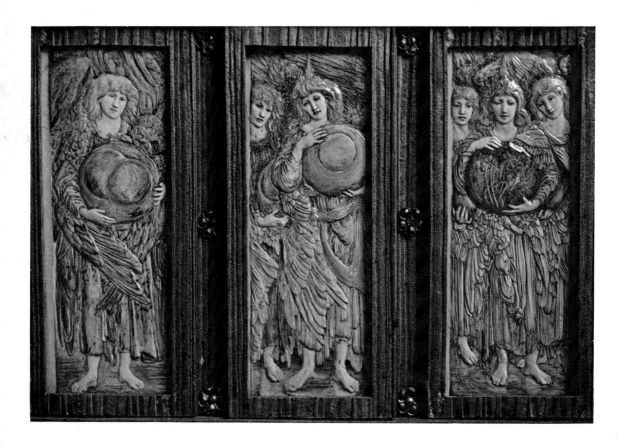

77 Edward Burne-Jones *The third day*
Watercolour sketch, $2\frac{5}{16}$ in. \times $5\frac{3}{16}$ in.
One of a series of small watercolour designs for *The days of creation*
Llandaff Cathedral, Glamorgan

78 Edward Burne-Jones *The days of creation*
Ceramic, six panels (modern setting)
Ceramic versions of the large paintings made by the Della Robbia
Pottery of Birkenhead
City Museum and Art Gallery, Birmingham

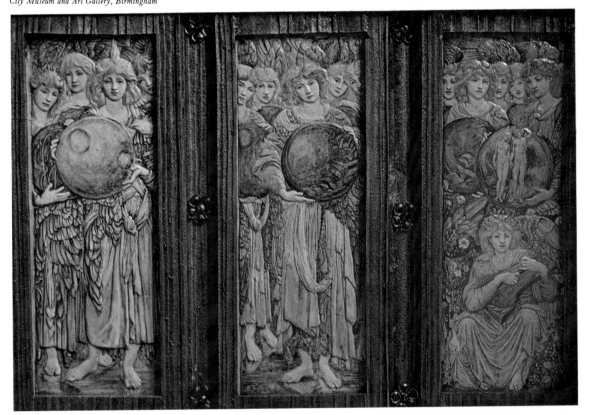

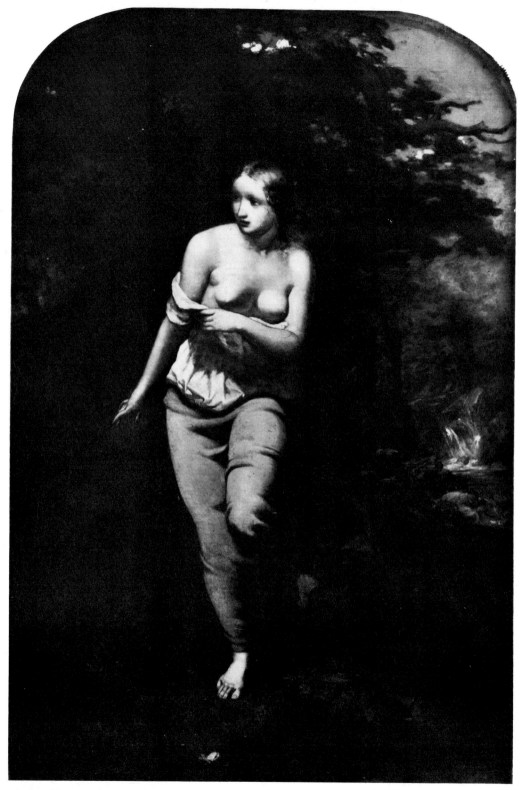

79 Arthur Hughes *Musidora* 1849
Oil on card, $7\frac{1}{8}$ in. × $4\frac{3}{8}$ in. Sketch for Hughes' first exhibited painting
City Museum and Art Gallery, Birmingham

80 Arthur Hughes *Twist me a crown of windflowers* 1872
Illustration to Christina Rossetti's volume of poems for children, *Sing Song*, Routledge, 1872

81 Arthur Hughes *The rift within the lute* 1858
Oil, 21½ in. × 36½ in.
City Art Gallery, Carlisle

82 Edward Burne-Jones, part of embroidered screen, 1861-2. 53½ in. × 28 ih.
Probably elaborated by Morris from sketches by Burne-Jones, this screen originally formed part of
the hangings of Red House

Victoria and Albert Museum, London

83 William Morris *Queen Guinevere* 1858
Oil, 28¼ in. × 19¾ in.
Tate Gallery, London

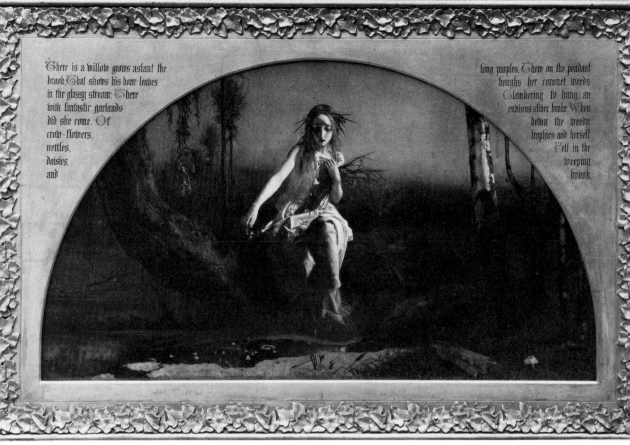

There is a willow grows aslant the
brook, That shows his hoar leaves
in the glassy stream: There
with fantastic garlands
did she come. Of
crow-flowers,
nettles,
daisies,
and

long purples. There on the pendant
boughs her coronet weeds
Clambering to hang, an
envious sliver broke. When
down the weedy
trophies and herself
Fell in the
weeping
brook.

84 Arthur Hughes *Ophelia* 1852
Oil, 27 in. × 48¾ in. (arched top)
City Art Gallery, Manchester

85 Arthur Hughes *My heart*
Full-page decoration for the *Sunday Magazine*, October 1870

86 Simeon Solomon *The painter's pleasaunce* 1861
Watercolour, $10\frac{1}{8}$ in. \times $13\frac{1}{8}$ in.
Whitworth Art Gallery, University of Manchester

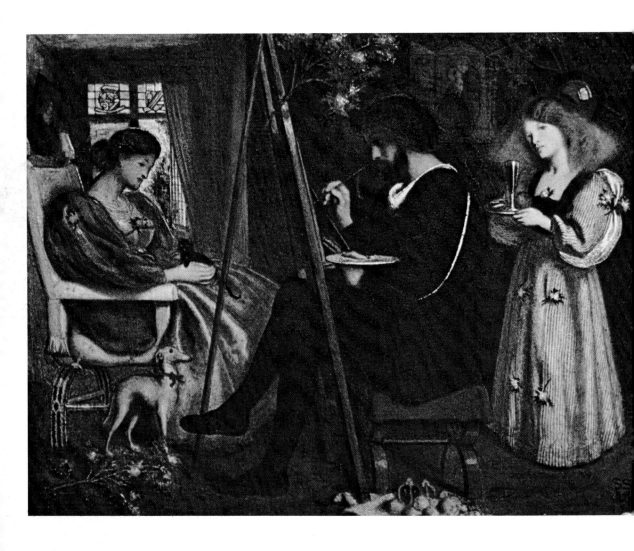

fact been busy eradicating with some pains what he considered to be the vices of a more facile technique learned earlier. His aim is self-contradictory. He does not wish the viewer to be seduced by his skill in rendering appearance so faithfully that the objects shown shall be enjoyed for themselves and the skill of their portrayal: they are to be impressed upon us by their vivid reality in order that we shall see beyond them to their collective message. In fact, this second result can only be achieved by the exercise of such skill and perception as must always court what Hunt regards as the seduction of the eye.

As Hunt moved out of the austerities of the Antique and Life Schools, and explored the world of colour, he began to find it an expressive emotional vehicle of novel power. It was Hunt, not Millais, who first used those colours which had been effectively neglected in European painting for centuries—the purples and violets, blues and greens of *The eve of St Agnes*—and they became key colours for the rest of the nineteenth century. One of the causes of confusion in the extension of the term Pre-Raphaelite to cover work which is more properly Aesthetic in kind stems from the widespread use of these colours. This was, ironically, the most arbitrary element in Pre-Raphaelite painting. For example, when Arthur Hughes, swept up by his enthusiasm for the new art, painted *April love*, he adopted a technique purely Pre-Raphaelite in its delicate naturalistic rendering of the real ivy and the real tree-trunk. But the choice of the colours of the girl's clothes was entirely wilful and designed. The doctrine of selecting nothing and rejecting nothing was applied to what was before the painter's eye; but he had already made selection of another kind as a vital part of his design. These colours were chosen as in other paintings, to provoke tension, to inject grief, to project regret, to assert tenderness.

Hunt's confidence and skill advanced rapidly and the technique of *The hireling shepherd* (pl. 34) is very much more relaxed and assured; his pursuit of nature reaches the point of establishing a recognizable personal style in which colour relations that go beyond simple natural appearance play a big part. And it was an advantage to Hunt that in painting the landscape of the *Hireling* he had Millais for companion, busy on his background for *Ophelia* (pl. 42).

The expression 'relaxed' is perhaps never quite appropriate to Hunt; his temperament, though he was so boisterously gay with friends as to be nicknamed 'The Maniac', was not one that allowed any slackening in his drawing or any skimping of effort. On the contrary, only by attempting problems whose difficulty should always challenge his concentrated effort could he feel sure that he was advancing. At the same time, the solution of such problems must always have an external objective; technical achievement was never to be courted for its own sake; virtuosity was a snare, a constant temptation.

In the course of his autobiography Hunt recounts how he lectured Millais on the need for good design of furnishings and common objects; describes his own designing of studio properties, and later, referring to the success of the work of the Morris firm, attributing it very rightly in large measure to Rossetti's genius, claims that he and Millais had advocated the same sort of thing twelve years earlier. The tone of all these passages indicates that in his old age he became somewhat paranoid. Not content with establishing with fair justice his claim to have been prime mover in the

field of painting, he must also assert something of the sort in every other field. Reduced to reasonable proportions by a consideration of his actual work, his claims in design seem to amount to an awareness of the idea of improvements in design common to many of his contemporaries, artists and manufacturers alike, and of the special responsibility of the artist, rather than the manufacturer, trade designer or craftsman, for the raising of standards and ideas. All of this was familiar enough in the 1850s and 60s, deriving from Haydon's agitation for the School of Design, from the work of Ewart's Commission, from the long-standing work of the Society of Arts, from that preoccupation with the importance of design which rose to the level of a national obsession in the Great Exhibition. At a more modest and personal level, his own need for studio properties which he could not easily buy and which must have characteristics appropriate to individual paintings, played its part. The lantern for *The Light of the world*; the embroidered cloth for *Isabella and the pot of basil* (pl. 31); some of his costumes, were of his own design and even, in one or two cases, of his own making. 'The dress of Julia . . . I made out of materials bought at a modern mercer's, and I embroidered the sleeve in gold thread with my own hand. The hat also I made myself, and the dress of Proteus was painted from my own tailoring.'[1]

But in spite of his obsessive pride in having originated Pre-Raphaelitism, Hunt, like Haydon, was deeply conservative. His Pre-Raphaelitism was a way forward, but necessitated a return to the roots, to the secret of traditional art—not a technical secret, but one of feeling and thought. In his painting he was most concerned with ideas, with expressive iconography, with the elements of factual and visual truth, the realization of setting and situation, of human relations visually expressed. His invention had to work within a framework of historic probability, or at least of circumstantial credibility. He would invent an embroidery—but it must conform to the character of such embroidery as might have been used at the time and in the place portrayed; and so with every property and circumstance of the painting. Very, very rarely was he able or willing to step out of this. His design is thus generally what he himself would have called archaeological, rather than original, and in this it conforms rather to the character of the work of the architect-designers than does the work of the members of the Firm.

What he says about his experience of ornament and design, though his references are meant to suggest to us that he had practical experience as a designer, never really amounts to evidence of practice. In view of his anxiety to establish his claim to leadership, we may fairly take it that had he been able to cite actual examples of work as a designer, he would have done so. But all the cases which he gives relate to his painting, and remain incidental. Certainly his time as an adolescent in Cobden's office, and his boyish attempts to imitate the work of the designer there, his daily familiarity with the seasonal flow of textile designs, must have given him a very specific awareness; and living over the furnisher's and upholsterer's shop in Holborn, which he cites as providing a hideous example of the taste of the times, must have extended this. In pointing out the need for improved design to Millais and Rossetti, he would argue that it was the painter's business, as the most responsible type of

1 W.H.Hunt *Pre-Raphaelitism and the Pre-Raphaelite Brotherhood* London, 1905–6, Vol. 2, p. 349

artist, the leader in sensibility, to design furnishings and common objects of use as well as noble ornament. But neither the measure of practical contact nor the missionary engagement with ideas seems ever to have led him seriously to undertake work as a designer. When he furnished his first house, it was Madox Brown who made drawings of furniture for him, even of the Egyptian chair, and the most interesting results of his theoretical concern are to be seen in association with paintings, in particular in some of his frames. But even the notion that the artist should design his own frames to suit each painting seems likely to have come to him from Brown.

Often the design of his frames shows all the harshness and tendency to the mechanical that appears in the work of Owen Jones and some of the trade designers, as, of course, some of his actual painting does on occasion. But not always. The frames of the two versions of *The afterglow in Egypt*, and of the two versions of *May morning on Magdalen tower*, have, in different ways, remarkable originality; they are highly personal, with an expressive quality such as he frequently aimed at but did not always achieve. He tried to use such motifs as would not just adorn, but would relate the frame to the theme of the painting. Just as no object or action is introduced into a painting without consideration of its iconographic function, so no decorative element is introduced into a frame without some emblematic value. The two *May morning* frames are especially splendid, and in them this expressive function of the frame is carried to such an extreme as to create objects of remarkable and uncharacteristic stylistic force. Both were made to Hunt's design by Ashbee's Guild of Handicraft, in copper repoussé. The larger, the Port Sunlight version, has curiously pantheistic symbols in its rising sun, fish, frogs, flowers, plants and birds, the intention of which is clearly to be associated with the exotic figure of the Parsee scholar who stands with the choristers to greet the sun; a Christian ceremony is thus referred to its pre-Christian antecedents.

A kindred strain of ideas is to be seen in the painting, *The triumph of the Innocents*, begun in 1876 and finished in 1887, based on an idea first explored in the mid-1860s. This is the painting which most fully realizes his developed concepts, both as to the nature and function of painting and as to his system of belief. It is at the same-time one of his most deeply traditional paintings, and curiously, it arose out of the one occasion on which he might have committed himself to carrying out a large-scale scheme of permanent decoration (pl. 26).

In 1865, the Rev. W.J.Beaumont, Vicar of St Michael and All Angels, Cambridge, proposed to Hunt that he should decorate his church. To Hunt, this meant above all to decorate it with paintings. The plan did not take effect immediately as he already had a number of important commissions in hand; the money had to be raised by public subscription, and in addition, his arrangements for his second trip to the Middle East were almost completed. In fact, the plan was never realized, since before Hunt felt free to undertake it, Beaumont had died, and the project with him. Some designs had been made, and Hunt gives an account of these in his autobiography.[1] He had chosen those areas of the church which he was to decorate, and

1 *Op. cit.* p. 250

his subjects were to have included the final battle between St Michael and his angels with the devil and all the host of Hell—the latter to be embodied in the forms of extinct reptiles. Opposite to this was to be a painting in which the devils were shown as tempters, hiding their faces with beautiful masks. He had also thought of another subject: 'the Holy Family on their flight into Egypt resting in the night, with St Joseph striking a light with flint and steel, while around, St Michael and his company standing on guard, and children as angels were attending and bringing food to the resting fugitives'.

Hunt married immediately before he left for Jerusalem, and in fact got no further than Florence, where he stayed for nearly two years. During this time his wife, Fanny Waugh, gave birth to a son and died of puerperal fever. In the Uffizi he came across a 'little picture by Annibale Caracci of the Holy Family in flight, with cherub angels bending down to them the branches of trees bearing fruit', which seemed to have anticipated his idea. He did not take this up again until after he arrived in Jerusalem in 1869. There, while painting *The shadow of death* (pl. 35), he developed the idea to include the Innocents. However, he left the oil sketch on the subject in Jerusalem in 1871, until he returned to work on it again (now married to his dead wife's sister) in 1875. The difficulty of getting reliable materials created endless problems for him, and was in part the cause of its taking another ten years to finish. Though he spent as much labour and thought on this as on any of his paintings, and made a large number of studies and drawings for it, so that it incorporates as much as ever the minute observation of the first Pre-Raphaelite pictures, it is by no means naturalistic in character, and is perhaps the most complete justification of his late claim that strict naturalism was not finally obligatory, though necessary as a mode of study and of reaching visual truth. The departures from naturalism are a logical and inevitable consequence of his having taken, unusually, a supernatural subject: it is the evolution of the ideas from his first admission of such a concept that not only allows but compels a painting of a different kind. Angels and spirits had no place in his earlier belief, only such identifiable persons as Jesus, Mary, Joseph, who could be portrayed as in everyday life, but, as Lear had occasion to remark, by the time this picture was painted Hunt had moved away from this moral rationalism and could conceive a painting of quite another order, and one which shows his heavy debt to Italian art. He had spent time in Venice and Rome as well as in Florence during his stay in Italy, and there can be no doubt that his study in the collections and churches there had reinforced his very early admiration for Titian. The *Triumph* is a very Titianesque picture, and the long-term inspiration of the *Bacchus and Ariadne*, the first important painting to enter Hunt's experience, is not to be discounted in assessing it.

Though Lear, in his surprise at finding how much Hunt had abandoned his earlier critical rationalism, described him as becoming a Fundamentalist, this is far from the truth: he made a synthesis of religious, moral and scientific ideas in which Christian belief had a central but by no means exclusive place, allowing him to make what use he pleased of the studies of comparative religion and of evolution which shocked and disturbed so many of his contemporaries. The narrative element in the *Triumph* tells us that the figure on the ass is that of the Virgin Mary, but she is

very unlike the usual Madonna; regal and pagan in appearance, she could as well be a Ceres or a Hera. The Christ Child too has all the appearance, and even iconographic attributes of a Bacchus, with his mass of dark-red curls. He lies back against his Mother, holding in his right hand, in a gesture of welcome and invitation to the main group of Innocents, three ears of green barley. Joseph leads the ass, stepping into a shallow stream into which three more Innocents cast flowers. A red rose is already in the water; one infant with another rose tucked into his girdle flings in a palm leaf, another behind him a vine branch; the third, in a pink robe rent at the breast, moves out of the picture, looking up in ecstasy. The main group surrounds the ass and its foal taking up most of the left foreground. One is a pace or two ahead, immediately below the Madonna: his curly head is bent as he examines a rent, emblematic of a wound, in the bosom of his white gown. Round his neck is a ruby necklace, the end of which falls through his fingers across and below the rent, making the effect of three drops of blood. He steps into the purling stream which is blue-green, rippled and moulded like glass; and his feet do not sink in it. A palm leaf lies in the water before him, and he is linked with the nearest of his fellows by the olive twig the latter extends towards him. This infant twines arms with the next behind him—half-hidden, but the long hair bespeaks a little girl; a green garland winds round both of them. He wears a wreath of pink roses on his head, she a braid of bright blue silk knotted with pink. These two are naked, as is the third who wears a blue necklace and is girt with a wreath of red, white and blue flowers, and links arms with a fourth, a robed girl with a blue girdle, the long end of which ripples away into the corner. She also has a square, pink-red headcloth with a silver coin fringe which is strapped under the chin with pearls; she wears, too, a pearl necklace. Behind her, the fifth infant leans back, looking out up to the left, and holding a double flute, while to the right of him the sixth lifts up a spray of apple blossom, but links hands with the seventh, who has a green headcloth set with emeralds, and also holds a leafy bough with buds; while before him the face of the last is shaded by his own hands and the pack on the ass's crupper. All these have an electric glow, and the fifth and sixth, as well as the detached infant, have also a misty blue-green nimbus. Above this group, three very sleepy, yawning, absolutely new-born babes fly in, variously haloed, the middle one in a white robe, a pink scarf entwining him with the third. The central one of this trio, clothed, holds a dead fledgling bird against his yawning mouth, almost stuffing it in.

The background is a moonlit landscape, with dark trees. In the middle distance two jackals creep by below the trees which shade a waterwheel; far to the right in a screen of trees glow the lights of a house—a passage of pure Adam Elsheimer—while sky and hills are wrapped in one deep soft blue-green-grey, in which shine three winking stars and the flames of three warning fires. But it is in the foreground that the most remarkable and unexpected inventions appear; truly Blakeian in kind. Below the muzzle of the ass, a seven-inch transparent bubble floats, brilliantly highlit at top right and bottom left. It contains an epitome of the creation, fall and salvation: it is Van Eyck's Holy Lamb in miniature. In its midst, the Tree rises, with fruited head cut off by the main highlight which centres on a point of great intensity at the top right, where the Lamb appears: the area around the Lamb, and spreading

down and to the left to cut off the top of the tree, is composed of a circle of singing angels. On the right of the Tree, a bowed figure bearing a great burden (a borrowing from Bunyan) is led by a haloed standing figure into a procession of men moving up round the edge of the circle and becoming more and more upright as they ascend until finally, they twist into the circle of singing angels. To the right, immediately below the burdened Man, a Lion and a Lamb crouch, facing into the centre. To the left of the Tree, the bowed or (literally) falling figure of Woman is both driven out, as from the Garden, and sustained, by an Angel, while immediately to the left and below, Adam sleeps, his head in a pale nimbus which is also the lower highlight of the whole bubble, diametrically opposite to the upper one. Adam's figure initiates a movement up and round to the left of the bubble by angels who soar up to join with the singers. The great highlight is a full round, the lesser only a crescent. In this complex, a synthesis of symbolism marries traditional Christian ideas with those of evolution and of pantheism; and it is renewed in a smaller variant in a second bubble floating in front of Joseph, just below the trio of Innocents. It holds an imploring man looking up into the highlight at the top right, while an Angel sweeps down on him from above, completing with him an S which divides the globe in the yinyang figure; and, to the left, a red serpent descends towards the Man's heel.

Hunt had travelled very far in a painting like this from the concepts of the *Druids*, and under pressure of the need to create such a complex of symbols he had not only considerably modified the naturalism of the finished painting (though not of the process of study towards it) but evolved a technique which brought him closer, once more, to the mature Rossetti, though the actual composition is totally unlike anything of Rossetti's, and carries one back to the Venetians. This was not due to Rossetti's influence; Hunt was simply driven in a similar direction by similar considerations, for the evolution of a system of symbols, though of a more private kind, was largely what had driven Rossetti away from Pre-Raphaelitism.

Indignant as Hunt became over the false view of Rossetti as the founder of Pre-Raphaelitism, he had a very just view himself of Rossetti's importance, which is set out clearly in his autobiography: '. . . whatever the full estimate of Rossetti's genius may be, there must be no belittling of his artistic power or of the influence he exercised over Morris and Burne-Jones. Beginning with them when they were far beyond the age of ordinary youths to enter upon the career of art, he managed to bring them to such proficiency as painters that small trace was to be seen of the results of loss of boyish training. From small experimental beginnings, Morris, allied with Madox Brown, Rossetti, Burne-Jones, and Philip Webb, acting, as I have shown, upon an idea promulgated by Millais and myself twelve years earlier, gradually developed a system of ornamentation so royal and perfect in principle, that again the spirit of British taste, which had produced the old cathedrals, the rich woodcarvings of various types and ages, the choice embroideries, the gorgeous metalwork of iron, gold and silver, the graceful fittings of old English homes, the exquisite Wedgwood ware, and the old Worcester and porcelain work, had been re-awakened.'[1] It is not likely

1 *Op. cit.* p. 405

that Morris or Webb would have cared to have Wedgwood or Worcester porcelain included in the antecedents of their work, but Hunt is just in his tribute to the work of Morris, Marshall, Faulkner and Company, and just in his assessment of Rossetti's importance to it, and to the work of Burne-Jones as a painter and designer.

9 Thomas Seddon and the Hogarth Club

The first Pre-Raphaelite paintings exhibited not only attracted much attention from the general public, but were of great interest to other artists. Arthur Hughes, a student in the Academy Schools, was excited by *The Germ*, but he was even more excited by the paintings which corresponded with the poems and articles in the magazine. They had an immediate effect on his own work, transforming it from skilful conventional painting to the meticulously observed naturalism of the new gospel (pls. 79, 84). Another painter, older and more experienced than any of the Brotherhood, a fine artist but an over-sensitive personality, the Liverpool painter William Windus, seeing Pre-Raphaelite works in the Academy Exhibition of 1851, was also completely captivated, and remodelled his style on them (pls. 75, 76). He set himself to promote the new painting among fellow-artists in his home town, and it was largely due to his efforts that for five successive years the Liverpool Academy gave its fifty-pound prize to Pre-Raphaelite painters. Windus may have had some inkling of the new movement before seeing its works, for among Madox Brown's friends of Tudor Lodge days were Mark Anthony, a fine landscape painter based on Liverpool and Manchester, and William Davis, a Liverpool Irishman, also an admirable landscape artist; while John Miller, the most important collector in Liverpool since Roscoe, had expressly advised him to look at Pre-Raphaelite painting at the Academy.

Another artist who was deeply affected by the work of the Brotherhood was Thomas Seddon. He too was an old acquaintance of Brown's, possibly from Tudor Lodge days, and knew Charles Lucy, the centre of that circle, in whose studio Seddon would go to draw from life. Seddon died aged thirty-five when his career as a painter was barely launched. He therefore appears as a minor figure in the Pre-Raphaelite story, as the man who went to work with Hunt in Egypt and Jerusalem, his reputation principally resting on his painting *Jerusalem from the Valley of Jehoshaphat*, now in the Tate Gallery.

But Seddon is an important figure in other ways: the Hogarth Club, which did so much to promote the work of the Pre-Raphaelite circle at the end of the fifties, might well never have been without Tom Seddon, though he had been dead eighteen months when it was founded in July 1858, and the development of the design movement in which Rossetti, Brown, Morris and Burne-Jones were to be so deeply involved owed a great deal to his initiatives. A few months younger than Madox Brown, he had been born in the City. When he was eleven, the family cabinet-making firm moved out to a new building in Grays Inn Road, designed by John Buonarrotti Papworth, though the family lived for some years yet in Aldersgate, not far from where Hunt's father managed his warehouse. Tom was at school in Epsom, learning, under the enlightened Pestalozzi system, not only Latin, grammar and arithmetic, but science, drawing and natural history. He was an eager reader, but

no less enthusiastic about drawing. A set of illustrations to Scott's 'Marmion' showed promise of a real talent. But that talent had to be exercised practically, within the family business, for although Tom wanted to be a painter his father was a devout Evangelical, and suspicious of the artist's career. At sixteen Tom was inducted into the family business. His father had offered to send him to the new Government School of Design, but this had no attractions for him, and it was not until he was twenty that he began to study formally at the École des Arts Décoratifs in Paris. He lived there for a year working hard and leading a gay social life which strengthened his wish to be a painter and to break out of the family mould.

Back in London in 1842, he continued to work hard in the business, designing, drawing ornament in the British Museum, joining the Society for Decorative Art and the Archaeological Society, attending lectures by the newly appointed Professor of Architecture at London University, Donaldson, and winning, in 1848, a silver medal from the Society of Arts with a design for a sideboard.

Working for the firm at a time when there was a great deal of earnest talk about design, and widespread concern about the superiority of French products and the consequent loss of trade, Seddon, supervising the execution of his designs in the workshops, was worried by the mechanical skills of English craftsmen as compared to the French. He modelled ornament for the carvers, encouraged them to draw, to work freely from his basic design, and to learn something about historic ornament and the forms of nature. In the evenings, he drew in Charles Lucy's studio, where he would meet Brown, Cave Thomas, John Cross, Mark Anthony and Roger Fenton, who had just taken up photography.

In the summer of 1849 he made his first venture into landscape painting, perhaps prompted by the Pre-Raphaelite pictures he had seen exhibited. With his younger brother John, he spent a month at Bettws-y-Coed, at that time the equivalent, for English painters, of the Forest of Barbizon. From then on, he spent some weeks of every summer in landscape painting (in 1850, at Barbizon, where he did some very Pre-Raphaelite studies) though for the rest of the year his duties as the firm's designer claimed him. The two pursuits, however, were not really separate. Back from Bettws in the autumn, he began to work out a scheme for teaching drawing and design to artisans, whose sole knowledge of this side of their work came incidentally—indeed hardly at all—in the course of their apprenticeship.

Very likely his first intention was simply to teach the workmen of Seddon's; but he took a much larger view than this; his scheme was to embrace craftsmen in all the trades in which such skills and interests could be useful. In Clerkenwell, in the Holborn and Grays Inn Road areas, in Kentish Town and Camden Town, there were scores of workshops, large and small, producing clocks, furniture, metalwares, painted glass. He canvassed friends for support—Cave Thomas, Brown, Lucy and Professor Donaldson. From the majority of well-established artists and architects he met with the response that the Government School of Design already existed, if there really were workmen able to take advantage of it. So it did, but it was not for working men already earning their living, and the instruction consisted only of repetitive copying, in pencil, of plaster casts or lithographic prints of classical

and renaissance ornament—the chief source in Seddon's view of bad design and life-less craftsmanship.

By March 1850 he had a working committee, on which not only his friends, but the editors of two enlightened and influential journals served: George Godwin, editor of the *Builder*, and Samuel Carter Hall, editor of the *Art Journal*. A public meeting was held in the St Pancras Vestry rooms, in the late summer, and Seddon went himself from workshop to workshop, canvassing support. As a result, eight hundred men attended, and of these, about a quarter actually enrolled as students. Cave Thomas undertook the duties of Headmaster; Neville Warren of Secretary; Seddon himself, Brown and other friends undertook to teach, and rooms were taken in Camden Town. The fees were, necessarily, small, and failed to meet costs—Brown's diary records that he never actually received his nominal salary of sixty pounds a year. At Christmas, 1850, therefore, Seddon organized an exhibition to raise money, working, as always, enormously hard, and sleeping the night before opening on the cold floor. This resulted in a severe attack of rheumatic fever, which put him out of action until the spring of 1851, and weakened his general health. But by now the firm had a showroom in New Bond Street, and his brother John was articled to an architect. Others were able to take some of his load, and at last old Tom Seddon (whose portrait Brown had painted) agreed to release him to become a painter, working for the firm only as a consultant.

He set about his new life with typical professional thoroughness, aiming, like any other young artist, at exhibition in the Royal Academy. Not having passed through the RA Schools, associated with the Pre-Raphaelite movement, he must work hard and leave nothing to chance. The way to attack the Academy was not with landscape, but a subject picture. He decided on the appropriate theme of Penelope, seated at her loom in the dawn light, her lamp still burning. Apart from the value of the familiar story, the solution of the technical problem of two sources and qualities of light, natural and artificial, would be likely to capture attention. He left nothing undone that could ensure the success of the picture. He made a model of the room, with suitable lighting; studied Greek furniture and costume from the vases in the British Museum, made the usual painstaking studies, with much help from Brown. The painting was hung, though skied, in the Exhibition of 1852; but it was not sold. However, the first professional hurdle was behind him.

In the summer following, he spent several weeks at Dinan in Brittany, painting landscape, but working, too, on subject pictures. On his way through Paris, he had visited Brown's old friend Dan Casey, and renewed his acquaintance with the Louvre, seeing the paintings now with a more sophisticated and informed eye. For him, as for Hunt, Titian was the great master; but he found another source of inspiration—the story of King René of Anjou. Writing to Brown, he said: 'I hope to become a *passé-maître en chevalerie*. I have got the Roi René's book on *Tournois* to read. He is such a courteous old gentleman, a perfect connoisseur of the olden time, who, if he lived now, would buy Hunt's pictures, and write the book of ball-room etiquette.' He had, by now, become close to Hunt as well as to Brown, and was negotiating with him about a joint journey to Egypt and the Holy Land, and among the subject pictures now begun was one of *Ruth amid the alien corn*—directly inspired, of course, by

Keats' 'Ode to a Nightingale'; but as he was working also on a painting of *Elijah and the Priests of Baal*, his mind was at least equally oriented to the original Bible story.

Back in England for the winter, he finished his Exhibition pictures and set to work on a book for Blackie, on furniture design, which he both wrote and illustrated, as well as making new designs for the firm. In June he was back in Dinan, painting a big landscape of the ruined monastery of Léhon—and courting Emmeline Bulford, a pretty, pious English girl who lived there. In November, back in Paris with the Caseys, he received letters from Hunt, who was now nearly ready to go to Egypt. Seddon set off almost immediately, and reached Alexandria early in December, where after a few days he had the good luck to meet, and become very friendly with, Captain Burton. Burton's information and introductions to the Arabic language and way of life were enormously useful to Seddon. Sociable and gay as well as devout, and with a real gift for languages, he dressed Arab fashion, and by the time his friend Edward Lear arrived at the end of the month, he had painted a Bedouin on a camel, made a portrait of Burton for the book the latter was writing on his travels in Arabia, and was thoroughly at home. By the end of January, Hunt joined them, and they spent nearly five months in and near Cairo, not taking ship for Jerusalem until May. Hunt, baffled by the unfamiliarity of the landscape, less willing or able than Seddon to adapt, and unable to get models in a Moslem country to pose for him, found, and overcame, many difficulties. Seddon preferred to camp outside the Holy City, across the Valley of Jehoshaphat, and set about the big landscape view of Jerusalem from the hillside opposite. He had a much deeper interest in landscape than Hunt, and where the latter was committed to the notion of figure subjects, Seddon had come with the express intention of taking back to England as vivid and faithful pictures of Biblical locations as he could. He was gay and full of high spirits—too gay for Hunt, who suffered from some of his practical jokes—but he could write home to a family friend and pastor, the Reverend T.F.Stooks: 'Art's highest vocation is to be the handmaid to religion and purity, instead of to mere animal enjoyment and sensuality. This is what the Pre-Raphaelites are really doing in various degrees, but especially Hunt, who takes higher ground than mere morality, and most manfully advocates its power and duty as an exponent of the higher duties of religion.'[1]

In October, leaving Hunt at work in Jerusalem, he travelled back to Dinan, to become engaged to Emmeline, stopping a while in Paris to work on some of the Egyptian paintings under Casey's eye. Back at last in London, he began to prepare an exhibition, and in March took rooms at 14 Berners Street. Writing to Emmeline, he tells her of 'mountains of things to be done' to make the rooms ready not only for him to live there, but to house his paintings for semi-public exhibition. 'I have to put my pictures into their frames [March 10, 1855] and to hang them up; and tomorrow evening I am to give a select tea-party to some half-a-dozen of the more illustrious of my artist friends. You may well say that no kindness can surpass Brown's; time just now is very precious to him [Brown was deeply involved in work on *The last of England*] yet he comes every week, at least, to advise me.' Seddon did his best to

1 J.P.Seddon *Memoir and Letters of the Late Thomas Seddon, Artist.* London, 1858, p. 127

repay the kindness: Brown was very poor at this time, and he not only lent him money, as Brown had earlier lent him money, but found him work, teaching drawing to the daughters of Sir John Slade.

By mid-March the exhibition was open. Ruskin came. 'Was very much pleased with everything,' Seddon wrote to Emmeline, 'and especially the *Jerusalem*, which he praised wonderfully.' In addition to his own work, he had hung a few drawings and paintings by friends—a large drawing by Rossetti, the little landscape of Shorne Ridgeway (a study for the background of the big *Chaucer*) which Brown had given him. But one of his own paintings was kept out to send to the Academy. He could not afford not to be shown there, even if he was holding his own show. But the hangers that year were most unsympathetic to anything tainted with Pre-Raphaelitism, and his *Pyramids* was rejected, while all other similar works were either thrown out or obscurely hung—even *The rescue*, by Millais, already elected an Associate. Millais made a scene, and got his painting re-hung, under threat of his resignation. Nobody else was quite so lucky.

It set Seddon thinking again. It did not matter so much to him, with his well-received private exhibition; but for some others, such as Hunt, it was very serious. On May 14 he wrote to Emmeline 'I have quietly tried to rouse a disaffected spirit or rather courage to do justice to ourselves, if others will not do it to us; and some dozen or fifteen men are to meet at my rooms next Monday, and consider whether we shall not set up an exhibition of our own, which I think there is every prospect of making a very prosperous thing. . . .'

Madox Brown's diary notes, for that Monday, May 21, the names of some of the 'dozen or fifteen'. 'In the evening the meeting. Halliday a sinecurist and gent; swell and hunchback and artist combined; known chiefly as a friend of Millais and Hunt. Not at all bashful. Martineau . . . Arthur Hughes, young, handsome and silent. Munro good-humoured and tritely talkative. William Rossetti, placid as wont. Cave Thomas. Woolner fierce as ever. Burcham, a new artist and quondam apothecary—forty—nervous and modest.' Millais' name is not given; in spite of his recent row with the hangers at the Academy, a young Associate would be cautious about any venture which set up in specific opposition to it.

But the row was not simply a spontaneous outburst, nor was the meeting of May 21 the beginning of a campaign. Seddon, gentlemanly, elegant, entertaining, was a cool organizer who looked ahead. Madox Brown's diary for March 15 had recorded, two months before, an invitation to a meeting. 'Seddon wants me to be at his place on Saturday, to meet Millais, Rossetti, etc. I won't go.' But he had gone. His entry for the 17th reads: 'To Seddon's, to meet Millais, Rossetti and Collins. Millais, when a hanger at the RA, *to write to The Times* if they do not put the best pictures in the best places . . . Collins occasionally chuckles hysterically at these grand projects . . .' The May meeting was in fact the beginning of a second stage of carefully planned counter-attack on the entrenched reaction of the RA. However, at this stage, no new association was formed; but the idea of a distinct and independent exhibition remained in the minds of some of Seddon's friends—in Brown's not least.

Seddon's own exhibition closed on June 3. It had had a number of good press notices, he had sold some small paintings, and been commissioned for new ones. He

could now consider himself launched. At the end of the month, in Paris, he was married to Emmeline, spent a honeymoon in France, and came back to London to settle down to work at his commissions (which included illustrations for religious books) and to work up new paintings from his Eastern studies. Some of these were shown in the Academy exhibition in the following May, and he repeated his successful private exhibition. A daughter was born on April 30, but since his success was so clearly bound up with his Egyptian and Jerusalem pictures, he decided to go out again to seek new material. Emmeline and the baby were therefore taken back to France in the summer, to her family, and in October Seddon himself began the second journey, reaching Alexandria on the 24th. He was looking forward to the renewal of his former happy experiences, to laying in a store of new studies, beginning new paintings; but he suffered a recurrence of the dysentery of his earlier visit, and on November 23, died.

The news was a real grief to close friends like Brown, who called a meeting at his studio to discuss what sort of memorial might be devised for him, what help or comfort given to his widow. The idea of a public subscription was mooted, the help of as many impressive names as possible applied for. Professor Donaldson was naturally approached; so too was Ruskin. Ruskin and Brown had never got on, and it took some effort on Brown's part to meet the critic, even for this purpose—especially as, to suit the great man's convenience, subsequent meetings of the committee set up were held at Ruskin's house in Denmark Hill. However, patient and tactful William Rossetti was elected Secretary, so all went well, and something near £600 was eventually raised. Two-thirds of the sum was used to make a formal purchase, for presentation to the National Gallery, of the *Jerusalem* painting, and a year later, the money was handed over to the young widow.

The absences of Hunt and Seddon abroad, the Ruskin divorce and Millais' absence in Scotland, together with several other factors, had tended to loosen what had once been a close and growing body of Pre-Raphaelite and sympathetic painters. The Seddon memorial brought them together again, and at last his notion of an independent exhibition, substantially Pre-Raphaelite in tendency, was realized. It was Brown, who had been closest to him, who set it going, who did most of the work, meeting expenses out of his scanty pocket, collecting paintings, getting artists to take part, finding suitable rooms, in Russell Place, now a part of Charlotte Street south of Fitzroy Square.

After Brown's *Christ washing Peter's feet* had been skied in the Exhibition of 1852, he never sent to the Academy again, though continuing to send to other public exhibitions. The English provincial exhibitions increased the small number of his patrons, introducing his work to the wealthy manufacturers and merchants of the North, and twice he was awarded the fifty pound prize of the Liverpool Academy. But he naturally failed to get the sort of notice in influential journals like *The Times* and the *Athenaeum*, which London shows would have brought him, as in spite of recurrent attacks on particular works, they brought his friends who continued to exhibit there. With a growing family, (including a mother-in-law) and a mortgage to repay, he could less and less afford to take his independent stand, especially as he worked laboriously, with many careful studies and revisions before any painting was

finished. Hunt had sold his *Scapegoat* (pl. 29) for a good price, and continued from that point to earn more and more; Millais was already an accepted Establishment favourite; and Rossetti, especially after he took Millais' place in Ruskin's favour, began to earn steadily with his small watercolours, readily saleable for thirty or fifty guineas.

Though he was now selling work, Brown had more pressing reasons than any other of the group to bear Seddon's idea in mind. With encouragement from Rossetti, and from Rossetti's two new disciples, Morris and Burne-Jones, he took the initiative. He canvassed friends for works, found rooms in Russell Place, had invitations printed, and in June, for a few weeks, the Pre-Raphaelites and their followers and friends held an exhibition in which all the work showed a strong family likeness, and nothing appeared in the old conventions.

Bell Scott's Memoir records this briefly: 'Again in June 1857 Rossetti writes me, mainly on my new picture of the *Building of Hadrian's wall*, and about a small semi-private exhibition opened by the set or coterie—we may as well call a spade a spade—in Fitzroy Place, accessible by free tickets, which exhibition was a forerunner of the Hogarth Club, constituted a year after.' Bell Scott was included in the exhibition, as were Brown himself, Rossetti, Hunt, Millais and Lizzy Siddal; Bond, Davis and Windus from Liverpool; Boyce, Brett, Campbell, Charles Collins, Lowes Dickinson, Halliday, Hughes, Inchbold, Martineau, Arthur Lewis, Wolf and J.D.Watson. It was not so much aimed at the general public, as at likely patrons and sympathizers, so that it got little in the way of press notice, though, after the event, a note in the *Athenaeum* by Thornbury acclaimed Rossetti as the leading figure, and praised *The last of England*, ascribing it to Holman Hunt!

Among the visitors was Ruskin, who brought with him an American, Charles Eliot Norton, of Cambridge, Massachusetts, a man very much interested in the arts; the exhibition, says William Rossetti 'proved very congenial to Mr Norton's sympathies in art'. Norton thus came to know the two Rossettis, and became very friendly with them. Among the exhibits, he particularly liked Lizzy's watercolour of *Clerk Saunders*, which he eventually bought. Another new acquaintance made by members of the circle at this time was a young ex-army officer, Captain Ruxton. Perhaps taken to see the exhibition by Luard, who had recently returned from the Crimea and was now launched as an artist with strong Pre-Raphaelite sympathies, he wrote to William Rossetti to suggest that an exhibition of English art might be taken across to the United States. Norton probably had something to do with the suggestion, but at all events, Rossetti brought Ruxton and Brown together. It seems as if at this point Ruxton's idea was simply to take the existing exhibition, as near as possible, over to the States with Brown coming too, to supervise the hanging. But there was a question of initial finance: it would cost a good deal to ship and insure the work. At this point Gambart the dealer was approached. He had already, for some years, been buying and selling Pre-Raphaelite work, though often with a great show of caution. It was no doubt at Gambart's suggestion that the scope of the show was widened to make it more generally representative: Brown certainly believed that it was due to Gambart's introduction to the scheme that he was dropped from it. His diary for January 17, 1858 records, among other recollections of past months: 'All this while

the American Exhibition had been going on. I was to have gone over to hang the pictures; however, that scoundrel Gambart put a stop to that, and all I had was the trouble of going to select the daubs.'

By late September, Ruxton was in America with the pictures, negotiating for their exhibition. Difficulties blew up suddenly because of a panic on the money market; but in the end the exhibition was shown in New York, Philadelphia and Boston, with considerable success, especially for the Pre-Raphaelite painters. Ruxton himself was well-liked, and had the active support of Durand, President of the us Academy: American artists as well as collectors and the general public responded warmly. The workmen who hung the pictures in New York, Ruxton wrote home, were most enthusiastic over the small version of Hunt's *Light of the world*, over Hughes' *April love* (lent by William Morris) and his *Sailor boy*; but 'Madox Brown's *King Lear* seems to be the most popular picture of this exhibition', Ruxton told William Rossetti, and again in Philadelphia, where the exhibition was seen in February 1858: 'No picture has such *even* approbation as Brown's [*Cordelia at the bedside of King Lear*]. Admirers and abusers of PRBism alike join in its praise.'

The object of the exhibition, of course, was not merely to show English painting, but to sell it, and as pictures were sold, their new owners tended to withdraw them. Ruxton wrote home asking for replacements, as well as for new pictures to augment the show—including Turner's *Whalers* from John Miller's collection. In spite of the admiration of his *King Lear*, however, Brown did not sell very well—though Hunt's *Light of the world*, Leighton's *Romeo and Juliet*, Charles Lucy's *Lord and Lady William Russell* all went for good prices. All Brown got out of it was thirty guineas for his little landscape, *Hampstead from my window*; but both *Our Lady* and *King Lear* were badly damaged on the way back, and he had to spend much time in repairing and restoring them.

The success of the exhibition, however, and the popularity of the Pre-Raphaelite works, once more prompted the idea of some sort of association of like-minded artists which should make them independent of the Academy, and, towards the end of the year, the Hogarth Club was founded, partly as a social centre for the artists concerned, partly as an exhibiting society. Its first exhibition held in January 1859 was, like the Pre-Raphaelite exhibition, a semi-private affair. Membership included non-artists, friends and patrons such as Miller and Plint, Vernon Lushington and his brother. The list of artist members numbers thirty-eight, among whom appear four architects—Bodley, Street, Webb and Woodward—and Ruskin—who nevertheless did not exhibit. On account of his membership Millais was not included. There were seven honorary members, all much older and well-established, among whom was Eugène Delacroix—most likely at the instance of Rossetti and Madox Brown.

Successive disputes and clashes of personality shortened the life of the club to three years. Some of the disputes arose from its conduct as a social body—Ruskin in the end withdrew when it was proposed to buy a billiards table—but the most serious disputes arose over the exhibitions. According to Holman Hunt, when his own early picture, *Valentine rescuing Sylvia from Proteus*, was borrowed from Fairbairn, the owner, for exhibition, Rossetti withdrew all his own work; while Brown withdrew from the committee when objection was made to his inclusion of furniture designs among his

work. Although, in the opening exhibition, his cartoon of *The Transfiguration*, done for Powells in 1856, had been included, and other stained glass designs, including some by Burne-Jones, had later been shown, many members took exception to mere furniture as not being Fine Art. Finally, at the annual meeting in September 1861, when the membership had already shrunk and threatened to sink still lower, a proposal to raise money by charging the public for admission to the exhibitions was defeated, and the Club wound itself up.

By this time, the cohesion of the Pre-Raphaelite Brotherhood was dissolved. Collinson had long since drifted away; Millais, well-entrenched in the Academy, living in Scotland, had become the model of popular success; Hunt, his early scepticism exchanged for a highly personal religious commitment, engrossed in his laborious didactic paintings and thinking of another trip to Jerusalem, began to see less and less of old friends; Stephens had ceased to paint at all; William Rossetti combined his art criticisms with the life of a responsible civil servant; and Gabriel had long since ceased to follow the Pre-Raphaelite canon, evolving a new world of art into which Morris and Burne-Jones had followed him. It was from the densely and richly designed work which Rossetti completed in the fifties, and from the diverse invention of Madox Brown, rather than from the Brotherhood proper, that the models and inspiration for the next phase came. With the sixties, though a substantial number of younger painters carried forward the high-minded naturalism with which the Brotherhood had begun in 1848–9, there were other new beginnings— beginnings of the Aesthetic Movement, of the Arts and Crafts Movement.

10 The significance of Ford Madox Brown

The work which Ford Madox Brown was doing in the years of his first acquaintance with Rossetti, and the practical help which he gave in the actual painting of his first pictures, gave the latter a very powerful impulse towards naturalism, almost immediately reinforced by his developing friendship with Hunt and Millais. The studies which Brown had done and was doing, for such paintings as *Chaucer, Wycliffe, Our Lady of Saturday night, Cordelia at the bedside of King Lear*, including the landscapes which were built into all of them, were based on that exact regard for natural appearance and the rejection of studio lighting which, before his journey to Italy, Madox Brown had expounded as matters of principle to Dan Casey in Paris. But it was his power and ingenuity as a designer which in the long run had by far the deepest effect on Rossetti's work. After the initial excitements of the Pre-Raphaelite Brotherhood had run their course, it was this aspect of Madox Brown's work which still helped the development of Rossetti's; and just as in the two Pre-Raphaelite paintings of *The girlhood of Mary Virgin* and *The Annunciation*, Brown's influence had contained the seductions of naturalism within a firm design, so when Rossetti moved on to the splendid watercolours of the 1850s, the same influence kept him from mere pastiche of mediaeval illumination.

From 1852, Brown's own work entered a new phase, and in this decade he produced two of his most important and completely realized works—*The last of England*, inspired by Woolner's going to the Australian diggings, and *Work*, which had rather larger origins. *The last of England* is one of the most perfectly designed and painted of all nineteenth-century pictures. Within its oval, shapes of umbrella, netting, ship's gunwale, shawl, run in a beautiful chain of order, a formal unity that perfectly supports its concentrated theme and makes it at sight the most satisfying of all the artist's pictures. But, begun at the same time, and studied and laboured over for very much longer, *Work* is in the end his masterpiece—not so easy to see and comprehend at first acquaintance, but unfolding enormous wealth as one looks again and again over a period. It is a more monumental painting than *The last of England*, more completely exploits his extraordinary powers as a realist painter, and, where *The last of England* explores and expresses a range of emotional reactions to one particular situation, *Work* elaborates, by truly visual means, the expression of a philosophy. The wealth and complexity of *Work* is such as to deceive the casual eye; but it is far from being a mere collection of clever detail and anecdote.

It *is* rich with detail, it *does* interweave a dozen implied anecdotes, it *does* make quite explicit social comment; but it is primarily a visual invention, and its actual painting is of superlative quality. It is a full and legitimate successor to the pure Hogarthian tradition; not a literary picture, but a painted morality. Madox Brown, with all his continental training and background, understood more

completely than all his friends and contemporaries the nature of Hogarth's genius; it was a genius which he shared and which, in *Work*, he exploited to the full.

Madox Brown's painterly sensibility brought into being the images through which the social comments and moral ideas are made explicit: visual sensation, values of tone and colour, provide the basis on which the painting rests; all are held together and made effective by a complex but finely controlled design. This joint function of painterly quality and formal design in giving expression to personally felt and historically typical social values makes this one of the masterpieces not only of Pre-Raphaelite painting but of all European art.

It is a triumphant painting, packed in every way with moral and social symbols, sociological and psychological observation, visual record and sensual delight— unified in a true visual order. Quite small passages worthy of special note are, for instance, the policeman at the extreme right, who moves on an orange-seller; not so much for its social observation in the action and reaction of the two people concerned, but for the superbly accurate observation of physical fact, and the organization of that observation. The falling oranges—fine, clean-skinned, golden-yellow—make bright round three-dimensional spots, in mid-air. Their shadows as they fall on the woman's white apron are contrasted very exactly in blue, and this relationship, a purely visual matter, creates a tremendous feeling of light and atmosphere surrounding the woman and the policeman, at once defining them and linking them with all else in the picture, for everything is observed and set down in exactly this way.

The flash young potman selling beer in the centre is spelled out in every detail: *The Times* under his arm; new clothes; tasselled tweed cap, red and blue printed velveteen waistcoat, printed shirt (with ballet dancers pirouetting all the way up the fly front) the bright drop of the fuchsia flower plucked and set in his button hole; the top waistcoat pocket with its bunch of fancy charms which include a miniature meerschaum pipe, a horseshoe; a spigotted barrel; a gridiron, a mug, a cigar. He has probably been fighting the night before—maybe throwing some drunk out of the pub where he works—for there is a new scar by his left eye. Two long clays lie in the top of the smart green pipebox, and probably the bright bandanna which lies on the hod belongs to him rather than the hodman. The hodman is an ex-sailor, middle-aged, ruddy, robust, wearing a stiff canvas smock; the sort of man who, all over the world, was then digging the tunnels and cuttings for the railways. The man who riddles sand for the mixing of concrete or mortar to be used in the lining of the trench in which they are laying the first Hampstead water-main, is also middle-aged, grey under the yellow and red bandanna which covers his head. He wears a waistcoat, once fine—there are three amethyst buttons, two others of common bone. He wears knee-breeches, and thick blue ribbed stockings. The young navvy at the left, who shovels earth out on to the heap, wears a white and blue checked shirt, open, but tied at the waist, over a yellow flannel singlet. His new corduroy trousers are kept up by a bright pure red scarf—not a belt—and he wears a black-and-white-banded cotton nightcap. His shovel, polished with use, takes a blue light from the summer sky, though it is within the same shadow as envelopes us. On the extreme left, against the brick wall that closes this side of the picture, the barefoot herb-gatherer— typifying those who have never learned to work—carries his basket of fresh flowers

and plants: ferns, groundsel, forget-me-not, rushes. His hat is wreathed with plantain. Behind him comes the very fashionable young lady—typifying those who have no need to work—who draws the skirt of her fine ribbed grey mantle away from the flying dust. In the Manchester version of the painting, her face is that of Madox Brown's wife Emma; in the replica painted for James Leathart it is the face of Maria Leathart. Behind her again comes the pious lady (put in at the request of Plint, who first commissioned the painting) dressed in sober dark clothes, but wearing a parma-violet bonnet with flower, osprey plume and broad ribbon, and a black lace mantle. Her flounced dress is white, with an orange-ochre sprig pattern; her belt is joined by a clasp, finely painted, of two mother-of-pearl ovals with silver rivets. From behind her skirts her little daughter peeps nervously. Behind her again, and above, the silk-hatted rider and his daughter, seeing their way blocked, rein in to turn and go another way; the rider was painted from Hunt's middle-aged pupil, Robert Martineau: behind these two, a sunlit opening is shut off by blue sky and a group of small houses, across the eaves of one of which runs a board lettered with the words Hampstead Institute of Fine Arts: below this again, on the house-wall, a green poster reads: Snoöx again tonight—Cats; and on the roof four cats play. Here Brown has incorporated a familiar nonsense of Rossetti's, Professor Snoöx being an entirely fictional character about whom Rossetti invented ridiculous stories.

A complete description of the painting would run to thousands of words, so full is it of incident; but what is most useful is to make clear that it is all *visual* incident, and to say something about the way it is all handled. And nothing better exemplifies Madox Brown's skill and perception than the painting of the tract which flutters down from the pious lady's hand into the excavation. Its functions are several: to define the character of the lady, to tell us something about the concept of social morality for which she stands; and to link her with the potman, the only person who has noticed it and who for his part represents the sort of temptation against which the pamphlet is probably directed. But in its painting it is a piece of pure observation, its visual character as perfectly observed as anything in Monet. We see it not quite edge-on, curving a little as the air bears it up, the top surface a pale blue-grey, the upturning near corner a pinkish-yellow grey. It has been perceived as having two reflecting surfaces—one taking colour from above, and sharing the bluish tinge seen in the gleaming shovel; the other taking colour from below, from the earthy colour of the pit—and at the same time offering an exact colour-contrast which gives the upper surface an extraordinary luminosity within the shadow as it swirls down. As with the spilled oranges, we sense light and air flowing round the paper. The same exact observation and record are to be seen throughout the picture.

But it is not only in his masterly registration of exact visual sensation that Brown is to be admired; the design of this painting keeps step with the other aspects, and as in all his paintings, not merely holds together but powerfully reinforces what the eye has seen.

The design of *Work* was evolved from the series of important subject pictures, starting with the cartoon, *The death of Harold*, and progressing through *Chaucer*, *Wycliffe* and *Cordelia at the bedside of Lear*. Each of these marks a step in Madox

Brown's exploration of systematic pictorial constructions which he went on using to the end of his life, with endless variety, and sometimes in ways that, combined with the dramatic action and strong expression of his figures, seemed grotesque to his contemporaries. These explorations had to do with his working away from older studio conventions and lighting, and the establishment of modes very much his own. In *The death of Harold*, where no buildings or comparable structures are involved and the composition is almost exclusively of figures, the affinities with later compositions are disguised, though real. It is in the *Chaucer* that we see the distinctive development. Here he overcame the problem of arranging a large number of figures, all of whom must have personal characteristics, on a small ground plan and in a large vertical canvas: he was not simply painting a crowd.

He achieved his object by using different levels and distances. The scene of the reading is the battlemented terrace of a castle, and as we look beyond this we see, falling away into the distance, the riverside landscape of Shorne. The old king is raised above his courtiers on a throne, the apex of a pile of figures at the right, leaving space around the figure of Chaucer who stands at a lectern before the king, his head against the bright sky, contrasted with the king's which is in shade. The *Wycliffe* varies both theme and structure, using only eight figures, including the child on the lap of the Duchess, and a half-seen boy at the far left. John of Gaunt is now the listener, seated on a low throne under a little striped awning, while Wycliffe reads to him from his translation of the Bible, standing almost dead centre and dominating the picture, making no use of the lectern to his right. Madox Brown's symbolic intention in this is plain. This specifically Protestant picture extends the *Chaucer* painting by symbolizing the importance of a vernacular Bible in enriching and forming the language. So, a little lower than Wycliffe to our left, stand Chaucer and Gower, at the head of a flight of steps up which come two pages, the first carrying the volumes of their poetry. Behind these figures, again seen against bright sky, we see another estuary landscape, this time of Sompting and the Adur valley, which introduces a much lower level as well as greater distance.

In *Cordelia at the bedside of Lear*, these ideas are developed yet further. We are no longer in the open air, but in a tent in the French camp (the theme is taken from *King Lear*, Act IV, scene vii) and there is no direct daylight. Lear lies asleep, Cordelia awaits his awakening. Through an opening in the tent we see the shore, and the anchored ships; the eye has been given a way out of the enclosure into the distance and sunset. Brown was to make increasing use of this device, often by way of introducing secondary themes to reinforce his main subject; always to make connections between the closed world of the painting and the larger context from which it is drawn. Hunt, as well as Rossetti, seems to have learned to use the same idea— in the *Druids*, and in his beautiful drawing illustrating Keats's 'He knew whose gentle hand was on the latch'. But where Hunt and Madox Brown will always give a logical account of the existence of different spaces and levels, it is enough for Rossetti to make use of them without any concession to probability; as in the tight-packed gallery of angels in the central compartment of the Llandaff altarpiece, or the faintly haloed heads of angels that appear below the altar-platform in his illustration to Tennyson's 'Sir Galahad'.

Different as *Work* is in theme and setting from the mediaeval-based *Chaucer* and *Wycliffe* or the *Lear*, it shows the same formal ideas at work. We are in the open air, on a bright sunny day: yet by closing the picture at the left with the foreshortened brick wall, and using the shade of the trees to envelop the right-hand half of the painting, we find ourselves included in a controlled space, which has three visual outlets. Two of these are at the back, one left of centre and high up, breaking into the sky; the other a good deal lower, at the right, where the road winds up and out behind the central dark mass of trees. At first it is only these two areas that register as exits, but as we read the painting more completely and are drawn into its life, we find the third exit, more subtle and much more important: it is the trench which the men are digging in the foreground. On a small platform inside it stands the young navvy who throws out the earth, but from below there appears a hand with another shovel. The unseen navvy is just as much a part of Brown's collective modern hero as the two who stand at the visible centre. This device, by which we become aware of an important figure by some token part, is often used by Rossetti also in his own different way. It became one of his favourite means of creating a mysterious atmosphere, as in *The tune of seven towers*, where a panel opens in the rear wall of the box-bed and an arm lays a flowering bough on the white sheet. Nor was it only pictorial devices that Rossetti took from his teacher. Brown had a considerable repertoire of knowledge of arms and costume, and many of the articles in his paintings were made to his own designs, by himself or others. Such things as the crowns of the *Weeping queens*, the semi-heraldic marks and ornaments of costumes and furniture in Rossetti's water-colours, have their origin in Madox Brown's inventions—sometimes simply borrowed, but more significantly, invented by Rossetti himself following Brown's example, and flowing again from him to Burne-Jones and Morris. By this Rossetti was freed of the irksome restraints of actual historical research and precise anti-quarianism, which, as much as visual naturalism, made it difficult for him to complete a painting.

Brown's diary records several instances of his designing and making properties for his pictures—costumes, furniture and other accessories. He also designed his own frames, which were generally made by Green, to whom frequent reference is made in his letters and those of others of the circle. Rossetti, Hunt, Arthur Hughes and others of the circle also designed their own frames; but it seems as if Brown was the true innovator. The kind of picture he painted, from *Chaucer* on, could not be put into conventional carved frames. The gothic and architectural character of the *Chaucer* and *Wycliffe* called for corresponding frames, and the frequent use of verses or quotations made necessary flat areas on which they could be lettered out. Where the original scheme of the *Chaucer* had included wings, never completed, and a very elaborate architectural frame, the simpler *Wycliffe* was framed with a substantial flat around it. This enabled him to include two subordinate elements, symbolizing the old and new churches, by piercing with roundels the spandrels created by the falling away right and left of the low pointed arch of the top of the actual picture. On framing, as on all practical matters, Rossetti took much advice from Madox Brown, but, willing as Brown always was to help and advise, he was equally willing to take suggestions from others, and he certainly did so in Rossetti's case. In writing

to James Leathart, for instance, in January 1863 he mentions that 'the frame is a combination and rearrangement of one I designed with Rossetti's thumbmark pattern'. This was evidently the frame for *Cordelia at the bedside of Lear,* which Leathart had bought, and in a further letter of the following month, it is again referred to. 'I am glad the frame of King Lear is so much to your taste—I had told Green to employ all or any of my patterns, as it might spread a taste for a different kind of thing from the debased article now in use—However it would be a wise thing to register the best—only fear the improbability of ever getting up the requisite energy to effect it.'[1]

By this time the Firm—Morris, Marshall, Faulkner and Company—had been in existence for nearly two years and had shown work and won prizes, and Brown was busy designing, chiefly but not exclusively, stained glass, but evidently his way into design had been through the design of properties and frames for his own paintings. It is uncertain when he first designed actual furniture other than for paintings, perhaps as early as the autumn of 1849, if the sofa referred to in his diary for October 5 of that year was to be made, by Seddon's, to his design—'Began a portrait of Mr Seddon; to be painted, and that of Mrs Seddon, for a sofa'; the entry reads. Hueffer also deals with the subject:

> He had designed his own furniture long before the firm of Morris and Co. was thought of and subsequently he designed a great many household articles for friends. That his designs were, to a certain extent, in demand, I am led to believe by the fact that, in the year preceding (1858) Mr Holman Hunt, in a letter, mentions incidentally a number of articles of furniture for which he would be glad to receive sketches. The table made to his own design is mentioned by Madox Brown in the diary (March 16, 1857) and is a characteristically substantial piece of furniture, with a top in shape like a vertical section of a barrel, and with pierced lockers beneath. These designs for furniture led to Madox Brown's first open rupture with the Hogarth Club. to the summer exhibition of which he this year sent them.

A table answering this description is among the pieces illustrated in an article by A.M.Tait in the *Furnisher,* 1900, on Madox Brown's furniture. This piece, like eight others, was made by Morris, Marshall, Faulkner and Company, and is described as a drawing-room table with lockers for books and music. It is quite plain except for simple ornamental cutting at the ends, of a slightly mediaeval kind. Another table illustrated in the same article is more distinctly mediaeval, with a rectangular top, bevelled at the edge, its legs crossed, with bevelled angles, some carving and a twisted wrought iron stay bolted through from end to end. All the Madox Brown pieces seem to have been carpenter-, rather than cabinet-made, and were intended to provide cheap, solid furniture suitable for the sort of artisans whom he and Rossetti and Seddon had taught. Doors close with simple latches, drawers have no attached handles but are pierced with hand-holds; the material (except of the two tables) seems generally to have been deal, stained green with oxide of chromium. Some of this furniture was recently discovered, stored away at Kelmscott, when the house was restored by the Society of Antiquaries (pl. 27). It includes washstands, towel horses, dressing-tables and beds. Among the other furniture illustrated

1 Unpublished letter in the possession of Dr Gilbert Leathart

by Tait is a chest of drawers designed for use at the Workingmen's College (not made by Morris), an Egyptian chair which must arise from either Seddon or Hunt's influence, and two light rush-bottomed chairs, one of which is very like the familiar 'Morris' chair, and the other, with a lower seat and very tall ladder back, anticipates the chairs of such designers as Voysey and Mackintosh, though keeping a much more homely character.

Nothing seems to be known of furniture made for his own family use. However, there is sufficient evidence, documentary and physical, of the active part he played in design, of actual utilities as well as special pieces for his paintings. In the latter connection, among the designs recorded are some for *The coat of many colours* (pl. 21), now in the Walker Art Gallery, Liverpool. He designed and had made a beautiful barbaric necklace for this, worn by Levi. No trouble was too great for him to take to realize his pictures completely, and his ingenuity as a designer and maker of objects of every kind played an appreciable part in this. It also played its part in the endeavour to orient the Hogarth Club in other directions than that of an exclusive Fine Art; and so in the founding of the Morris firm and ultimately of such bodies as the Artworkers Guild, the Arts and Crafts Exhibition Society, and other similar bodies. Brown's chief work, of course, was as a painter, but a painter whose works were all very deeply designed; his stained glass was of course only a step away from this, and in the early glass of Morris, Marshall, Faulkner and Company his influence is obviously very considerable. Had he chosen, like Morris, the path of design rather than that of painting, it is clear that he would have made one of the greatest contributions to Victorian design; as it is, he made that contribution rather obliquely, and has had virtually no credit for it.

11 Rossetti: artist and graphic designer

The 1850s were a critical and formative period for Rossetti. During these years he established himself as a poet, and, despite his avoidance of exhibitions, also as an influential painter, detaching himself from Hunt and Millais and the tenets of the Pre-Raphaelite Brotherhood, and gathering round him a following distinctly his own. His relationship with Lizzy Siddal, who was to die in 1862, dominated his emotional life, but before the end of the decade he had become closely involved with Morris and Burne-Jones, and through Morris with Jane Burden, who was to become a central source of inspiration.

The bad critical notices which *Ecce Ancilla Domini* received in 1850 resulted in Rossetti's swift rejection of religious themes for his next two paintings. Both *'Hist!' said Kate the Queen* and *Dante and Beatrice in Paradise* were inspired by literary texts, sufficiently well known indeed to be recognized by a large part of the sophisticated picture-buying public, well steeped in Browning and Dante. He was unable to complete either of them but in what was finished of *'Hist!' said Kate the Queen* there were already departures from the Pre-Raphaelite painting, the beginnings of a more formal, less naturalistic manner.

The naturalism of Pre-Raphaelite technique had, however, served two purposes in the minds of its originators: it had freed them from preconceptions of style and expressed their themes in all the immediacy of the present. Paintings like *Work*, *The last of England, The awakening conscience* and Collinson's little-known but exquisite *The emigrant's letter* were intended as topical documents; it is into this category that *Found* falls (pl. 46). It was begun in 1853, with Fanny Cornforth as the model. Rossetti probably met her soon after his first acquaintance with Lizzy, and she posed for several careful studies when he began the actual painting. It again was never finished, though he worked at it on various occasions over the next twenty years at the instance of more than one friend or patron. It is a painting too easily set aside as exemplifying his incapacity for sustained effort and the disciplines of conventional drawing and composition, his waywardness with patrons, and his ambivalent attitudes. There are two reasons for Rossetti's failure to finish it. One lies in the ambivalence of his relations with Lizzy Siddal and Fanny Cornforth. If he envisaged Lizzy as playing Beatrice to his Dante on some ideal plane, this left wide scope for Fanny and the world of sensual pleasure. There seems no reason to think that at this stage Rossetti felt any guilt towards Fanny, but every reason to think that he did feel both guilty and frustrated because of the two incompatibles. The establishment of this situation may well have initiated the actual painting in 1853, but the theme occurs in his Browningesque poem 'Jenny', and in 'Bride Chamber Talk', finished in December 1849 for the first issue of *The Germ*. It was also the topic of earnest talk with Bell Scott on the occasion of Rossetti's visit to him in Newcastle.

Rossetti's letter to William on the subject, from Newcastle, is full of unease, and whether this related to his feelings for Lizzy or for Fanny is immaterial: the fact is that he was unable either to end or to develop fully either of these two relationships.

But another, technical, difficulty confronted him, to which his years of sterile academic copying undoubtedly contributed. Rossetti found it extremely difficult to draw from immediate actuality. For many years he found it hard to catch a likeness, though he had made a number of successful family portraits, not least those of his mother and Christina which figure in his first two paintings. This was to be an important factor later in driving him to the establishment of formal types. Making credible drawings of accessory objects irked him no less, for they had no intrinsic interest for him. To invent accessory objects—crowns, lamps, gowns, banners, was one thing, but to render them naturalistically he found difficult and irrelevant to his purpose. He found, like Fuseli and Blake before him, that 'Nature put him out'. What is really remarkable is that his early commitment to Pre-Raphaelite doctrine was so enthusiastic as to carry him over this difficulty for two or three years, and to enable him to make the very naturalistic paintings of the *Girlhood* and the *Annunciation*, though on these he had very much more direct help from Brown and Hunt than on any later work. The difficulty of meeting these practical demands, and his own divided feelings about the subject, together combined to prevent Rossetti ever finishing the picture. Luckily, however, he was already finding an outlet for his imaginative talents in another direction.

By the late summer of 1852, the need for solitude with Lizzy and for privacy with clients had prompted Rossetti to move out of the family home and settle in Chatham Place, Blackfriars. Here, on the riverside at the north end of Blackfriars Bridge, he was within walking distance of William at Somerset House in the Strand, and Lizzy on the south bank, with the Surrey Theatre and other places of entertainment just beyond the bridge foot. Settled there, he began to devote more time to painting watercolours; partly because it was cheaper, partly because it was physically convenient, and he could easily turn from one to another as his ideas developed, and partly because working at sight size and on a small scale gave him more control over the problems that had irked him on the larger scale of seven-footers like *Kate the Queen*: problems of construction, proportion, visualization. It may well have been Madox Brown who initiated Rossetti into this new medium. He had used watercolour and chalk not only in making sketches and studies, but in some important pictures such as *Our Lady of Saturday night*. The scrubbed and stippled mosaic manner he had evolved, often inelegant but generally rich and colourful, suited Rossetti admirably and he soon became adept at scraping out and patching until everything became right. Ruskin's enthusiasm for mediaeval miniatures was a later influence on both his composition and techniques.

It should be noted that none of the Pre-Raphaelites or their associates, except Bell Scott, worked in the English tradition of watercolour, a tradition established by topographical draughtsmen, using free washes and paying much attention to light and atmosphere. They used a technique much more akin to that employed in painting figure subjects, where the medium tended to be handled in a more solid manner to imitate oil painting or the miniature, and depended much on carefully

placed small touches. Much attention was paid to local colour and form. Often the stippling made use of optical mixtures of different colours, though in a less self-consciously scientific way than that of the Impressionists thirty years later.

Rossetti's Dantesque and Arthurian watercolours and drawings, and the *St George* series, all on a small scale, densely composed, luminous in colour, completely freed of Pre-Raphaelitism, along with the illustrations to Allingham, Tennyson and the poems of Christina Rossetti, establish a formal style which while making much of mediaeval and legendary motifs and details, is not antiquarian or reconstructive, but sets up a private symbolic vocabulary. When the work calls for it, this may become quite precise and explicit, but it may equally remain elusive and mysterious, operating in a metaphoric way, at the same time as on the sensuous plane. Rossetti's unorthodox uses of watercolour, his scrapings and scumblings and scratchings and stipplings, his mixed colour and his mixed media, create great richness of surface, while giving a barbaric or heraldic character to the tightly pressed forms. The concreteness, the sensuous vigour, which Keats made so important an element in his poetry, and Rossetti in his, have their equivalents here, and the effects are intensified by the scale on which we see them work. However arbitrary his treatment of formal space and volume, however inexact in drawing or impossible of construction or use the packed forms which Rossetti invents, they work together to create a picture plane of compelling quality; however much may be improbable, nothing is vague.

The tune of seven towers (pl. 48) is brutally divided by the diagonal of the lance which suspends a long, bright, vertical pennon to close off our leftward view. What confronts us is not bad drawing or inaccurate research; we are in the dream with the painter, and as in a dream, the improbable, even the impossible, is real, immediate, present, and we accept it. Nobody ever knew better than Rossetti, or exploited the knowledge so fully, that it is vividness, precision, concreteness, and not vagueness or indeterminacy, that most powerfully creates the otherness of a dream world. And the dense packing of these pictures with so many forms that are arbitrary, geometric, heraldic, fills the picture space with strong pattern enclosed in a very tight box.

All we see, all that must exist for us, is confined within this tight, agorophobic box, from which we are not to escape except by very specific routes: there may be an exit through the rear plane into some yet tighter half-seen space; or an upward retreat, as in *Dante's dream* (pl. 57), where an opening in the roof of the chamber in which we stand and watch Dante approach the dead Beatrice leads up and out; or there may be two levels—a stair to some low room or loft, a gallery where angels sing and play lutes or zithers.

The same sort of thing is also to be seen in the individual elements in a painting, where a seat or throne may have a solid base, the panel of which opens to show us a flask or book within; or its back may extend overhead into a sort of canopy which is also a tiny gallery, or another cupboard where golden bells hang, and are rung by a dreaming girl who stands below, or by an angel hand that reaches through a window. The source of these recurrent motifs is manifold: chiefly, no doubt, mediaeval, and especially the work of Flemish and North European artists, such as Van Eyck, Dieric Bouts, Gerard David and above all, Memling, whose work so captivated

Rossetti when he and Hunt visited Brussels, Ghent and Bruges in 1849; the German Little Masters, too, and Dürer, beloved of Bell Scott; perhaps, but much less directly, something of Blake, since Rossetti bought the Blake notebook very early on, though it was valuable to him chiefly for its poems and commentary. And yet it is difficult to say more than this, so unimitative, so little concerned with historic style was he, so intent on expressing his ideas, at once poetic and plastic. Although the presence of things is important to the effects he must achieve, nothing in his watercolours comes near the naturalism with which his Flemish begetters realize objects; pattern is more to his purpose, and as he uses it, would be weakened by too exact a rendering of real appearance. Much of his pattern is produced by the crudest of means; garments are parti-coloured, strewn with stars in gold or red which are no more than scrawled crosses of colour; striped, adorned with sun or moon, or with interpenetrating wavering points derived from heraldic practice, but certainly never reducible to any meaning admissible by the College of Heralds. Walls may be panelled, or as in *The blue closet*, tiled with small squares which also cover the floor under our feet: hung with a wavering curtain, or pierced by a small shuttered window; but half their area hidden behind tall thrones or canopied beds or raised banners.

One particular example of Rossetti's invention, the *Blue closet* watercolour already referred to, is worth a close look. It was bought by William Morris at the same time as he bought Madox Brown's *Hayfield*, and Rossetti's own *The tune of seven towers* and belonged to him for about seven years. To both the Rossetti watercolours he wrote poems, which appear in his *The defence of Guenevere* of 1858. The poems no more describe Rossetti's paintings than Rossetti's own illustrations had described Tennyson's poems—rather less; but they made equivalents. Morris did the same also with the watercolour of *King Arthur's tomb*. That he was able to do this so successfully was due partly of course to the intense sympathy between him and Rossetti, the closeness of their feeling for the same sort of poem, the same sort of painting; but it was also due to the nature of Rossetti's concepts, and the effective fusion in his mind at this period between poetry and painting, neither having precedence over the other, both felt as vehicles of expression equally accessible. Perhaps it is in *The tune of seven towers*, and *The blue closet*, that this is easiest to see. Neither picture has any narrative import: we may invent as we please around the artist's figures and properties, but he tells us nothing of any story; nor do we need one. *The blue closet* is effectively symmetrical about a vertical axis, and working upon a principle of counterchange; its four figures are balanced, two and two, right and left of the odd little organ which stands in the centre of a tall narrow space: above the organ stands a cabinet containing bells, which are rung by the left-hand woman, who wears a wimple; both she and the woman immediately facing her, who wears a crown, also finger the two keyboards of the instrument; behind each figure a second figure stands, less substantial, and the four figures fairly fill the space. That space hardly has depth enough for even these slender forms, and it is cut off behind them by its continuous pattern of tiles; small tiles, which bear no exactly decipherable motif, simply three or four calligraphic brushmarks, derived as much from those on oriental porcelain as from the more pictorial motifs of the mediaeval tile, but strictly like neither. These small, slightly irregular motifs, repeated as if on two-inch tiles all over the rear wall

and across the narrow strip of floor, close off the space rearward and define a ground plane. Among the very earliest products of the Firm are the small blue-and-white tiles used, for example, in the Witley fireplaces (painted, not printed—the Firm printed no tiles), where they support the picture panels, also tiles, which tell the story of Sleeping Beauty, or Cinderella. And when we look at the pictorial tiles by Burne-Jones inset into these fireplaces, we find compositions derived as Rossetti's were derived, from Flemish painting, from northern manuscripts. In whatever creative direction the partners of Morris, Marshall, Faulkner and Company moved in those first years, they moved in directions indicated by Rossetti, using forms established more by him than by anybody else except Madox Brown.

As a student Rossetti modelled himself on such illustrators as John Gilbert, Richard Doyle and Gavarni; Retzsch or Bell; and men like Franklin, who were influenced by the German school. After 1850 his romantic, rather formless groups based on popular vignettes gave place to more tightly constructed compositions. This transition begins in such drawings as the *Borgia* but it is with the first Dantesque designs that we see the new styles established. It is at the same time that he begins his graphic work as distinct from his painting.

He had enormous influence in the field of graphic design, out of all proportion to the actual amount he produced. His influence spread not only in England and Scotland, but to Europe, from Vienna to Barcelona and to Brussels; and to the United States of America. In 1849 and 1850, after the success of his first painting, and during the period when *The Germ* was being planned, he projected a portfolio of etchings on themes from Dante's *Vita Nuova*, to be accompanied by his own translation. In the mid-nineteenth century, this was a very popular and often lucrative form of publication, first exemplified perhaps, much earlier, by the Flaxman plates to Homer, and continuing until at least as late as 1887 when Bell Scott published his etchings to 'The King's Quair'. Nothing ever came of Rossetti's scheme, though no doubt some of the designs were later reworked, nor did he ever publish any etchings. His first direct acquaintance with wood engraving as an artist came in 1851 when he was earning—probably not much or for long—by drawing on the wood for engravers. This is referred to in the long letter to his Aunt Charlotte, of February, dated from 17 Red Lion Square, Deverell's studio, and it was most probably through Deverell that he got the work. This was not designing, but simply drawing on the block for the engravers—humble, commercial work but a useful if undistinguished source of income for many artists until Thomas Bolton's invention for the photographic transfer of images to the woodblock superseded it. The stories of his difficulties with the Dalziels over the later engraving of his illustrations to 'The Maids of Elfenmere' and to the Moxon *Illustrated Tennyson*, usually lay the difficulties at Rossetti's door, and no doubt some of the problems were of Rossetti's making; but these were chiefly of delay, not of any technical kind. It is not true that his drawings were unsuitable for engraving, and all the references in his letters make it clear that he understood very well what he was doing—and what the Dalziels were *not* doing. Though there were good engravers in the Dalziel workshop, there were poor ones too; it was one of the two or three biggest trade houses, and its work showed all the marks of the de-

generation that had already begun to overtake wood engraving. Few of the craftsmen employed could draw; most were simply facsimilists, who cut line for line and were incapable of interpretation. When one of Rossetti's Tennyson drawings was cut by William Bell Scott's old Chartist friend, W.J.Linton, he was very happy with the result and there was no dispute whatever with the engraver. Linton, last of the great 'white line' engravers, could cut a fine facsimile or a faithful and imaginative interpretation, according to the nature of the original. Confronted with Rossetti's drawing on the block, he understood its meaning; that it combined pen and pencil and chalk was no handicap to him. Rossetti, unlike Morris, never learned to engrave himself; his impatience of the actual execution of any process like engraving or etching, which got between his vision and his hand, prevented this. But he understood very well what the engraver could do for his invention. From Linton, as later from Charles Faulkner, he got what he needed. From Dalziel, he did not.

His first published graphic work was a single illustration that appeared in Allingham's *Day and Night Songs*. It was begun at Blackfriars, but finished at Hastings, in 1854, when staying there with Lizzy. It illustrated the poem 'The Maids of Elfenmere', and deeply moved Burne-Jones and Morris when they encountered it, giving the former a model whose emotive power and formal concepts alike served him to the end of his days.

This drawing is unusually severe, with none of the elaboration of detail or pattern of the later Tennyson illustrations. The three singing maids, with distaff and spindle, stand in a tall, narrow space, perhaps a tower; at their feet sits, listening, the awestruck young man; behind and above, the roof and walls of the tower-chamber are pierced by curious plain rectangular openings, through which we see the sea, the town asleep under the moon, the church spire with its clock. The columnar figures, lit from an opening in the ceiling, set up beautiful vertical rhythms countered and complemented by the dark seated figure on the floor. It is no wonder that Burne-Jones wrote of this drawing as he did.

Moxon's scheme for an illustrated Tennyson seems to have been conceived at the end of 1855, when he called on the three leading Pre-Raphaelites, Hunt, Millais and Rossetti to ask their help. He had no conception of issuing a volume with any kind of visual unity, only of getting the biggest sales by a combination of the best-selling poet with as many well-known artists as he could get: he did not set out to promote the Pre-Raphaelites, but included them because, their notoriety now turned to fame, their names would be helpful.

The five Rossetti illustrations probably did more to bring his work before a mass public than anything else, since he so seldom exhibited. All bear a close relation to his paintings of the fifties and early sixties: as always, he made watercolours from drawings, drawings from watercolours, and often even oil versions of favourite themes. Four of the Tennyson drawings are identical in spirit and character with the typical fifties romantic watercolours: *Sir Galahad, St Cecilia, The Lady of Shalott* (pl. 59) and *The weeping queens*. The fifth, *Mariana in the South*, is rather different. In spite of the familiar background details of cupboard, lamp, spinning wheel, mirror and tiled floor—all put in, however, rather loosely—this is a different sort of drawing. More than half its area is taken up by the kneeling figure of Mariana, who has flung

157

herself at the foot of a crucifix and is kissing the feet of the Christ. Her whole pose, the attitude of the head, her expression, quite clearly belong to the studies for *Found*.

The four illustrations to Christina's 'Goblin Market' of 1862 (pl. 62) and 'The Prince's Progress' of 1866 (pl. 55) show an appreciable change, consistent with changes overtaking his painting, and relating also to his now well-established work in stained glass. All fine lines and delicate detail, subtle changes of tone and intricate pattern, have gone. Instead we have large simple areas of black and white in counter-change, broken by very simple but effective patterns using motifs as innocent as a four-petalled flower, a cross, a heart; the designs relate to the unpublished title-page for his own *Early Italian Poets*, in which two kissing lovers, derived from the earlier Paolo and Francesca theme, kneel in front of a low rose-trellis surmounted by a grille of thirteenth-century character, but the published designs for Christina's poems are solid and weighty—more voluptuous, too: *Golden head by golden head* can have had no other model than Fanny Cornforth. Five designs for the Tennyson; one for *Day and Night Songs*; four for Christina's poems: appearing at intervals during a decade this is a small body of work to have had so powerful and lasting an impact. Young Walter Crane (pl. 105) saved up to buy the Tennyson, published at the price of a three-decker novel, by no means a cheap book. Other young artists and later designers found in Rossetti a valuable model; Will Bradley in Chicago (pls. 93, 95), Aubrey Beardsley in London (pl. 101), Mucha in Paris, and the 'Spook School' in Glasgow.

It is from this period that what came to be seen as the typical Rossetti painting, and, more mistakenly, the typical Pre-Raphaelite painting, really dates. Millais' identification with the Royal Academy and his long residence in Scotland coupled with Hunt's absences in Egypt and Jerusalem, and his carefully fostered image as a sort of John the Baptist of modern art, had left the field open in London for Rossetti to become the dominant figure in a series of interlocking circles, social and artistic. By 1860 the movement was identified, by the public if not by painters, with Rossetti, and whatever he did was considered Pre-Raphaelite. Since his activities extended in the first fifteen years of his career from painting to poetry and design, the images and formal arrangements of his later invention and development, which were quite opposite in spirit and purpose to the spirit and purpose of the paintings of 1849–51, came to have the term attached to them.

This mistaken notion of Pre-Raphaelite art came to be that of a painting or draw-ing based on a readily recognizable formula. It would be a half-length female figure, dressed in flowing, opulent, rather indeterminate robes, perhaps with bare arms; with a mass of unbound hair, in the sixties red, in the seventies dark; an oval face, broad and rather pale, to set off its huge dark eyes—dark, whether blue or black or brown as to actual iris colour—long fine nose and full mouth whose curves tended, after Jane Morris became Rossetti's favoured model, to be improbably formal. The neck was bare, long, and generally circled by some necklace with, perhaps, a jewel. One hand might play with the jewel, or idly pluck at a not-too-precisely described musical instrument, hold a hand-mirror, caress a flower; and as likely as not a large area of the canvas would be occupied by a mass of flowers. Perhaps a dove would fly in from some mysterious opening above, the source of light. It mattered not that

Rossetti actually used a number of different models—Fanny Cornforth and Lizzy Siddal in the fifties, Jane Morris and Marie Spartali in later years, with Mrs Herbert and Mrs Beyer, and Alexa Wilding. The characteristic arrangement and choice of beauty—and beauty, not of classical type, was absolutely a part of this—was so strong, the pattern of formal qualities so deeply ingrained in his vision, that the rest of the world, less precisely observant than himself, can be excused for thinking that they saw always the same model. In an individual sense, they did not; in a formal sense, they did, and we still do. It is in his establishment of such a commanding formula that Rossetti both departs from Pre-Raphaelite painting and makes himself the leader of the Aesthetic school in painting, and by extension in graphic design. Where the true Pre-Raphaelite painting must be read with care, however strong its impact, and studied for the iconographic value of all its minutely delineated parts, the later work of Rossetti relies much more completely on an immediate impact; not the impact of a 'real' scene unfolding before us, but the impact of a painting which is conceived both as a system of symbols, and as an artefact, an object of beauty and sensual delight. The painting as a beautiful object was not part of the first Pre-Raphaelite intention but it became an essential part of Rossetti's, from the time of the watercolours. Certainly the Pre-Raphaelites had contributed new types of beauty, as far as human face and figure go, to the scheme of the acceptable and desirable, Rossetti playing his full part in this. Now indeed he played a weightier part simply because in his paintings there was so little of narrative or scene, so great an emphasis on the single symbolic figure. But in establishing his types and their accessory symbols, though he no longer tried to paint with the sharp intensity of the first years, and above all had given up the idea of the pure sunlight as an ideal source of light (more and more of his work was actually painted by artificial light—gaslight), he did paint with great pains and care, spending a great deal of time and money in getting to his liking a bough of laurel, a sheaf of lilies; and the painting of flowers, jewels, robes, furniture, when from Rossetti's own hand and not from that of an assistant, is often very fine. Having freed himself from external constraints, and found his own way, he began in the sixties to be able to paint all he needed with growing mastery. There is no doubt that the commission for the Llandaff altarpiece (pl. 49) helped him to achieve this, though it was six years in the doing. The challenge, too, of teaching Lizzy, and then Burne-Jones and Morris, of taking up the role of master, played its part; there was nothing objective about Rossetti's attitude to the actual practice of his art. For him a painting did not deal primarily in the physical account of forms and colours and arrangements as experienced, or in giving form to certain accepted ideals or norms held to embody a truth; it expressed a state of mind, of aspiration or despair; it symbolized fatal love; it was extremely subjective and therefore, within all the apparatus of formal symbols which he created to serve his own ends, it had a certain expressionistic element.

Two of the finest and most deeply impressive of Rossetti's paintings, both done in the 1870s, though one had its origins twenty years earlier, are *Dante's dream* (pl. 57) and *Astarte Syriaca* (pl. 58). There are many other paintings by him which are more immediately likeable and beautiful; but these two show the full depth of his expressive power in their quite different ways.

In *Dante's dream* we have his largest and most formal work. It took a long time to paint, and its first conception can be dated by a watercolour of 1856, the year of *Fra Pace*, and his first association with Burne-Jones and Morris, when he was first working on sketches for the Llandaff altarpiece. It was resumed and painted as a large oil about 1870, at the time of his new relationship with Jane Morris, and repeated on a smaller scale in 1880, two years before his death.

The theme of Dante's relationship with Beatrice, to be realized only on an ideal plane, was inextricably bound up for Rossetti with his relationships first with Lizzy Siddal, then with Jane Morris; and this, which he regarded as his most important painting, which uses the devices of the jewelled watercolours of Lizzy's lifetime, in a new, monumental way, thereby succeeds in transcending his private obsessions with the two women as individuals. These devices, by which we see doves flying in with poppies, symbols of sleep and death, love with the arrow and angels looking down on the dead Beatrice, are none of them new. The idea of the red dove with the poppy was used in *Beata Beatrix* of 1863, immediately after the death of his wife. But because these devices now operate on the scale of life, we are ourselves drawn into the same space that contains the bier where Beatrice lies, struck by the dual dart of Love and Death, and Dante stands fearing equally to sleep and to wake. This is no rich miniature to be taken in the hand, but because of its scale and its completely worked-through order, imposes on us something beyond enjoyment. The *Astarte Syriaca* is a painting of much more disturbing power, in which the latent expressionism of Rossetti's art erupts especially in the colour, and the triple likeness of Jane Morris evokes a real sense of fate and menace. It dates from 1877, five years before his death, when his health had already been undermined by insomnia, chloral and whisky, and he had undergone several periods of serious mental collapse. The relationship with Jane, which in 1870–1 seemed to promise a new life, had turned into something more frustrating and devastating than ever that with Lizzy had been, and his life was more and more solitary and suspicious of friends. The most simply voluptuous phase of his painting was over; but in spite of sickness his power was not less; only somewhat differently directed.

Astarte Syriaca was commissioned by the photographer Clarence Fry. It had been preceded by a pen drawing on the same theme of 1875, in turn anticipated by the remarkable, careful pencil drawing *The death of Lady Macbeth*, a truly horrific interpretation in which the central figure is uncomfortably like Jane, with its great mass of wildly flowing hair, strongly marked features and wringing hands. Fry can hardly have imagined how awesome and even terrifying a painting he was commissioning, though it is by no means simply horrific. This is the painting to which Graham Robertson refers in *Time Was* in the chapter headed 'The spell of Rossetti':

> A few years ago I was straying through some loan collection . . . on this occasion I shied violently across the room at a terrible work which, to my shocked and instantly averted gaze, announced itself as an unusually bad Rossetti. I saw—against my will—a face with purple lips, huge lilac arms sprawling over lumpy fulvous folds, distorted drawing, tortured paint. For very love of Rossetti I would not look again; I would forget as soon as possible.

Some days afterwards I began to be haunted by a beautiful Presence, vague, half-remembered. A wonderful face, gentle and noble, with eyes that dreamed and lips that faintly smiled, a lovely pattern of clinging white fingers, the gracious fall of flowing draperies . . . I had seen no such beautiful picture very lately. Suddenly it came to me—it was the picture Rossetti was trying to paint when he produced the lilac and purple horror.

It is indeed at sight a repulsive painting, but one of his very finest. The colour is dark, purple and greyish contrasted with dull orange; the Goddess is a tall, massive, rather frightening figure, dominating not only the canvas but the room in which it hangs. Part of the effect of great height is due to the smallness of the head under its immense mass of thick waving hair, partly to the excessive weight and length of the left arm, which (and this is to be seen in some other of Rossetti's paintings) looks like an arm by El Greco—a painter of whom Rossetti can barely have been aware. The frame bears two verses reading:

> Torch-bearing, her sweet ministers compel
> All thrones of light beyond the sea and sky
> The witnesses of beauty's face to be

and

> That face, of Love's all-penetrative spell
> Amulet, talisman, and oracle—
> Betwixt the sun and moon a mystery

Elements of the imagery are to be traced as far back as the figure of Love in the earliest designs for *Dantis Amor* (pl. 61)—a figure standing between sun and moon, carrying a dial and an inverted torch; in the *Astarte* we have two attendant figures, each bearing a torch; the symbolism has been re-ordered, but is clearly the same. Imbued with all the despair of Rossetti's emotional situation of the time, this painting forecasts much that was given a less ordered and more savage expression in Strindberg's plays and Munch's paintings: what is astonishing is that at this point Rossetti still retained such mastery over what he did.

12 Burne-Jones, Morris and Rossetti

A truer perception of what was needed, and of what was possible, in order to revive a feeling for the almost forgotten art of design was due, as I have always thought, mainly to the initiative of Rossetti.

J.Comyns Carr—COASTING BOHEMIA London, 1914

At the end of 1853, Edward Burne-Jones and William Morris, students of Exeter College, Oxford, first began to be aware of the Pre-Raphaelites. Hitherto their interests and those of the other students with whom they associated, chiefly young men from Birmingham, had been religious and literary, though Morris had brought with him from Marlborough his passion for mediaeval art and architecture, and Burne-Jones was an enthusiastic amateur draughtsman. Now both men began to find themselves more and more drawn to the visual arts, where their friends could never quite follow them. By the end of the year, they had read with excitement Ruskin's *Edinburgh Lectures*, and been alerted by him to the existence of Pre-Raphaelite painting; then Millais' picture, *The return of the dove to the ark*, was shown for a time in the window of Wyatt the art dealer, and then, says Burne-Jones, 'we knew'.[1]

In the following May, they saw in the Royal Academy Exhibition the two paintings that established Holman Hunt's success—*The awakening conscience* and *The Light of the world*; and while in London, they visited the collector B.G.Windus, one of the first patrons of Pre-Raphaelite art, and saw in his collection more drawings and paintings by Millais, and their first Madox Brown, *The last of England*. They began to seek out such work wherever they could hear of it, and back in Oxford, visited Thomas Combe, director of the Clarendon Press, the owner of the Millais picture they had first seen, where they saw also Hunt's *Druids*, and the portrait of Canon Jenkins called *New College Cloisters*. But what most excited them there was their first sight of a painting by Rossetti—the watercolour of *Dante drawing an angel in memory of Beatrice*. 'We had already fallen in with a copy of *The Germ*,' says Burne-Jones, 'containing Rossetti's poem of "The Blessed Damozel", and at once he seemed to us the chief figure in the Pre-Raphaelite Brotherhood.'[2]

Both had come to Oxford with the idea of taking Orders; but had moved away from that first intention, becoming more absorbed in the practice of drawing, painting and poetry. Though the romantic idea the whole group had been nursing, of a close community of lives dedicated to truth and beauty, had had its day, a new notion now arose which was to unite them more practically in a significant concerted effort: the founding of a magazine. No doubt their discovery of *The Germ* prompted

1 G.Burne-Jones *Memorials of Sir Edward Burne-Jones* London, 1904, Vol. 1, p. 99
2 *Op. cit.* p. 110

this. The aim of the proposed *Oxford and Cambridge Magazine*—for they had one or two friends at Cambridge—was, like that of *The Germ*, to combine reviews and articles promoting the ideas in which they believed, with poems, stories and occasional etchings, in which those should take creative form. Plans were made during the summer of 1855, after Burne-Jones and Morris had spent three weeks in a tour of the churches of Northern France, including Paris, where Morris was disgusted by the restoration of Notre Dame, bored by the opera, delighted by the Musée Cluny and took special pleasure in showing Burne-Jones the same Fra Angelico, *The coronation of the Virgin*, which had been one of Rossetti's own discoveries in the Louvre.

Back in Oxford by mid-October, Morris resolved to become an architect, Burne-Jones to be a painter. Burne-Jones began work on a series of drawings in illustration of a proposed volume of *Fairy Ballads* by their friend MacLaren, in whose gymnasium they boxed and fenced, but whose real passion was, like theirs, for art and literature. Morris wrote a long article on the churches they had seen, others of the group also worked on material for the magazine. Burne-Jones wrote a review of Thackeray's *The Newcomes*, which had appeared in the summer with Doyle's illustrations, and in the course of the article went out of his way to praise, as the finest of all illustrations, Rossetti's drawing *The maids of Elfenmere*. They had been so enchanted by this drawing that Morris had immediately begun to experiment with wood-engraving and Burne-Jones set about remodelling his own drawings in the light of the little master-piece.

Morris took his degree, and articled himself to George Edmund Street, diocesan architect for Oxford. But for Burne-Jones to pursue his career as a painter meant two things. He must meet professional artists, and above all, Rossetti. This, of course, meant London. The magazine was taking shape: Morris, who was financing it, preferred not to edit, but offered William Fulford a salary of a hundred pounds a year to do so. Fulford moved to London in order to do this and in the New Year the first issue appeared.

Burne-Jones also went to London. Learning that Rossetti took a weekly class at the Workingmen's College, now in Great Ormond Street, he went there to make inquiries and a few nights later met Rossetti at Vernon Lushington's rooms in Doctors' Commons. Rossetti invited him to visit him at Chatham Place the next day, when they talked rather of poetry than of painting, and of Morris's poems in particular, for Rossetti had subscribed to the *Oxford and Cambridge Magazine* and been impressed by Morris's work. Burne-Jones, intensely shy, was shown many drawings and designs, and stayed to watch Rossetti at work on the watercolour then on his easel. But Rossetti was also pleased with the reference in Burne-Jones' review of *The Newcomes*, to his own drawing. He wrote to William Allingham, author of the poem, saying of this: 'It turns out to be by a certain youthful Jones, who was in London the other day and whom, being known to some of the Workingmen's College Council, I have now met. One of the nicest young fellows in—Dreamland, for there most of the writers in that miraculous piece of literature seem to be. Surely this cometh in wise of *The Germ*, with which it might bind up?'

Burne-Jones was now completely caught up in painting, or at least the idea of painting, since at this point he seems only to have made drawings, and not even to

have embarked on watercolours. He abandoned the idea of taking his degree. The opening of the Royal Academy Exhibition in May saw him, with Morris, seeking out the Pre-Raphaelite works: and, compared with the previous year when the Pre-Raphaelites had been thinly represented and even Millais' *The rescue* skied, there was a real feast for them. Five works by Millais included *Autumn leaves, Peace concluded* and *The blind girl*: more significant, perhaps, since more purely Pre-Raphaelite in feeling, were Hunt's *The scapegoat* (pl. 24), Wallis's *Death of Chatterton*, William Windus's *Burd Helen* and Arthur Hughes's triptych of *St Agnes' Eve*, and his *April love*. It was a year of signal triumph for the Pre-Raphaelite sympathizers. Morris was so captivated by the last-named painting that, back in Oxford, he wrote to Burne-Jones to 'nobble it for him'—which was immediately done.

Burne-Jones now began to see Rossetti regularly and to work under his guidance— eventually, with the valuable help of Ford Madox Brown, the universal friend. Morris, at work until Saturday afternoons in Street's office in Oxford, would come up to London and stay until Monday morning, bringing his latest poems. Together they would go to Rossetti, or he would visit them; or they would all go to the play, or to easy, informal stimulating parties at the studios of his friends, leading a bohemian life more innocent than Rossetti's own, in the shadows of which moved such ambiguous figures as Annie Miller and Fanny Cornforth.

Surprisingly, they did not meet Lizzy Siddal for nearly two years. Rossetti's life was now very full and various and he did not bring all its parts together. Ruskin's patronage, and that of northern industrialists and merchants, meant that he sold as he produced, and got frequent commissions that left him free to develop his own style in subjects now chiefly drawn from Dante or Malory. He had no need of the public exhibitions. In addition to the watercolour *Fra Pace*, on which he was busy when Burne-Jones first went to Chatham Place, he was working on a large watercolour of *Dante's dream of the death of Beatrice*, and on designs for the altarpiece commissioned by John Seddon, architect to Llandaff Cathedral. He had also, as a result of a visit to Oxford, met another architect, Benjamin Woodward, whose friendship and enthusiasm for Pre-Raphaelite art seemed likely to bear fruit in the shape of more commissions. Rossetti's friends Munro, Woolner and Tupper had all been commissioned to make statues for the new Museum and no doubt Rossetti hoped for a commission himself, for some sort of mural decoration. Nothing came of this but, clearly, the possibility led to the later decorations of the Debating Hall, in 1857–8.

Although it was Pre-Raphaelite painting that had brought him to notice and made Ruskin his friend, Rossetti was by now really almost done with the original Pre-Raphaelite idea. But in another sense he was more seriously Pre-Raphaelite than ever, in his search for inspiration and the confirmation of his own impulses in pre-Renaissance painting. He had recently met Layard the explorer, who was just back from Italy with careful copies of early paintings. 'They have hundreds—whole reams of these things—of course more interesting than one can say,' he wrote to William Allingham in April 1856. 'Benozzo Gozzoli was a god . . . I believe some means will be taken to publish or show publicly all these things. A most glorious treat which I had yesterday is the sight of the Giotto tracings made for the Arundel Society, and now in the Crystal Palace.' Madox Brown, who had seen the originals,

was less impressed; but to Rossetti the revelation of pre-Renaissance art must have been enormously exciting. To Hunt these replicas might be suspect as mere archaeology; to Rossetti, Burne-Jones and Morris they were opening doors to a new creativity.

Another such door was, undoubtedly, the patronage of the wealthy provincial buyers who were excited by the direct reference to nature in Pre-Raphaelite painting, moved by the romantic themes and intense colour which Rossetti and his friends exploited, and without the preconceptions of an older and more metropolitan patronage. They were men who had read the Bible, *Pilgrim's Progress*, Milton, Shakespeare; were reading Dickens, Scott, Thackeray, Tennyson and Browning. They brought to their judgement of a painting, not Lemprière's classical dictionary and the academic rules, but their own experience. What Holman Hunt, Millais, Brown, Hughes, Rossetti offered stirred very personal chords and responses; responses which they could afford to indulge, and did, with Ruskin as their guide.

The colour sketch of *Hist! said Kate the Queen!*, which Rossetti had already sold to his Aunt Charlotte, took the fancy of Marshall, the Leeds millionaire, when he saw it, still in the painter's studio. No sentimentality prevented Rossetti from offering his Aunt another painting instead; Aunt Charlotte was made happy with a portrait of her sister Eliza, and *Kate the Queen* went to Eaton Square. Another patron, also from Leeds, was Thomas Plint, a successful stockbroker, who commissioned a watercolour of *Saint Cecilia*, having seen the beautiful design Rossetti was preparing for Moxon. Presently, perhaps moved by the reprinting in the November issue of the *Oxford and Cambridge Magazine* of Rossetti's early and splendid poem, 'The Blessed Damozel', Plint offered an extra twenty guineas for a painting on this theme rather than the St Cecilia.

'The Blessed Damozel' was not the only work of Rossetti's that had appeared in the magazine: his 'Burden of Nineveh' had been published in the August issue, and in referring to the magazine he now spoke of it as 'conducted by friends of mine'. The new group, with himself as sun and centre, was well established by the end of 1856, when he went to Bath to join Lizzy Siddal, with a commission for a drawing from Morris, at this stage patron as well as disciple. Morris was being drawn more and more into the world of the artist as distinct from the world of the architect; drawing, modelling, studying and emulating mediaeval illumination in his spare time, he became steadily more and more committed to direct, manual creation. The last issue of the *Oxford and Cambridge Magazine* was that for December 1856. It had run, as intended, for a year. Its function had been to act as the organ of a group with common tastes and aims and it had supplanted the more ideal notion of a 'monastery', just like *The Germ* before it. Now, as it came to an end, this unifying function was called to mind again, and the idea of some sort of artists' community, with studios and living quarters, was raised again—perhaps first by Morris and Burne-Jones. The intended participants were these two, Madox Brown and his wife Emma, Rossetti and Lizzy Siddal (at this period, it seems, thinking of marriage) and Holman Hunt. It was to be very specifically a community of practising artists; but it went no further when Lizzy absolutely refused to live in a community that included Holman Hunt. By now Morris had given up his articles with Street, and moved entirely into the field of painting and poetry. Even the removal of Street's office to London, which

had given him more opportunity to spend time with his new friends and to draw and paint with them, did not satisfy his new hopes. It has to be remembered that before Burne-Jones arrived in London he had had no formal training in drawing, and had never painted, while Morris's studies had been limited to the drawing of architecture and ornament. Now both needed the more complete discipline of drawing from models, and chiefly, the figure. In this too Rossetti had been helpful. 'Is it in rule to beg tickets for friends to the Langham Chambers meetings?' he wrote in a letter of late 1856 to Lowes Dickinson. 'Two friends of mine have already accompanied me thither, and might often like to go, when it might not be convenient to me to fetch them; and as they are both stunners as artists and bricks as coves, I venture to make this request; viz. that you will bestow tickets of leave on Edward Jones and William Morris Esqs., both of 17 Red Lion Square.'

They were in fact living in the rooms in Red Lion Square which he and Deverell had had years before. Rossetti wrote to Allingham:

> [Morris] and Jones have lately taken those rooms in Red Lion Square which poor Deverell and I used to have . . . Morris is rather doing the magnificent there, and is having some intensely mediaeval furniture made—tables and chairs like incubi and succubi. He and I have painted the back of a chair with figures and inscriptions in gules and vert and azure, and we are all three going to cover a cabinet with pictures . . . Morris means to be an architect, and to that end has set about becoming a painter. In all illumination and work of that kind he is quite unrivalled by anything modern that I know—Ruskin says better than anything ancient.

By the end of November 1856 Rossetti had convinced Morris that he too should become a painter, and that he and Burne-Jones would be much better off in unfurnished rooms than in lodgings—one in Oxford and one in London. The Red Lion Square rooms being empty, he had wasted no time but installed the two there as soon as possible. Burne-Jones's description in a letter home supplements Rossetti's:

> We are quite settled here now. The rooms are so comfortable, not very furnished at present but they will be soon; when I have time I will make a rough drawing of the place and send it down. Topsy [Morris] has had some furniture (chairs and tables) made after his own design; they are as beautiful as mediaeval work, and when we have painted designs of knights and ladies upon them they will be perfect marvels.[1]

The chairs were painted, as Rossetti's letter shows, and as appears in the rough drawing, which Burne-Jones did indeed send down. It is worth noticing that, apart from its upward extension into a tall, over-hanging, panelled back, the chair on which Burne-Jones shows himself in that drawing—he is examining the painted panel—is identical with the stool in Rossetti's drawing *Hesterna rosa* (pl. 51).

Here in Red Lion Square the two worked for nearly two years. On a Thursday, when Ruskin took his drawing class at the Workingmen's College, he would look in and stay to talk with them, and Rossetti or Brown would come and advise them over their work—which in Morris's case included wood-carving: bursting with energy,

1 *Op. cit.* p. 147

eager to try everything, he had during his time with Street already practised illumination, designed ornament, modelled in clay, learned to embroider. Burne-Jones worked at pen drawings and watercolours, making scrupulous studies; in the evenings they would go to the Langham Place Studios to draw from life.

Burne-Jones had become engaged in the summer to Georgiana Macdonald, sister of an old school friend and fellow-student at Oxford, but so far he had earned nothing. Rossetti, whatever the reasons for his own unresolved relationship with Lizzy, knew how important it was for his young friend to establish himself professionally, and took the first, and indeed every opportunity to help. When in July, William Windus of Liverpool wrote to ask if he would find, and oversee, an artist to draw on the wood his Royal Academy picture *Burd Helen*, for an engraving to be reproduced in the new *National Magazine*, Rossetti immediately offered the work to Burne-Jones. But before he could begin, Morris showed Rossetti some designs which Burne-Jones had been too diffident to disclose, which so impressed Rossetti that he refused to let Burne-Jones go on with what was, after all, exacting hack work. Having himself been asked for designs by Powells of Whitefriars, who had recently launched into the production of stained glass, Rossetti offered the commissions to Brown and Burne-Jones. By the end of the year they had both produced substantially finished cartoons that might well have been months longer in coming from Rossetti's hand. Early in 1857, too, he introduced Burne-Jones to Plint, the ideal patron for such subjective artists as these. Plint made no stipulations as to what he wanted, when, in March, he commissioned two pictures from Burne-Jones, but gave him an advance payment. Burne-Jones began two designs to illustrate 'The Blessed Damozel' and these, his first commissioned paintings, were to be the main work of 1857. At the same time, he completed five more cartoons for Powells, besides innumerable drawings and designs. *The blessed damozel* paintings were not finished, nor was the commission given by the same enthusiastic and generous patron to Morris, on which he was hard at work under the eye of Madox Brown during the summer. Morris's design was for a theme from Malory: *How Sir Tristram, after his illness, was recognized by a little dog he had given to Iseult.* Before either painter was near finishing his task, Plint died suddenly; but it was really another enterprise of Rossetti's that made them put their paintings aside.

June 1857 saw Madox Brown organizing the Pre-Raphaelite exhibition in Russell Place. When this was over Rossetti invited Morris and Burne-Jones to visit Oxford with him, there to meet Woodward, now busy supervising the building of the Debating Hall. Burne-Jones, deeply involved in his paintings, stayed in London; but Morris and Rossetti met Woodward and looked over the new building. The earlier hint from Rossetti as to mural paintings in the Museum was now renewed in this new connection; the proposal was put before the officers of the Union Society—and agreed. Paintings were to occupy the large spaces of wall beneath the open-timbered roof and above the galleries that ran around the walls. Each bay, between the roof trusses, was in fact pierced by two fairly large round windows, making these particularly unsuitable areas for murals, but inexperience does not always see difficulties, and Rossetti and Morris came back from Oxford full of excitement. The paintings were to be on themes from Malory, illustrating the story of the Sanc

Grael—and the artists would work without fee, the Union Society providing their materials and maintenance. Hungerford Pollen, whom Rossetti had met some little while earlier, and whose decoration of the Chapel of Merton College had long been admired by Morris and Burne-Jones, was invited to take part; so too was Arthur Hughes; and Rossetti brought in two more from the Little Holland House circle: Spencer Stanhope and Val Prinsep. The arrangements were altogether too spontaneous and ideal: the walls were unprepared, as were the artists, none of whom knew anything about the sort of painting they had undertaken.

Morris with typical impatient energy, was first to set to work, on his design of *How Sir Palomydes loved La Belle Iseult*, in which his enthusiasm for the sunflower as a decorative motif, and perhaps, too, his lack of confidence in drawing the human figure, led to the third figure, of Sir Tristram, being almost entirely hidden behind the flowers. Rossetti meant to paint two bays, and he and Burne-Jones were next to begin, followed by the rest. They took lodgings in the town, and for two or three months led a jolly bohemian life. Among all the fun, Rossetti found time also to work on one of the finest of his small watercolours, *The wedding of St George and the Princess Sabra* (pl. 47), while Morris did some stone-carving, some embroidery and designs for stained glass; and, more significantly perhaps, wrote a good deal of poetry, soaked in mediaeval feeling, tough, tender, dramatic. Some of it found a specific object in beautiful young Jane Burden, seen at the theatre one evening and persuaded to pose for them. The summer ended: Morris, his picture finished, set to work on a patterned infilling for the roof. Rossetti distracted by visits to London, where Lizzy was left alone at Blackfriars and his large altarpiece claimed attention, abandoned his painting in November. Burne-Jones's painting, also interrupted by spells in London and Birmingham, was not finished until February. After the completion of the roof, no more work was done, and splendid—like the margin of an illuminated manuscript, Coventry Patmore said—as the paintings looked, the Union Society was naturally far from pleased at the time taken, at the cost, at the fact that the work was left unfinished. Burne-Jones, though the *Blessed damozel* paintings for Plint were unfinished, received yet a further commission from the same patron and Morris resumed his easel painting of *Sir Tristram*, staying in Oxford entranced by Jane.

Burne-Jones, alone in Red Lion Square, worked alternately on the commission for Plint and on another painting of quite a different kind. Among the furniture made to Morris's designs was a tall wardrobe, and on the front of this, Burne-Jones painted a scene from Chaucer's *Prioress's Tale*. But he began to fall ill; a spell down at Maidstone with Arthur Hughes and his wife failed to draw him out of the depression into which he had fallen after the dispersal of the happy group in Oxford. Georgie was in distant Manchester, Morris and Rossetti elsewhere. From Maidstone he wrote, reviving the old idea of a community of artists, to ask Ford Madox Brown to go and look at a large house in Kensington. Hughes, he said, would be ready to join the scheme. Whether Brown looked at the house or no, nothing came of this, though Rossetti, too, might well have taken part.

But for most of the first half of 1858 Burne-Jones was too ill to work, and was swept off by that universal aunt, Mrs Thoby Prinsep, to be nursed and cared for at Little

Holland House. When at last he came back to Red Lion Square, his work went slowly and Rossetti joined him for a while. Morris announced his engagement to Jane Burden in August, and with Philip Webb, worked out plans for the house which Webb should build for him when he and Jane were married. Red Lion Square was given up, and Burne-Jones took rooms alone in Russell Place. The Oxford circle was now finally breaking up, and the Rossetti circle began to take on a new character. The old Pre-Raphaelite circle was quite at an end.

Morris's marriage in April 1859 brought about the building and furnishing of Red House, and it is a commonplace of the story of the Arts and Crafts Movement that the decoration and furnishing of this house—described by Rossetti as 'a most noble work in every way, and more a poem than a house such as anything else could lead you to conceive, but an admirable place to live in, too', played an important part in the establishment of the famous Firm: but it ought not to be forgotten that that marriage hastened on two other marriages which also played their part in that evolution. Burne-Jones and Georgie had been engaged for four years when they married at Manchester in June 1860; and on May 23 of the same year, after ten strange and often tormented years, Rossetti and Lizzy Siddal had at last married, at Hastings. The Rossettis went to Paris, and the younger couple were to have met them there; but a sudden illness of Burne-Jones drove him and Georgie straight to their still only part-furnished rooms in Russell Place.

Here they found the table, solid, of oak, which had been made for them. Other furniture was yet to come. The boys of the Boys' Home in Euston Road were still at work, making chairs and sofa, like the table, from designs by Philip Webb. Presently they arrived—the chairs highbacked, stained black, with rush seats—a forecast of the later Morris chair—and the companion sofa was of panelled wood, also black. In the unsettled week before his marriage, Edward had amused himself by painting some figures upon a plain deal sideboard which he possessed, and this in its new state was a delightful surprise to find.

Mrs Catherwood [Burne-Jones' aunt] gave us a piano, made by Priestly of Berners Street, who had patented a small one of inoffensive shape that we had seen and admired at Madox Brown's house; we had ours made of unpolished American walnut, a perfectly plain wood of pleasing colour, so that Edward could paint upon it. The little instrument when opened shows inside the lid a very early design for the *Chant d'Amour*, and on the panel beneath the keyboard there is a gilded and lacquered picture of Death, veiled and crowned, standing outside the gate of a garden where a number of girls, unconscious of his approach, are resting and listening to music.

Returned, the Rossettis at first meant to take rooms or a house in Highgate or Hampstead, as better for Lizzy's health; but after no very long time they found themselves back in Chatham Place, where, by taking the corresponding floor of the next house, and opening a door between the two sets of rooms, they doubled the size of Gabriel's original apartment. This done, they began to furnish and decorate. It is from this time, very early in 1861, that there dates Rossetti's single design for a wallpaper. It survives as a sketch in a letter to Allingham (pl. 60). Rossetti's own description of it fills out the rough black and white of the sketch:

Our drawing room is a beauty, I assure you, already, and on the first country trip we make we shall have it newly papered from a design of mine which I have an opportunity of getting made by a paper-manufacturer, somewhat as below. I shall have it printed on common brown packing paper and on blue grocer's paper, to try which is best. The trees are to stand the whole height of the room, so that the effect will be slighter and quieter than in the sketch, where the tops look too large. Of course they will be wholly conventional; the stems and fruit will be Venetian Red, the leaves black—the fruit, however will have a line of yellow to indicate roundness and distinguish it from the stem; the lines of the ground black, and the stars yellow with a white ring round them. The red and black will be in the same key as the brown or blue of the ground, so that the effect of the whole will be rather sombre, but I think rich, also. When we get the paper up, we shall have the doors and wainscotting painted summerhouse green.

It should be remembered that the house in which it was used was of eighteenth-century building, and, as his reference to wainscotting makes plain, still had its original panelling; so that the height of the paper would not be from floor to ceiling, but from dado height, perhaps four feet from the floor, to the ceiling. The whole effect must have anticipated in everything except the rather sombre colour the typical wall-decoration of fashionable middle-class houses of the nineties and early nineteen hundreds, and made the strongest possible contrast to fashionable decoration of its own day. Here is the first use of that motif of the tall, slender flowering tree against a bare ground which appears at every turn fifty years later, from the work of Mackintosh and Baillie Scott downward.

This letter, of January 1861, goes on to say 'we are organizing a company for the production of furniture and decoration of all kinds, for the sale of which we are going to open an actual shop!'—and to name the seven who, in April, issued their circular under the name of Morris, Marshall, Faulkner and Co.

Three members of the Rossetti circle were thus, at the same time, busy with the design and decoration of furniture and interiors. The furniture was mostly very plain in form—much more so than the characteristic turned and carved goods available from the furnishing houses. Apart from any sense of the virtue of simplicity and truth to construction which played some part in the design, this was largely to allow of painted decoration. All three men were painters at this point, all deeply soaked in mediaeval ideas of colour and ornament, all tending to take the mediaeval illumination rather than the renaissance painting as model. They saw no incongruity whatever between the function of a chair or cabinet as an object on which to sit, or in which to store other things, and its function as an image-bearing surface, bright with colour and pattern. They were not unique in this frank use of the plane surfaces of their furniture for decorative and pictorial ends; Butterfield, Burges and others had already done the same thing, and it was an accepted fact of the practice of many architects who also designed furnishings. What was different in their practice— apart from the very distinct character of their painting—was the simplicity of design in the actual form of the furniture, the minimal use of gothic motifs and of carving, the use of deal in some cases rather than insistence on oak—though they did often use oak. Some of the simplicity of their forms may be due to little more than the naïveté of their approach to actual construction; perhaps, had Tom Seddon lived,

these early pieces might have been a little more in line with sophisticated design practice. Philip Webb was at this stage quite orthodox in his gothic furniture; but pieces designed by Morris and Rossetti themselves tended to be a little neglectful of practical joinery.

All this might be called the Pre-Raphaelitism of design: the simplicity of form, the unsophisticated construction, the pictorial and heraldic enrichment of flat surfaces were certainly meant to get behind the renaissance norms; and certainly none of it would have come about in the way it did had not Rossetti first been one of that other group of seven, the PRB, or Morris and Burne-Jones not first been moved by Pre-Raphaelite painting.

'The Praeraphaelite Brotherhood introduced into painting something that might well be called a revolution,' wrote William Rossetti, 'and the Firm introduced into decoration something still more revolutionary for widespread and as yet permanent effect. The first suggestion for forming some such firm,' he goes on, 'came from Mr Peter Paul Marshall, an engineer, son-in-law of Mr John Miller of Liverpool.' Commenting on this, Birkbeck Hill, in his *Letters of Rossetti to William Allingham,* adds: 'However true this may be, nevertheless, as Mr Arthur Hughes points out to me, the germs of it are to be found in the "intensely mediaeval furniture" which Morris had made for his rooms in Red Lion Square, and in the cabinet which he, Rossetti, and Burne-Jones covered with pictures. A further development of this is seen in the decorations of Morris's house at Upton.' Birkbeck Hill was at Oxford during the painting of the murals, and became very close to the Rossetti circle; his own study table was made by the Firm. Morris seems to claim the initiative for himself in the letter which he sent with the Firm's prospectus to his old tutor, Guy: it opens thus: 'By reading the enclosed you will see that I have started as a decorator which I have long meant to do when I could get men of reputation to join me, and to this end I have mainly built my fine house.' But Madox Brown might fairly claim an important share in initiating the work, if not the idea of an actual business organization; for he had already designed a good deal of furniture for himself—the portraits of old Mr Seddon and his wife were made in payment for a sofa made by Seddons, and he had designed other things for friends. What is really to be seen in the founding of the Firm is not the implementation of an idea of any one person, but the coming together of a group, all of whom shared and chose to give effect collectively to ideas which they had arrived at individually. The common enterprise at Oxford, the share all took in decorating and furnishing Red House, and the homes of Burne-Jones and Rossetti, the example of Madox Brown, the long-established practice of these and other painters in designing and having made—or even making —costumes and properties for their paintings, all tended in the same direction. Marshall may have been responsible for bringing all within the frame of a formal business arrangement; he, too, a competent amateur pupil of Madox Brown, designed some furniture and stained glass.

Burne-Jones took the view that it was the building of Red House that initiated the Firm.

It was from the necessity of furnishing this house that the firm, Morris, Marshall, Faulkner and Co. took its rise. There were the painted chairs and the great settle of

which mention has been made already, but these went only a little way. The walls were bare and the floors; nor could Morris have endured any chair, table, sofa or bed, nor any hangings such as were then in existence. I think about this time Morris's income derived from copper mines began to diminish fast, and the idea came to him of beginning a manufactory of all things necessary for the decoration of a house. Webb had already designed some beautiful table glass, made by Powell of Whitefriars, metal candlesticks, and tables for Red House, and I had already designed several windows for churches, so the idea grew of putting our experiences together for the service of the public. For the fireplaces at Red House I designed painted tiles . . . For the walls of other rooms than the drawing room at Red House Morris designed flower patterns, which his wife worked in wool on a dark ground, and it was a beautiful house.

As we talked of decorating it plans grew apace. We fixed upon a romance for the drawing room, a great favourite of ours called 'Sir Degrevaunt'. I designed seven pictures from that poem, of which I painted three that summer and autumn in tempera. We schemed also subjects from Troy for the hall, and a great ship carrying Greek heroes for a large space in the hall, but these remained only as schemes, none were designed except the ship. The great settle from Red Lion Square, with the three painted shutters above the seat, was put up at the end of the drawing room, and there was a ladder to its top and a parapet round it, and a little door above, in the wall behind it, that led into the roof . . . I began a picture from the *Niebelungen Lied* on the inside of one of the shutters of this settle, and Morris painted in tempera a hanging below the Degrevaunt pictures, of bushy trees and parrots and labels on which he wrote the motto he adopted for his life, 'If I can'.[1]

The beautiful rooms at Chatham Place were Rossetti's home for less than two years after his marriage. On May 2, 1861, Lizzy gave birth to a dead child, and the depression induced by this, added to her constant illness—which seems to have been psychological in kind—finally brought about her suicide in the following February. Rossetti, after a short time spent at his mother's house in Upper Albany Street, moved to chambers in Lincolns Inn, before finally settling in the house in Cheyne Walk, Chelsea, at which he and Hunt and others of the Brotherhood had looked, years before, with a view to joint tenancy.

Lizzy's death and his removal to Cheyne Walk roughly mark the end of his close participation in design work for the Firm other than in cartoons for glass, which had not the same domestic connotations, and in kind and scale allied themselves readily with what was going forward in his painting. He seems not to have embarked at Cheyne Walk on any such conscious scheme of original decoration as had given him and Lizzy so much pleasure in Chatham Place. The Chelsea house owed its decorative effects rather to the accumulation of exotic objects, of blue and white china, Japanese fans, peacock-feather switches and the hanging of paintings and prints, than to any scheme deliberately devised by him, room by room. But this was not, of course, any sort of end to Rossetti's influence on design and designers. He remained the centre of a large array of painters, poets, designers, and though Morris and Burne-Jones reached their own maturity and went their own ways, they were by no means the only ones to feel his impact and to derive inspiration from his personality and work.

1 *Op. cit.* p. 213

13 The Firm

The great development in design which is so characteristic of the nineteenth century would have taken place without William Morris or any other particular individual. It was already well under way before the Firm was launched and the Great Exhibition of 1851 had demonstrated a decade earlier the widespread interest and concern in the field. But the peculiar character of the English development was largely moulded by Morris and his associates and followers.

It was recognized by the trade from the beginning that Morris, Marshall, Faulkner and Company were potentially very effective indeed, and their presumption, as a band of painters who enjoyed the friendship and patronage of Ruskin, was resented by the well-established furnishing and decorating firms, and by designers and architects already in practice. The scathing references to Ruskin in *The Art of Decorative Design*, already published (1856) by Christopher Dresser, suggest the hostile reception which a group of his protégés might expect; and Lewis F. Day (like Dresser, a first-rate trade designer) records how when he first heard of them as a young man learning to be a designer they were described to him as 'a bunch of amateurs who are going to teach us our trade'. They demonstrated, in the first year of the Firm's existence, with the work submitted to the Exhibition of 1862, which won two awards, that they were really to be reckoned with. Amateurish in many ways they and their designs must have seemed to the trade; but the quality of their design, their invention, their colour, the effective absence of the stock products of the furnishing trade meant that in a year or two they were indeed teaching the trade about design.

The variety of talent, experience and above all, personality, which they brought to their enterprise, young as most of them were, was exactly of the kind to launch it with an energy that no other concern could match; the fact that they worked as equal partners was directly contributory to the vitality of their products. Each had a voice, all might be called upon for designs and all might share in their evolution. This is nowhere more apparent than in their stained glass, for long their most important product, and the field in which their experience of the freedom of invention possible in painting marked their work off most sharply from that of the trade. The vigour and unity of schemes of design in which three or four of them took equal part is splendidly seen, for instance, at Llandaff and at Lyndhurst.

Webb was an architect, skilled like many of his kind in the design of furniture Morris had worked with him in Street's office, was practically learned in carving, embroidery, illumination, and had been a painter for three years; Brown, the most versatile painter of the group, had designed costumes and furniture for a decade; Marshall, a civil engineer, was a clever amateur painter; Faulkner, the mathematician, had no creative gifts, but excellent manual skills; and Rossetti and Burne-Jones were painters of genius, both gifted with quite unusual powers of imaginative

invention. All were men of the widest interests and culture, and while much of the actual making of their goods was necessarily put out to craftsmen in the various trades, they learned the importance of supervising all of it: no design work was ever put out to hacks.

While most men involved in such ventures were either architects or decorators, the character of the Firm was determined by the predominance of painting and imaginative art in the work and background of its members. It was a factor that could well have kept their work at a level of amateur ineptitude, such as was so largely exhibited by the Omega Workshops seventy years later. Standards of professionalism were then very high among their competitors, however barren the application of that professionalism. With a public accustomed by 1861 to the work of Pugin, Owen Jones, Burges, Butterfield and Scott, as well as that of other designers like Alfred Stevens untouched by the wave of the Gothic Revival, amateurism would have sunk the Firm in its first year. But the Firm consisted of men who knew their own minds and could exact from themselves and others the highest standards. It is perhaps worth while to mention Rossetti in this context, since it might well appear, from his early indiscipline, his unwillingness to submit to technical instruction, his dilatory way with commissions, that he was an exception to this rule; but he said quite truly of himself, very early, that he could not resist making the best he possibly could of a painting, and that therefore when one left his studio it was likely to be worth very much more than the price he had agreed for it. He was certainly well able to exact the best from others. It was an advantage, too, that by the beginning of 1861 the group had known and worked with one another for some years—Madox Brown and Rossetti for over a decade—and they all had a proper respect for, and indeed pride in, the divers and abundant talents of their colleagues. Unplanned, perhaps, but hardly unawares, they constituted an extraordinarily well-balanced and richly endowed team.

The business side of the firm was managed, between 1865 and 1870, by Warington Taylor, introduced to the Firm by Rossetti. When in 1874–5 the original partnership was dissolved and the firm became Morris and Co., under Morris's sole direction, this recognized a reality, and gave formal expression to what already obtained in practice. Morris had developed admirable qualities in his direction of the concern, but in the early days it had been of the greatest importance that he should be freed from strictly managerial work and able to give himself to design and workshop direction, while Taylor established sound business procedures and set the partners on the way to a financial stability which certainly had not characterized their first twelve months' trading.

We must distinguish between the *fact* of their activity, as designers, and its *quality*. The mere fact they shared with many others of great competence and better financial resources at a time when there was an enormous increase in such work. The quality was their own, and inimitable. It is, above all, in their imaginative drive that they differ from most of their competitors. They not only invented; they invented freely. Well able to work within the conventions, their individual and collective genius was conspicuously unconventional. It was not just a matter of Morris's cavalier way of dealing with customers or Rossetti's arbitrariness in the interpretation of an idea.

The conventional professionals in the business, architects or decorators, worked within a huge but rigid repertoire of visual and ornamental conventions, historically backed, archaeologically accounted for, and to a large extent based on the researches and prescripts of the Ecclesiological Society—for the quasi-religious conventions of Gothic revival had already become formal routines.

It was Rossetti who played the leading part in this liberation; not simply because he was so very much the leading figure and dazzling sun of the group—as certainly he was—but because, in shaking off the Pre-Raphaelitism that had made painting possible for him, and in working his uninhibited way through the magnificent watercolours and illustrations of the 1850s, he had learned something essential about his own genius, but at the same time something revolutionary about design. That something Morris and Burne-Jones were especially prepared to learn from him, and especially able in their different ways to extend into design and back into painting. It was something which few outside their circle really understood, but which went very far to account for the special quality of the work that came from Red Lion Square. It made a step into the modern world, and in this way.

The conventions of pattern designing, of applied ornament, of pictorial composition, were elaborate and well-defined. However much the old eighteenth-century taste had been weakened or modified, or outright rejected, the idea of taste itself remained unmoved. The notion that there were and would always be certain models, patterns, norms, an ideal, by which all that was old stood and by which all that was newly created must be judged, was still operative and central to men's thinking about the arts. One might be an unregenerate Classicist, a practitioner in revived Renaissance style, or an austere Gothic Revivalist; whatever quarrels practitioners and their patrons might have among themselves as to the merits of the diverse modes, they were in agreement on some important points, to deny which must lead to chaos. There were norms, there were ideal forms, historically fixed and consecrated by the rules and practice of the great past. It might be more difficult to ascertain and fix ideal rules in Gothic than in Classical, and embarrassing to try in the case of Renaissance art which was, on examination, often very mixed indeed; but ornament, decoration, style, all derived from precedent and one was only free to invent in the sense of skilfully recombining already sacred forms.

Pre-Raphaelite painting had been shocking because it broke through this concept in respect of pictorial art. But the steady reference to nature, to unmediated actuality, to sensory experience, to which the PRB pretended *was* revolutionary, in so far as it replaced the idea of the normative, the ideal, sanctioned by historic precedent, with the sanction of immediate and particular experience. What the viewer of a Pre-Raphaelite painting was asked to do was not to compare what he saw, framed and hanging on the wall, with other objects prescribed as noble works of art, but with his own experience of the kind of objects or figures depicted, to assess the relations of figures not by their conformity to the rules of art, but the probability of human behaviour. It was because they challenged one eyewitness experience with another, appearing at least to draw no support from the canons of good taste, that the young painters had such an impact, were so much feared by the academicians, so excitedly pursued by the new patrons.

175

The artist, and his patron, had since the Renaissance been largely taught by reference to pattern books, copies, plaster casts and the writings of learned critics, what to enjoy, how to create. But experience, the real drama of relationships, the actual perception of form and colour, would keep breaking in like cheerfulness upon the philosopher, and convention must constantly run after invention; new pages, however unwillingly, were now and then to be added to the pattern book, which Italy had provided for so long. Now the Gothic North had been added, and in one or two places like Owen Jones's *Grammar of Ornament*, there were indications that yet other extensions were to be made. The inclusion of African weaving and Maori woodcarving, albeit drawn from non-European and by implication less important and non-historical sources, was based on the observation and appreciation of their formal qualities. And one of the great discoveries of the nineteenth century about art and ornament was that all of it, ultimately, was derived from some actual observed fragment of the real world. We had copied the formal acanthus leaf from classical or sub-classical sources for centuries—now, guided by Owen Jones, the botanist Christopher Dresser unrolled a real leaf, spread it out flat and showed what geometric order in the living leaf had made it possible for man to base that familiar invention upon it. Any cheap popular book on science or the wonders of the microscope would reveal similar things—the regular forms of crystals, the starry variety of the snowflake. Under the comfortable conventions lay the reference to real things seen, and to our innate sense of order, our response to rhythm and repetition—abstractions, unless clothed in some particular form.

Rossetti, as even devoted William would cheerfully acknowledge, was the least scientific of men, and he made no such analyses. But in wrestling with his own painter's problems of expression and design, of the visual exposition of human drama or fantasy, he had discovered something very similar for himself. His pictorial models of the fifties were to a large extent the illuminated manuscripts of the Middle Ages, early woodcuts, the designs of the Blake notebook. He learned that one could pack an enormous amount into the tiniest space, by virtue of relaxing the traditional—or indeed the Pre-Raphaelite—requirement of probability in representation and seeing one's design as an emblem, a metaphor, rather than as a description. The story of his being supplied with a block one-sixteenth of an inch too short for one of the Tennyson illustrations and exclaiming when it was suggested that this was not important 'Good God, I could get a whole city in there!' is not most significant in any reference to his ingenuity. He learned, from his close study of mediaeval work in particular, that historic or visual truth may be something quite different from the form that will create a desired atmosphere, produce the required emotional tension. An area of bright blue—perhaps the sky, perhaps a cloak or a canopy—powdered with bright stars, which a more formally equipped artist would have rendered with due respect to historic probability and with the aid of compasses, was not merely as effective, but far more effective, when the stars were splashed down impetuously as criss-crossed strokes of gold. If he had drawn a room too small to contain the five figures of his drama, some shuttered window could be cut—literally—in the background wall, and heads and hands would reach in to take their part with all the force and mystery of the old ballads. He discovered, in fact, and liberally used,

87 Fred Walker *The woman in white*
1870
Drawing for a poster advertising
the dramatization of Wilkie
Collins' *The woman in white*

88 J.D.Watson *The crimson flower*
1862
Illustration to story by the Coun-
tess de Gasparin, *Good Words* 1862

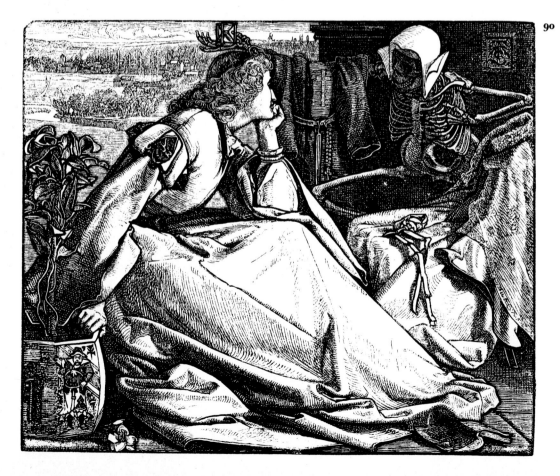

89 William Bell Scott *Studies from nature* 1875
One of a number of etchings illustrating his
Poems, 1875

90 Frederick Sandys *Until her death* 1862
Illustration from *Good Words*, October 1862

91 Selwyn Image, title page for *The Century Guild Hobby Horse* 1886

92 Burne-Jones and Morris *A dream of John Ball* 1892
Frontispiece and opening of text from the Kelmscott edition. Drawing by Burne-Jones, type and borders by Morris

93 Will H. Bradley, poster for *The Chapbook* 1895
14 in. × 21 in. Published by Herbert Stone, Chicago

94 M. Yendis, cover for *The Poster* 1898
Printed in black, blue, blue-grey, green and yellow

95 Will H. Bradley, poster, late 1890s
Influenced by *The Blessed Damozel*

96 E.M.Lilien, poster for the *Berliner Tageblatt*, late 1890s
Posters now an international art-form. Sunflowers, stars and flowing hair can be traced back to the days of the Oxford murals, but the lettering speaks of the new century

97 Laurence Housman, binding for *The End of Elfin Town* by Jane Barlow, 1894

OPPOSITE

99 Laurence Houseman, title page for *The End of Elfin Town*

100 Laurence Houseman, full-page illustration for *The End of Elfin Town*. Wood-engraving

101 Aubrey Beardsley *La Belle Isoude at Joyous Gard* 1893
Double-spread illustration and borders from *Morte D'Arthur*, published by J.M.Dent

98 Heywood Sumner, decoration from the *English Illustrated Magazine* 1892

THE END OF
ELFINTOWN

BY
JANE BARLOW
ILLUSTRATED BY
LAURENCE HOUSMAN

LONDON
MACMILLAN & CO.
1894

102 Louis Davis, decorative drawing, 1892
An obvious reworking of Rossetti's *Amor* figure, from *English Illustrated Magazine*

103 Reginald F. Knowles, endpaper and title-page combined for J. M. Dent's Everyman Library, 1906

POETS ARE THE TRUMPETS WHICH SING TO BATTLE POETS ARE THE UNACKNOWLEDGED LEGISLATORS OF THE WORLD SHELLEY

THE POEMS & PLAYS OF ROBERT BROWNING 1833-1844

LONDON: PUBLISHED by J. M. DENT & SONS L.T.D. AND IN NEW YORK BY E. P. DUTTON & CO

104 William Morris *The strawberry thief* 1883
Design for chintz

105 Walter Crane *The Sleeping Beauty*
Wallpaper designed for Jeffery and Co.,
for machine-printing

106 C.F.A. Voysey *The owl c.* 1880
Design for woollen cloth, clearly derived
from the Morris pattern *Birds*

107 C.F.A. Voysey, silk and wool tissue, 1898
Derived from the Morris *Daisy* pattern

108 Chair designed by Rossetti in the early 1860s, made by Morris, Marshall, Faulkner and Co. On the wall behind, the Morris *Fruit* wallpaper; on the floor, a Morris machine-made Wilton carpet; behind the chair, the St George cabinet of 1860

109 E.G.Punnett, armchair, 1901 Made in oak with ebony inlay and rush seat

110 Chair designed by Baillie Scott for the Duke of Hesse Darmstadt, and made by C.R. Ashbee's Guild of Handicraft, *c.* 1898

111 Cabinet, probably designed by George Jack, made by Morris and Co., for Henry Arthur Jones' play *The Crusaders*, 1891

112 Sideboard designed by W.R.Lethaby, *c.* 1900. Oak with ebony inlay

113 Music cabinet designed by Baillie Scott for the Duke of Hesse Darmstadt and made by C.R.Ashbee's Guild of Handicraft, *c.* 1898

the licence for the painter which the poet may use with words. Analogy, inversion, metaphor were the devices which ousted carefully carpentered circumstance from his watercolours. What mattered was to discover such devices as would achieve the emotional intensity of dream and to use them without fear. In doing this, in casting off not only the conventions of traditional painting which he had not mastered, but of Pre-Raphaelite painting too, he released in himself a creative energy and invention which survived yet other changes in his style of work. This dynamic he passed on to his associates—even to Ford Madox Brown, who had played a big part in his discovery of himself.

Although he did invent properties for his paintings, especially in earlier years, and though he designed some pieces of furniture which were actually made, Rossetti was not really interested in the design, still less in the making, of the ordinary artefacts of life. To paint invented objects into his pictures was one thing; to consider the measured details of real construction and to work out a practicable three dimensional form was another. Even in stained glass, whose two dimensions are less exigent than the three of furniture, the mechanics of actual making and assembly neither interested him because they were necessary, nor stirred his invention as such practical matters will stir the craftsman-designer. In this he was the antithesis of the architect-designer like Webb or Morris, or the ornamental designers trained in the furnishing trades or at the Government School of Design, with their historic repertoires.

For Rossetti, design existed chiefly in imaginative terms, as an extension or derivative of the needs of his paintings, in which the relationships between objects and persons, persons and patterned surfaces, pattern and colour, were established solely in order to induce atmosphere and emotional response: that they were also decorative was almost incidental. So too the fact that the imagined circumstances might call for mediaeval dress and interiors—these arose out of Rossetti's favoured themes and not because of any antiquarian passion for the mediaeval. Such details were to be used associatively, to create mood and atmosphere and support a drama, savage and foreboding as in *How they met themselves,* or *Launcelot in Guenevere's chamber;* mysteriously languorous as in *The blue closet;* romantic and ballad-like as in the *St George* watercolours. There is no narrative or truly descriptive intention in the accumulated detail of *The blue closet* or *The tune of seven towers;* only an intense effect is sought. There is little behind them of the careful research and historical study which Ford Madox Brown or Hunt would have undertaken before committing themselves to the final forms. Sometimes Rossetti would achieve his effect by association, painting a stool, a prie-dieu, a cithern, a helmet or a banner as necessary properties of his drama; but in their detailed drawing and decoration he might be quite free, inexact and arbitrary, while alongside these stage properties other elements, equally necessary to his effect, would be devised in an abstract or a symbolic way. In the *Paolo and Francesca* diptych (pl. 54), for instance, we see the two lovers as they kiss, the book on their knees, the window behind them making its pattern of small panes to frame or focus our attention on their heads; we also see them as Dante saw them, floating in the storm of Hell, against a background of flying flames whose burning tongues also make a pattern. The pattern in the one case is derived from and

partly describes probable circumstance; in the other it is purely symbolic and invented; while in neither panel is definition carried so far as to commit the painter or spectator to a merely circumstantial notion of the story.

Hunt, commissioned to paint the same theme, would have been compelled to treat it quite differently. With the scene in which the two acknowledge their love in kissing over the book, he would have dealt effectively and given us something very like *The awakening conscience* in fourteenth- instead of nineteenth-century costume; he would have studied and faithfully painted all the likely furnishings of such a room as the two might have been in and many of the objects would have been chosen and placed and coloured so as to invest them with symbolic value—as in Van Eyck's Arnolfini portrait each real object is also playing its part in a scheme of symbolism. But the rigorous naturalism and careful drawing and arrangement would all have been aimed at creating the immediacy of actual presence, compelling us to change our role of spectator for the quite different one of eye-witness. With the other half of the theme, the lovers in the whirlwind, Hunt could not have dealt at all, unless very much later in life, and then exceptionally, as in *The triumph of the Innocents*. In the same way, though Madox Brown was much closer to Rossetti than Hunt in his concepts, and had played a very important part in helping Rossetti to this sort of painting, he could not have been content with the arbitrary constructions with which so many of Rossetti's paintings are so effectively filled. When he himself had visualized his *Wycliffe reading the Bible to John of Gaunt*, he saw the book as resting on a lectern, which he proceeded to design, but not simply from his imagination. He went to the British Museum and there looked out Pugin's *Designs for Gothic Furniture*, looked up appropriate costumes and made them, traced out an authentic Gothic alphabet; everything in this painting (which F.G.Stephens was quite correct in describing as the first Pre-Raphaelite painting) had to have the mark of historic authenticity and practicability.

Philip Webb and William Morris, steeped in Gothic architecture, working in the office of G.E.Street who was a learned member of the Ecclesiological Society, were trained to think and visualize in terms of correct historic ornament, propriety of construction and strict probability of time, place and style. Their first approach to design was naturally in terms of contemporary design practice, at the head of which stood the architects: and it was a very long time before Webb, who continued to practise as an architect, could relax his Gothic habit in the design of furniture. When Morris designed furniture for 17 Red Lion Square, Rossetti described it as 'intensely mediaeval'. In fact it was simple in its forms and substantially without carving— much less conformist and elaborate than Morris would have designed had he continued, like Webb, as an architect, but its forms were Gothic, and to that extent rooted in his training as an architect.

But his close association with and submission to so dynamic and imaginative a personality as Rossetti's, with his own gifts in poetry as well as in design, broke through the conventions which he had been absorbing ever since as a boy at Marlborough he had developed his obsessive interest in architecture. For three years he saw himself as a painter, drew and painted with Burne-Jones and under the guidance of Rossetti and Madox Brown, and so, although he abandoned painting as a career,

he found his way to a conception of design much richer and more expansive than he could have achieved, without much long and baffled search, had he stayed inside the architectural profession as an orthodox Gothic Revival practitioner. In this larger concept, conventions, historic ornament, the knowledge of traditional forms remained valuable, but ceased to be binding. The objectives of such a designer as Morris went beyond the mere covering of surfaces and reached out to the achievement, within the limits of ornament as distinct from the possibilities of painting, of a contained exercise of the imagination, an emotional effect, by the combination of colours, forms, arrangements, rather than the strictly associative values of reference to the historic styles.

Other than stained glass for Morris, Marshall, Faulkner and Company, between 1861 and 1874 Rossetti cannot really be said to have left a body of work as a designer: only a chair, a sofa (pl. 53), a sketch for wallpaper (pl. 60), half a dozen illustrations, title-pages and bindings for three or four books. His chief output was in painting, and it is at least as much with his painting as with general design that his stained glass must be associated. Nor did he leave any kind of theoretical writing or attempt to work out any system of ideas, though he was a penetrating critic of art and literature. It was in the actual practice of designing, and in the discussion of the work of the Firm, that his ideas were communicated. The destination of the work, its social implications, its use, did not concern Rossetti, as they did Morris, whose roots were in the Ruskinian field; or Brown, who was equally concerned with the social and ethical implications of the arts. Rossetti was, to this extent, more single-minded than they; he was concerned with the making of a painting or design, and only looked beyond the act to the next act of the same order. He had, thanks to Brown, Hunt and Ruskin, won himself a position in which clients came to him seeking what was specially and peculiarly his. He chose his own themes, developed his own style, made his own technique—outside the academic conventions and untouched by the all-pervading historicism of the time. His typical mannerisms, themes, devices, colour, were sought because they were his, and unlike anything else. It was his freedom from the conventions of others, his originality, which made him so influential.

He was also influential, of course, as a member of the Firm, as were Brown, Morris and Burne-Jones. Their association over something like fifteen years both made a very powerful public impression, and helped each one to develop—but Morris most conspicuously.

Morris began to be a recognized influence in the world of design from the mid-seventies. For a decade, as the co-ordinator of the Firm's work, rather than as an individual designer, he had been a force: after the dissolution of the original Firm, and his assumption of complete control, its work was extended into new fields, and he became more and more its sole designer, except in stained glass, resuming the pattern design in which his genius was most effective; and a few years later, with his first public lecture, on 'The Lesser Arts', in 1878, he extended his influence into the field of theory. From this time he lectured constantly, so that his ideas came to be very thoroughly worked out and familiar to fellow designers, students and the public everywhere. Some of his lectures, like that on Pattern Design, are concerned with the actual practice and principles of designing; but all are concerned with the exposition

of his ideas on the use and necessity of art in daily living. Both his ideas and his practice were widely influential until the turn of the century.

What Morris said or wrote about art, architecture or design was always lucid, illuminating and authoritative. He came to be the greatest figure in the design world of the last quarter of the nineteenth century, both as practitioner and theorist. His theoretical ideas were derived, in the first place, from those of the Ecclesiologists, like his master Street; in the second place, from the writings of Ruskin; and from his own experience in the world of practice, in which the influence of Rossetti, though often oblique, was very strong. It is my view that it was Rossetti's influence which, working on Morris's own great creative genius, enabled him to break through the conventions of his earliest view of art. For both Morris and Burne-Jones, Rossetti was exemplar and catalyst—as Ford Madox Brown had been for him.

Heywood Sumner *December* 1892 from the English Illustrated Magazine.

196

SELECT BIBLIOGRAPHY

Allingham, Helen and D.Radford eds *William Allingham, A Diary*. London: Macmillan, 1907; reprint Centaur Press, 1967

Andrews, Keith *The Nazarenes*. Oxford: Clarendon Press, 1964

Angeli, Helen Rossetti *Pre-Raphaelite Twilight: The Story of Charles Augustus Howell*. London: Richards Press, 1954

Bate, Percy *The English Pre-Raphaelite Painters: Their Associates and Successors*. London: George Bell, 1899; rev. ed., 1901

Bell, Mackenzie *Christina Rossetti: A Biographical and Critical Study*. London: Thomas Burleigh, 1898

Bell, Malcolm *Sir Edward Burne-Jones: A Record and Review*. London: George Bell, 1898

Bennett, Mary *Ford Madox Brown 1821–1893*, catalogue of a loan exhibition organized by the Walker Art Gallery, Liverpool, 1964
John Everett Millais 1829–96, catalogue of a loan exhibition organized by the Walker Art Gallery, Liverpool, 1967
William Holman Hunt 1827–1910, catalogue of a loan exhibition organized by the Walker Art Gallery, Liverpool, 1969

Bickley, Francis *The Pre-Raphaelite Comedy*. London: Constable, 1932

Burne-Jones, Georgina *Memorials of Sir Edward Burne-Jones*, 2 vols. London: Macmillan, 1904

Caine, T.Hall *Recollections of Dante Gabriel Rossetti*. London: Elliott Stock, 1882

Carr, J.Comyns *Coasting Bohemia*. London: Macmillan, 1914

Cartwright, Julia *Sir Edward Burne-Jones, Bart.: His Life and Work*. (Christmas number of the *Art Journal*.) London: Virtue, 1894

Chesneau, Ernest *The English School of Painting*, translated into English by Lucy N.Etherington. London: Cassell, 1884

Clutton-Brock, A. *William Morris: His Work and Influence.* London: Williams and Norgate, 1914; New York: Henry Holt and Co., 1914

Coley, Curtis *The Pre-Raphaelites*, catalogue of a loan exhibition of paintings and drawings by the Pre-Raphaelite Brotherhood and Associates, organized by the John Herron Museum of Art, Indianapolis, 1964

Crane, Walter *An Artist's Reminiscences.* London: Methuen, 1907; USA reprint, Detroit: Singing Tree Press, 1969
 William Morris to Whistler: Papers and Addresses on Arts and Crafts and the Commonweal. London: Bell, 1911
 The Decorative Illustration of Books. London: Bell, 1898; USA reprint Detroit: Gale, 1968

Doughty, O. and Wahl, J.R. *Letters of Dante Gabriel Rossetti*, 4 vols. London: Oxford University Press, 1965–7

Doughty, O. *A Victorian Romantic: Dante Gabriel Rossetti.* London: Muller, 1949; 2nd ed. London: Oxford University Press, 1960

Davies, William and Sarah Smetham eds *Letters of James Smetham, With an Introductory Memoir.* London: Macmillan, 1891

Davies, William *The Literary Works of James Smetham.* London: Macmillan, 1893

Day, Lewis F. *William Morris and His Art* (Easter number of the *Art Journal*). London: Virtue, 1899

Dickason, D.H. *Daring Young Men; The Story of the American Pre-Raphaelites.* New York, 1953

Frith, W.P. *My Autobiography and Reminiscences*, 2 vols. and supplementary. Richard Bentley, 1887. One-volume abridgement, 1890

Gaunt, William *The Pre-Raphaelite Tragedy.* London: Cape, 1942. Reissued as *The Pre-Raphaelite Dream*, London: Reprint Society, 1943

Haydon, B.R. and Hazlitt, William *Painting and The Fine Arts*. A. and C.Black, 1838

Hazlitt, William *Criticisms on Art.* Templeman, 1843

Halle, C.E. *Notes from a Painter's Life.* London: Murray, 1909

Hill, George Birkbeck ed *Letters of Dante Gabriel Rossetti to William Allingham, 1854–70.* London: Unwin, 1897

Holiday, Henry *Reminiscences of My Life.* London: Heinemann, 1914

Howitt, Anna Mary *An Art Student in Munich.* London: Longmans, 1853

Hueffer, F.M. *Ford Madox Brown: A Record of His Life and Work*. London: Longmans, 1896
 Rossetti. London: Duckworth, 1902
 The Pre-Raphaelite Brotherhood: A Critical Monograph. London: Duckworth, 1907

Hunt, William Holman *Pre-Raphaelitism and the Pre-Raphaelite Brotherhood*, 2 vols. London: Macmillan, 1905–6; USA reprint, New York: AMS Press

Ironside, Robin *Pre-Raphaelite Painters*. With a descriptive catalogue by John Gere. London: Phaidon, 1948

James, Admiral Sir William Milburne ed *The Order of Release*. London: Murray, 1948

Leathart, Gilbert, Introduction to *Paintings and Drawings from the Leathart Collection*, catalogue of an exhibition organized by the Laing Art Gallery, Newcastle upon Tyne, 1968. Research and arrangement by Nerys Johnson

Lewis, Cecil *Self Portrait* (Charles Ricketts RA). Peter Davies, 1939

Mackail, J.W. *The Life of William Morris*, 2 vols. London: Longmans, 1899

Marks, H.Stacey *Pen and Pencil Sketches*. Chatto and Windus, 1894

Marillier, H.C. *Dante Gabriel Rossetti: An Illustrated Memorial of His Art and Life*. London: Bell, 1899

Massé, H.J.L.J. *The Art-workers' Guild*. Shakespeare Head for the Art-workers' Guild, 1935

Mills, Ernestine *The Life and Letters of Frederic J.Shields*. London: Longmans, 1912

Preston, Kerrison *Blake and Rossetti*. London: De la More Press, 1944

Pye, John *Patronage of British Art*. London: Longmans, 1845

Quilter, Harry 'A Chapter in the History of Pre-Raphaelitism', *Preferences in Art, Life and Literature*. London: Swan Sonnenschein, 1892

Redgrave, Richard and Samuel 'The Pre-Raphaelites', *A Century of Painters of the English School*. London: Sampson, Low, 1890, 2nd ed

Robertson, W.Graham *Time Was: Reminiscences*. London: Hamish Hamilton, 1931

Rossetti, William Michael *Fine Art, Chiefly Contemporary*. London: Macmillan, 1867;
USA reprint, New York: AMS Press
ed *Collected Works of Dante Gabriel Rossetti*, 2 vols. London: Ellis, 1886, revised 1911
ed *Dante Gabriel Rossetti: His Family Letters, with a Memoir*, 2 vols. London: Ellis
and Elvey, 1895
Foreword to the catalogue of the Leathart Collection, Goupil Gallery, 1896
ed *Ruskin: Rossetti: Preraphaelitism. Papers 1854 to 1862*. London: Allen, 1899
ed The PRB Journal, *Praeraphaelite Diaries and Letters*. London: Hurst and Blackett,
1900; USA reprint, New York: AMS Press
ed *The Family Letters of Christina Georgina Rossetti with Some Supplementary Letters and
Appendices*. London: Brown, Langham, 1908

Ruskin, John *Pre-Raphaelitism: By the Author of 'Modern Painters'*. London: Smith,
Elder, 1851. Reprinted in Everyman's Library (no. 218)

Seddon, John P. *Memoir and Letters of the Late Thomas Seddon, Artist. By His Brother*.
London: Nisbet, 1858

Scott, William Bell *Autobiographical Notes . . . and Notices of His Artistic and Poetic
Circle of Friends, 1830–1882*, ed by W.Minto, 2 vols. London: Osgood, 1892
Poems: Ballads, Studies from Nature, Sonnets, Etc. London: Longmans, 1875
Albert Durer. London: Longmans, 1869
The Little Masters. Sampson, Low, Marston, 1879

Smetham, Sarah and Davies, William *Letters of James Smetham, with an Introductory
Memoir*. London: Macmillan, 1891

Sizeranne, de la Robert *La Peinture Anglaise Contemporaine*. Paris: Hachette, 1895

Stephens, Frederic George *Dante Gabriel Rossetti*. (The Portfolio) Seeley and Co., 1896
Flemish Relics. A.W.Bennett, 1866

Stirling, A.M.W. *William de Morgan and His Wife*. London: Butterworth, 1922

Stuart, D.M. *Christina Rossetti*. London: Macmillan, 1930

Swinburne, A.C. with Rossetti, W.M. *Notes on the Royal Academy Exhibition 1868*. John
Camden Hotten, 1868

Taylor, Tom *Life of Benjamin Robert Haydon*. London: Longmans, 1853
Handbook of the Pictures in the International Exhibition of 1862. Bradbury and Evans,
1862

Vallance, Aymer *William Morris, His Art, His Writings, and His Public Life: A Record.* London: Bell, 1897; USA reprint Scott's Corner (Conn.): Milford House

Welby, T.Earle *The Victorian Romantics 1850–1870: The Early Work of Dante Gabriel Rossetti, William Morris, Burne-Jones, Swinburne, Simeon Solomon and Their Associates.* London: Howe, 1929

Williams, G.C. *Murray Marks and His Friends.* John Lane the Bodley Head, 1919

Woolner, Amy *Thomas Woolner, RA, Sculptor and Poet: His Life and Letters.* London: Chapman and Hall, 1917

Woolner, Thomas *My Beautiful Lady.* London: Macmillan, 1863, 1864 and 1866

English periodicals of the time which contain illustrations and articles by or about the Pre-Raphaelites and their associates, precursors or successors, include:

The Germ (USA reprint, New York: AMS Press, 1967)
The Art Journal
The Magazine of Art
The Studio
The English Illustrated Magazine

The *Penny Magazine*, the *People's Journal*, the *Illustrated London News* and *Arnold's Magazine of the Fine Arts*, are also useful, giving some of the sources of the early ideas of the PRB.

INDEX

Name index

Ford Madox Brown, Edward Burne-Jones, William Holman Hunt, John Everett Millais, William Morris and Dante Gabriel Rossetti are not itemized, as their names appear on almost every page of the book.

General index